WOMAN to WOMAN

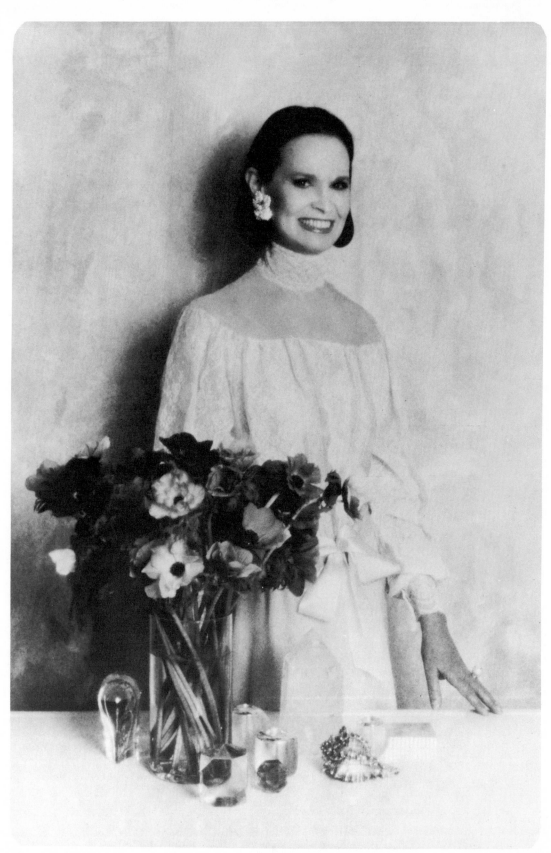

GLORIA VANDERBILT

WOMAN to WOMAN

DOUBLEDAY & COMPANY, INC.
GARDEN CITY, NEW YORK
1979

Art Direction: Alex Gotfryd
Design: Robert Aulicino

Dedication

To Carol
who knew from the beginning

Loving thanks
To Gloria Safier, whose encouragement inspired me to write this book;
To Dale McConathy without whose help—as has often been said,
but this time with truth—this book would never have been written;
To Cris Alexander who over the years has taken
some of my very favorite photographs;
To Kate Medina who brought it all together;
And to Alex Gotfryd who brought it visually to life.

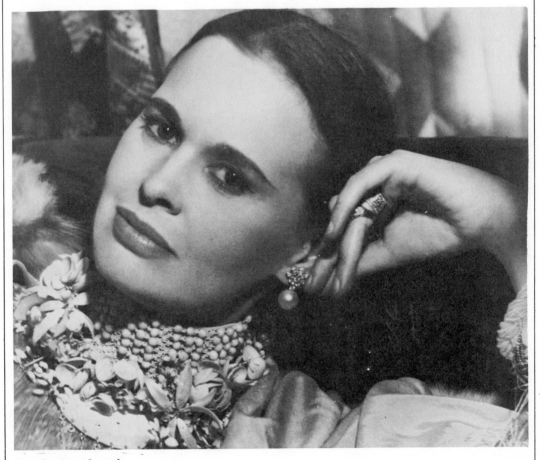

Photo by Cris Alexander.

CONTENTS

This is the story of one woman's development. Not an autobiography, not a biography, not the story of a life—but how I learned to see, feel and think on my own, how I became an artist and a person.

WOMAN to WOMAN

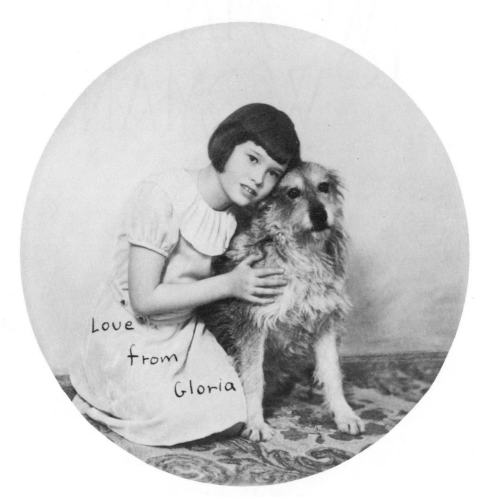

Gloria with 'Sandy,' 1932.

WOMAN to WOMAN

THIS BOOK IS NOT AN AUTOBIOGRAPHY, although in it I talk about many things that are close to me. Rather, it is a book about a person's evolution—the evolution of my spirit, how I grew and changed.

I have written the book in hopes that some of the things I have learned will be of use to you as well.

In many ways, I seem to have come of age at the same time that the American woman was coming of age. What follows in these pages is something we've learned and grown through together. I recognize this in the lives of my friends, and in the secrets many women have shared with me in letters and during my trips around the country, visiting department stores and giving talks.

Often, when I'm traveling across America, the press have said how lucky I am to have been born a Vanderbilt. What they don't see is how lucky I am to have been able to make of my life something that is my own. And the extraordinary freedom that can come once one sets aside the ties of tradition and privilege.

I grew up with Little Orphan Annie, and we learned a lot growing up together. We had a great many things in common.

About her, it was written, "Annie, child of indomitable spirit, lost and wandering . . . could stand as a metaphor for courage, morality, innocence, and optimism in the face of cynicism and pessimism."

Annie inspired survival and how to go on even when grown-ups let you down. She said once—and I'm not certain where or why—but it has stuck with me: "Remember, you're never fully dressed without a smile." Her words have gotten me over a lot of rough spots.

When I began this book, I thought of her smile and I wanted it to be your smile, too. I wanted to share some of my life with you, in the belief that what I've learned, sometimes the hard way, may save you some steps in your life, too.

3

I want this to be about your life, too—to be your book, as well. So I'm going to ask you to go through several experiences with me, layers of thought and experience, the pattern of which will become clear, I think, as we go along. There is no real secret about what you're about to read, except, maybe, the smile.

Life is no longer a question of rules, as it was when I was growing up, when etiquette was considered all-important. To some, which fork to use and which pair of gloves to wear mattered more than anything else, for it was often the structure on which lives were built. Now, I think real kindness and consideration have replaced all the old ideas about how things should be done. What you make of your world is up to you, your heart and your imagination.

I suppose that the old rules about how we should look and live, the careful ideas that prevailed when I was growing up, had something to do with a certain insecurity about American life, our search for a style. Europe *should* know best because Europe had been around so much longer!

When I was growing up, it was always said that there was neither good taste nor bad—only taste. I have since learned not to believe in the idea of taste at all, but rather in expression. When someone uses the word *taste* too often, I begin to suspect that here is a soul that has gone stale. Where are the enthusiasms that contradict the rules, that make something new? I'm more on the side of the people who make change in the world— the artists, the poets, the mothers, the creators—instead of critics who worry about how things "should" be.

I'm always surprised and gratified by what I hear and learn from the women I meet in cities across the country. Now more than ever, American women speak their own minds and share their own experiences, their "secrets." We know what we want. We have recognized that the tired, old tyrannies of "good taste" have ended and that we are responsible for the excitement and the quality of the world that we and our families share.

Some say that aristocracy, money, and taste go together. I feel rather that the true aristocracy has always been and always will be an aristocracy of feeling, per-

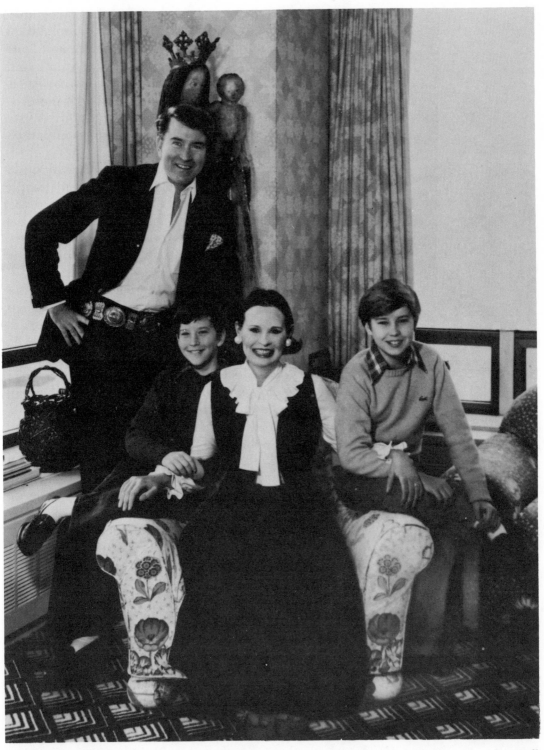

The Cooper family, 1977. Photo by Cris Alexander.

ception and creation—an aristocracy of hearts and minds, not dollars. In the history of this country, women have frequently taken the lead, to improve the lives of those around them both materially and spiritually. Whether this leadership took the form of quilts or broadsides, paintings or soup kitchens, books or banners, taste was not the question. Nor is it now.

No, I do not believe in taste. But I *do* believe in the spirit of the American woman that has enriched, leavened and lightened all of our lives.

When I first became involved with patchwork quilts and other forms of American handicrafts, many people were puzzled, or so they told me, because they didn't see what I found beautiful in them; quilts didn't seem "profound"—as "art" was supposed to be. But, for me, the patchwork quilt proved to be a revelation—and in many ways this book is a patchwork creation.

I first became interested in the patchwork quilt because it seemed an extraordinary art form and it was one that had been invented by American women. It was supremely useful, ultimately practical, but each one was also unique. I had sensed that so much about what was then considered "art" or "taste" sought to exclude life, to pare down, and here was a form of expression where everything could find a place.

The patchwork seemed a metaphor for memory—bits and pieces from the past useful in the present—and for the deeply loving and caring way in which women transform the world around them, starting from what they have as individuals and weaving it into a pattern of life.

The patchwork also seemed to me to say something about feeling, to be a concrete expression of the feminine spirit in action. My intuition had already told me the power of objects to speak love and concern; quilts seemed to say that love and concern were absolute necessities day by day, woven into the world around us.

What's more, patchwork quilts seemed tangible proof that old ideas about what matched and what didn't had absolutely nothing to do with real beauty. Anyone who has looked at a crazy quilt knows what I mean.

Often as part of the price we pay in growing up, we lose or we have smothered or frightened out of us that

Fabric design "Garden Party" based on patchwork quilts.

innocence and sense of wonder and trust that children have in abundance. We stop looking and seeing and feeling with the clear, clean eyes of youth. We stop growing and start mistrusting ourselves, our impulses, our tastes, our instincts.

The patchwork quilt represented to me aspects of the freedom a woman can have if she trusts her impulses about color, form, and design, her intuition of wholeness. In making quilts, there are no rules to follow except what delights one's eye. Quilts are often the most personal expression of a woman's hopes and dreams, not only about herself but about the home she creates.

So the patchwork quilt became a symbol for me of the creative power of the individual mind and spirit—the way art constantly recreates the past into something new. And in that sense, the patchwork quilt is also a symbol of this book, the way pieces from my life, my past are juxtaposed with ways I now dress, live, entertain, think, spend my time. Writing this book meant carefully working the small pieces of my life, my ideas, into a whole, following an inner logic that expressed itself only in the making.

In these pages, I hope to share with you some secrets about my life, a patchwork of experience, to show something about how a woman dresses, entertains, works, decorates, and why she does these things uniquely in her own style—using myself as one example. The meaning of all this is only coming clear to me now, and I want to share with you some secrets about my life, how I live and why and how I've come to live this way, in the belief that some of the things I've learned might be useful to you.

Sorting out these bright scraps of memory, silks, and velvets from here and there, I have recognized certain themes and threads that piece the whole together. I think one of the goals of life is to try and be in touch with one's most personal themes—the values, ideas, styles, colors that are the touchstones of one's own individual life, its real texture and substance. These touchstones affect everything we do—dress, home, work—and they come from many things, but especially from our experience of the past, and memory. I have come to recognize the extraordinary energy that has come to my work and my life through memory. So the

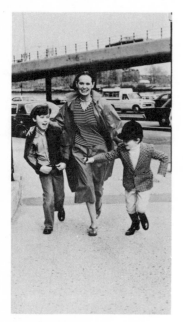

Gloria with her two sons,
Carter and Anderson.
Photo by Susan Wood.

power of memory, its effect on how we look and live, is what I'll talk about first.

That intricate, amazing process called "memory" is reflected not only in the patchwork quilt, but also in my use of the collage—a technique that has now passed from my work into my life, permeating how I live, how I think, and therefore the world I have tried to create for myself and my family. The power, and usefulness, of collage as a way of thinking, of getting in touch with the themes of one's own life—that is the second most important secret, after the richness of memory, that I will share with you. And also the usefulness of fantasy, and dreams, in understanding one's self.

The greatest part of my understanding evolved from a recognition of the golden thread of self that came to connect my imagination and the various aspects of my life, and that (I came to see) affected what I wore, where I lived, the days of laughter and loneliness I shared. I would guess the same is true for you.

Our inner secrets, as we come to understand them through memory, dreams, are reflected in one's outer world—the true image of self one conveys through friends, books, dresses, homes, good times. These are the outward expressions of a gentle wisdom about ourselves that we acquire over time.

The secrets I have to share are about love, family, money, loneliness. About self. And about time. About the importance for a woman to work, and how memory, fantasy, dreams lead to self-discovery, and self-expression in all one's life.

But the most important of these secrets is one that we share together, if we have the courage to recognize it in ourselves. That is the real story of these pages: that each of us has in ourselves the power to change, to recreate a world, to change it, as we live day by day, with love, work, instinct, to create something which is strong and enduring—a gift from your self.

As you turn these pages, know that none of this has come easily. But it has not been a question of pain but of patience. The hope was ever there. The expression has been a long time in coming. When I speak of my work, my art, I speak of my life; you can too. That is now one of our secrets.

Part I
SHARING DREAMS: A COLLAGE

As a teenager, 1937. Photo by Hal Phyfe.

1

The Bright Garden of Memory - and Taste

MEMORY SEEMS TO ME THE DEEP TREASURE trove of all creativity, one of the sources of beauty and wholeness that is locked within each of us. In this chapter, I'll indicate some of the keys to that treasure I've found for my life in memory, in the hope that dreaming along with me, about what I've known and loved in the past will provide you with a few secrets that will help you tap the creativity in your own memory, as well.

Your taste, my taste grows out of an accumulation of memories, of longings. Memory is concerned with the senses—as is "taste." We have to learn to understand the chains of memory that are connected to all our experiences in order to recognize what we like, and why, and to trust our responses. Memory plays tricks on us—it isn't always accurate, and various memories conflict with each other. And we have to choose among them.

The memory that survives is usually the "truest" version of our feelings. My first feeling about a past memory usually turns out to be the one I keep, and it often leads into my paintings, my dress, the objects I arrange in a room. Memory is inextricably linked with

*Gloria's drawing
"Girl Planting," 1968.*

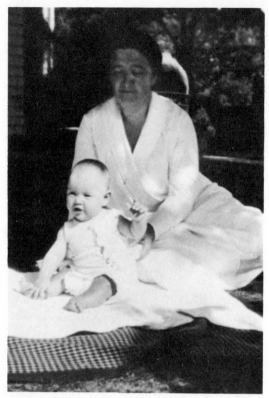

Gloria, at four months, with Dody, her nurse, 1924.

On her father's farm, Sandy Point, Newport, Rhode Island, with Dody, 1924.

Playing with Dody, 1924.

A favorite snapshot of Gloria's—with Dody, 1925.

A dip, 1924.

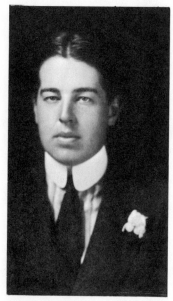

Reginald Claypoole Vanderbilt as a young man.

Gloria's father, Reginald C. Vanderbilt.

my work, and life. We are used to analyzing our emotions about experiences but I don't think we're as used to sorting out our feelings about color and touch. That's why the chain of association in memory can be so important, because it helps you to discover *why* you like something, which opens up new possibilities of returning to the origins of your feelings.

The past has so much to do with the direction one takes. But I also believe that every day is a beginning. Appreciation and amazement can only come after we've distilled what has come before.

The reason I return again and again to my childhood nurse Dody in my memory and in my work is that she was an integral part of my life from my first memory in a way no one else was. She had come to me as nurse the day I was born and remained until the custody case between my mother and my Aunt Gertrude. It was then that she was taken away from me and I went to live with my father's sister, Aunt Gertrude, in Old Westbury, Long Island. The years up until then had been happy for me because of Dody and my grandmother. Even my grandmother's sudden moods of volatile hysteria, which erupted unexpectedly, and were experienced by me as ominous tremors of thunder, as though something terrible were about to happen, even these were forgotten during days of warmth and closeness with the three of us together.

My grandmother was passionately manipulative so that eventually her nature was largely responsible for the custody case that not only changed my life but my relationship with her. However, that came later, for in the early years she was devoted, although possessively, giving me love and security in her way, as Dody did in hers. Dody was balanced and her serenity was unquestionable. She was all the world to me and surrounded me with love, the memory of which will stay with me always. There was no male frame of reference ever, except fleeting images of German princes with monocles, beaux of my mother's and Aunt Thelma's, who clicked their heels as they bowed to kiss a lady's hand. I then had no sense of loss over a father I'd never known and it never occurred to me that anyone lived differently.

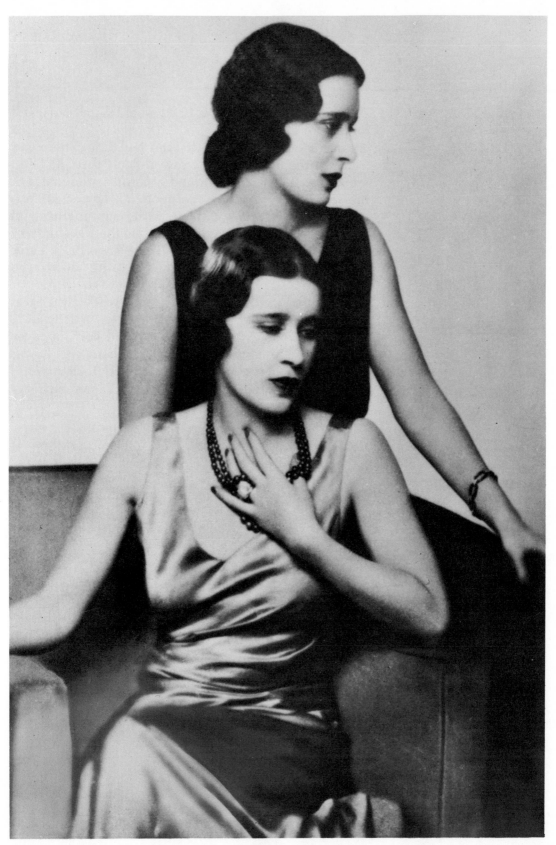

Gloria's mother, in profile, with her twin sister Thelma, Lady Furness, seated, 1931.

It was only later that I missed what I didn't have and longed for a father.

I can recall a recurrent dream I had then. There was a gate in the midst of a low row of doors that had been erected as a barricade around a construction site. On the street side of one of the doors a scrawled graffiti: "Fear not, love is here." I ran with pounding heart to open the gate, believing he would be there waiting for me. But there was nothing, only the huge pit of earth the workmen had made when tearing down the building.

A fantasy I used to keep close to me when awake was that my father had written me a letter, a long one, telling me about himself, about me and how much he loved me. This letter existed somewhere and it was only a matter of time before I would find it. Or it would be delivered to me at a moment when I least expected it.

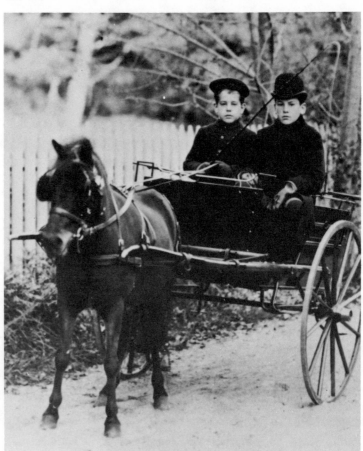

Gloria's father, Reginald Claypoole Vanderbilt, as a child, taking a pony cart ride with his brother, Alfred Gwynne Vanderbilt, 1895.

There was always the overwhelming longing to belong. I can remember trying to copy my mother's handwriting because I wanted desperately to merge with her and to be her. I imagined my mother and I were the twins, not my mother and her sister, Thelma.

I spoke earlier of memory and expectation but there is also another side to what can jog the imagination. A certain kind of music can do it, tug the memory into feelings we often have no words for. Remember Noel Coward's line in *Private Lives* from the balcony scene; his haunting song, "Someday I'll find you" is playing in the background. "Strange how potent cheap music can be," Elyot says with tongue-in-cheek to Amanda. Everyone has his favorite songs for these sentiments, songs of memory. What are yours? What memories do they evoke—what colors, textures in the scenes? Among mine are the tinny sound of a hurdy-gurdy or music from a calliope. And the "Liebestod" from *Tristan und Isolde,* "Un bel dì" from *Madame Butterfly* or the "Musetta's Waltz" from *La Boheme.*

Smell also can evoke memories—for some people, more than music. Perfumes, autumn scents, cider, leaves, apples, spring rain falling on the trees, the baking of bread. The fragrance of a loved person—mother, grandfather, childhood friend. One of my favorite books is C. S. Lewis' *Surprised By Joy,* for in it he describes most accurately these mysterious feelings of "romance" or "joy"—fleeting experiences we all have at one time or another triggered by a bar of music, a landscape or a forgotten memory. As Chad Walsh writes in his afterword of Lewis' book *A Grief Observed*—"the experience of an instantaneous sense of seeing into the heart of things, as though a universe beyond the universe opened itself wide for an instant and as instantly slammed its doors shut." One of Lewis' experiences of "joy" came through a Beatrix Potter Book, *Squirrel Nutkin,* from which he mysteriously ... perceived "the idea of autumn" from the images the words conveyed. It happens suddenly, an unplanned revelation, often with long spaces of time in which we remain unvisited by the intimation of "joy"—and then it comes unannounced, and in full strength.

Until I was twenty-five I kept a diary, and then I destroyed it. Being unable even to imagine the years beyond the ripe old age of thirty, I had the romantic notion that I wouldn't live that long. I thought: suppose a flower pot falls on my head and there it is—that diary expressing only superficially all those feelings teeming inside me.

Although I had learned to survive, I found my need to share was greater than ever. At fourteen, I can remember hugging the trunk of a gigantic tree, wanting to merge with its beauty and strength. Nature always fulfilled this desire in me. I could experience a mystical loss of self while imagining I was part of an apple tree in bloom or the sea, with limitless horizon.

As children, many of us feel that adults know the answers to a secret and that when we join the adult world we too are going to be let in on the mystery. It's only later, when you grow up, that you discover there isn't any secret except the one you have to find in the center of yourself. It can't happen in any other way. Then and then only can you realize that you're alone and everyone is alone and it's all right.

That realization of aloneness makes it possible to begin to share. Certainly, some of the happiest memories are connected with sharing and warmth and communication with another being. Those moments come most often when a feeling is shared such as experiencing someone else's vision of beauty in a painting, or discovering a poem and thrilling to feelings you have also felt but were not able to articulate.

One's reaction to art changes at every point in one's life. The essence of the initial experience often has become internalized and been forgotten. It helps enormously to be able to share those experiences. If you're with someone, the response comes more spontaneously. I never question, did I like that? I try to put myself back in a world that was magical. I try to see without the rules or without considering what is and is not permissible or even what is accepted.

My first memory, not the first actual memory, but the memory that pervades all other memories of my childhood, and therefore the memory that pervades my life and work, and affects my taste, sense of color, is of the

South of France. It's a memory of paradise that speaks to me always of the power of light and color. There is a painting by Maurice Denis in the Musée d'Art Moderne in Paris called "Paradise" that comes close to expressing what I remember. The images come whole and complete—the simplicity, the blue of the ocean, the green of the tree, the children reaching out to one another and toward the sun—and they are images without shading. That memory stood for all the other memories for me—memory and color were inextricably linked.

I believe that every single human being on this earth experiences color in a different way. It is unique to each person. Men favor specific colors, not only in what they select to wear, but what they choose to surround themselves with. Usually, women are diametrically opposed in their choices. Who is right? Who is wrong? There is, of course, no such edict. As for me, certain colors look muddy and, therefore, are a mistake. To others they look right.

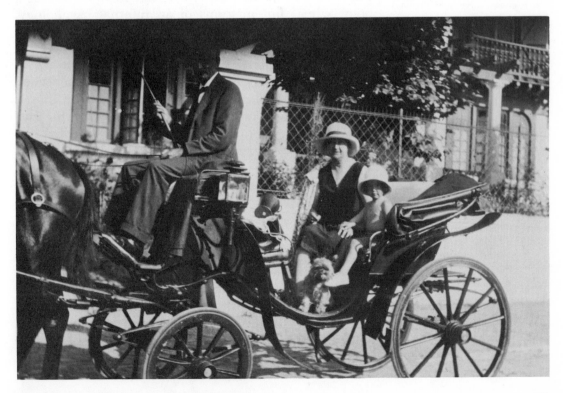

Taking a spin with Dody on the Riviera, 1928.

Laura Kilpatrick Morgan, Gloria's maternal grandmother.

Harry Hays Morgan, Gloria's maternal grandfather, 1930.

Color in fashion brings another response. Much more than the texture of fabric, color is your style. Skin tone and hair coloring become cosmetic colorings. Fashion colors are in no way related to the pigments used in painting—you can never tell if the color of a dress works until you wear it. My husband Wyatt Cooper* said that no one would be attracted to a girl wearing orange. Why would a certain color turn a man off? But it's so, isn't it?

Then, also, our color senses change. I once used mainly dark colors in my painting. The paintings of Blakelock and Ryder affected me deeply, echoing the painfulness of spirit I felt at that time. My paintings were night scenes full of darkness. Later I found that pure brilliant colors acted as an antidote to these feelings and gradually my whole being and response changed. Now I can get absolutely high on certain colors not only when I'm working but by reacting to colors I see every day in my life, in the way I've designed our home. Different colors relate to each other for me in different ways, not in the sense of a color wheel but in terms of an internal psychology. Have you thought about your own color sense, where it comes from?

I always dream in color. Memories come to me in color. In my mind's eye, I can see a room or landscape in color. People also appear to me in vivid color. I think of my mother's raven hair and gardenia skin. Her mother, my maternal grandmother, Laura Kilpatrick Morgan, I experienced visually as a Toulouse-Lautrec painting—her hair, spun sugar, carrot-ginger in color, worn in the Belle Époque style, swept up high in front. Remembering the color of her hair brings her back to me.

She wore eccentric make-up, flour-white, plucked eyebrows with penciled-on arches, lips thin, almost disappearing when she was angry. Her nose was long and thin—"Roman," she called it—probably inherited from an Iberian ancestor. She was short, proportioned perfectly, with minuscule hands and feet in keeping with her size. Dark eyes used expressively and constantly to telegraph her moods, sometimes hid coquet-

*Wyatt Cooper, author of *Families: A Memoir and a Celebration.*

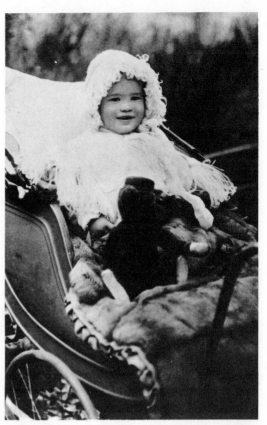

Gloria with her mother, 1924.

Gloria gives a teddy bear friend a lift, 1925.

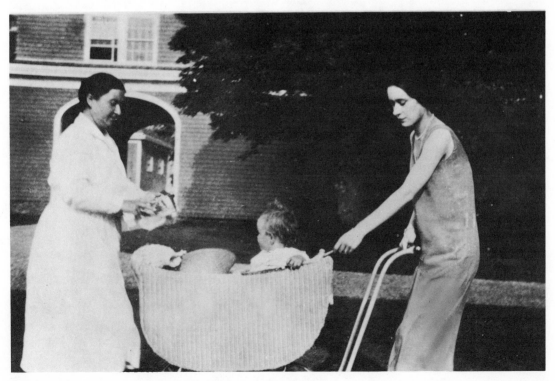

Gloria in her wicker pram with Dody and her mother, 1924.

Gloria distracted, 1924.

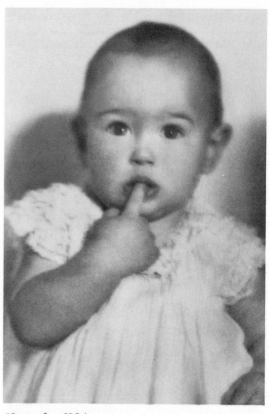

Gloria shy, 1924.

Gloria and bonnet, 1924.

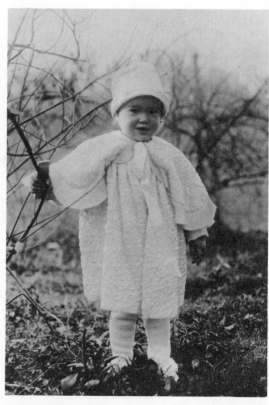

Stepping out, 1925.

tishly behind a fan. She had all sorts of theories about beauty. "Never stay long out in the sun," she might say, "it ruins your skin." Having exquisite skin herself, perhaps she had a point. "Every night, before going to sleep, cream your hands and sleep with gloves on." More often than not, she dressed in rust colors, a subtle continuation of the color of her hair. And she almost always wore long sweater-jackets with lapels. She was so wonderfully vain that I didn't see her without make-up until the very end of her life. I called her Naney. She was a fascinator and I adored her.

As you can see, color is very closely tied up with memory for me. Is it for you? What are the colors of figures, scenes from your past? My sun- and flower-filled memories of the South of France are important to me because they represent the happiest moments of my childhood, the times when I was free and able to be by myself. Several years ago, I had a chance to go back to Cannes because of a film festival. In my memory, all the buildings had been birthday cakes with fanciful angels and flowers of white icing. Suddenly, as an adult, I discovered they were gray and embellished with curlicues, more like Disney World façades, almost mundane. It was no longer possible for me to experience the scene whole. Unlike my memory, people in bright sunlight cast no shadows.

Gloria invades the toy chest her father built for her, 1925.

But that is one of the tricks of memory. The sensations of color and touch are accurate but the mind plays tricks with the scale. My mother's pearls looked as huge to me as quail's eggs strung together with crystal cord. That was true to a little girl's eyes and hands. Now, they are a necklace of white beads.

I really have so few memories of her from those days. I saw very little of her, actually, because she led the life often typical of women in her world. A very social life in London or Paris, out most of the night and sleeping late in the day until the round of parties began again. She was beautiful and exquisite and my memories mostly are of her dressed to go out for the evening. She was mysterious, remote, and unattainable to me. The ropes of pearls against the soft velvet of her yellow dress. How could I ever reach her or be part of her?

I can remember her decorating a bright yellow box to

present to a friend, covering it with découpage. I've put that together, in my mind, with the dress she was wearing going to a party, the long yellow velvet gown that seemed magical, unreachable. Both the yellow box and the yellow velvet gown are alive in my memory as if it were yesterday.

That house in Paris at 14 Rue Alfred Roll is the first place I remember living. I recall that in the living room there was a white bearskin rug with the head still on, sprawled out against the chestnut color of the parquet. I loved to stretch out on it, savoring the warmth of the fur, imagining myself in some remote forest; the Louis XVI furniture was transformed into exotic trees, the pale aqua of their brocades became patches of sky, and the burnished parquet of the floors seemed pathways of adventure winding in and out among the intricately patterned Persian rugs.

One other incident fixes that house in my mind and it too is a visual memory. One day, my mother had asked someone to lunch and, as a special treat for me, asked me to join them. She explained that her guest was blind and that we must do everything we could to make him feel at home. I remember waiting for him in the living room with the bearskin rug. When he arrived, I started to show it to him, then stopped myself. We went in to lunch and suddenly, while we were eating, a butterfly floated in through the open window. Of course, this time I couldn't contain myself and exclaimed with delight. How kind he was about what I had seen that he hadn't.

And I think I should also say about those childhood years that in filling in my coloring books I never paid attention to the dots and, as with all children, the color combinations were my own.

My life as an artist began when I went away to the Mary C. Wheeler boarding school as a teen-ager. There, in the art department where we could work after study hours, I began to find myself. For the first time, I experienced a highly supportive atmosphere as well. The teachers respected me and I received recognition from the other students. But I left school and didn't go back. I had to continue fighting to work out other areas of my life. It was not until my early twenties

when I started doing the dark paintings I mentioned earlier that I became a working painter.

Even under the best of circumstances most of our early years are often spent in the search for an identity. While growing up I didn't have well-defined feminine and masculine figures as a frame of reference. This was confusing to me and it took me a long time to work this out not only in my personal life but in my working life as well. However, I am not complaining, because in the long view it couldn't have happened any other way. I may be the stronger because it took me so long. Nothing is achieved without hard work. Then it's real and has true value.

But my career might have evolved in an entirely different way had I grown into my talent faster and discovered myself as an artist sooner.

There is not enough understanding about the conflict society sets up between being a woman and being an artist. For example, it is almost impossible for me to work with make-up on. It is distracting and unreal to me. It takes away from my concentration. That conflict a man doesn't have to face at all. He can be dressed in ten minutes not only for his work but for his social life as well. What a luxury to have that kind of freedom in your life!

Often make-up for a woman is symbolic. Much of what impressed my mother, grandmother, and Dody, my governess, was how I looked. I was concerned with pleasing them and getting their attention. It's interesting to me that many women now stress that using make-up puts up a barrier between the world and their true feelings. To many, much of that concern no longer exists. We're no longer preoccupied with masks in the same way.

Painting gave me access to feelings in myself that I could approach in no other way. The image of the mother and child—me with my governess and grandmother, as well—occurs again and again in my paintings. I keep going back to the long days on the beach in the sun. In the South of France, I had the feelings of love and warmth and closeness, far from the tensions of the house in Paris.

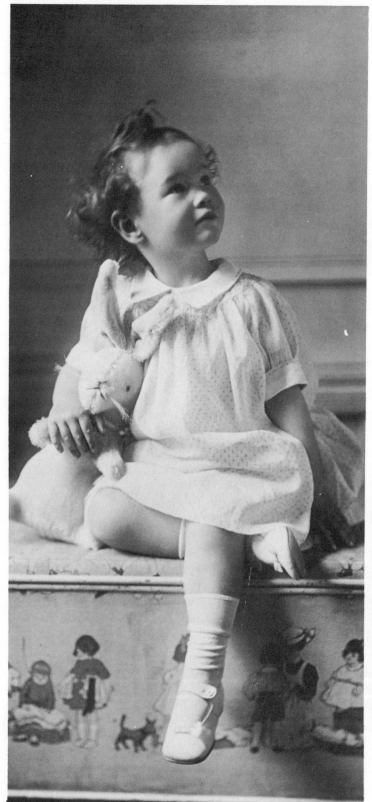

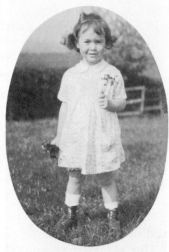

Gloria gathers wildflowers, 1927—one of her favorite snapshots and the subject of many of her paintings.

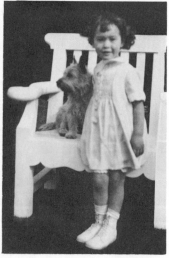

Gloria and a dog friend, 1928.

Gloria and rabbit friend, 1927.

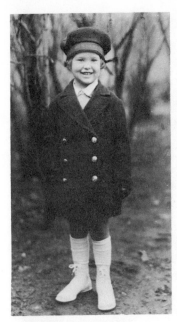

Gloria goes for a stroll— wearing a reefer and a sailor's cap, inscribed USS New York.

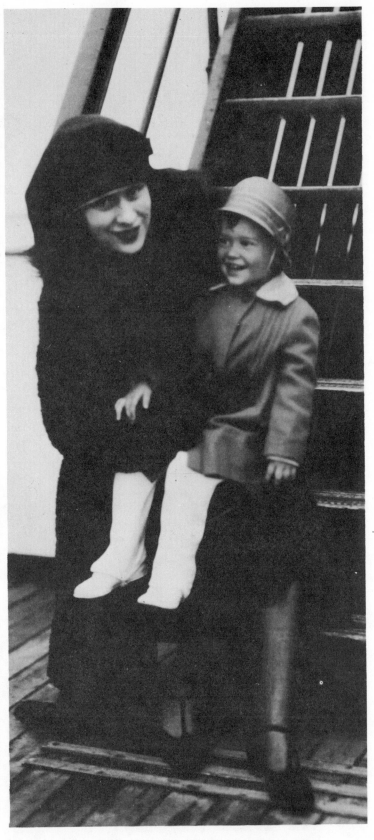

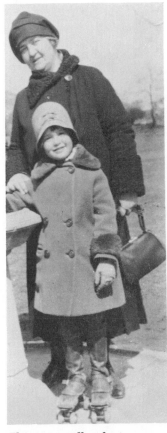

Gloria goes roller-skating with Dody.

The two Glorias sail for Europe on the <u>S. S. Leviathan</u>, 1926.

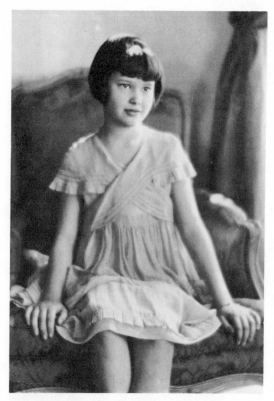

Age 9, sitting for a portrait.

In the south of France, Gloria with friend Peter Salm and his grandmother, 1931.

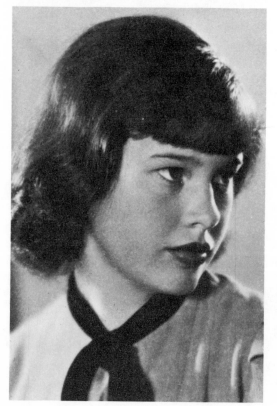

Gloria at 14.

Gloria grows up, 1938.

Gloria cuts up with her school chum Constance Withington, 1940. 29

Gloria with her four pals, Westbury, Long Island, 1940: Fletcher Godfrey, Geoffrey M. T. Jones, Jay Eddy and Ray Higgins.

Gloria at the Wheeler School with Constance Withington and Ann Root, 1940.

There all my ideas of serenity and beauty began. It was a world of vast green golf courses, of Hispana-Suizas pulled up under bright awnings, of hotel rooms looking out on the Mediterranean, and everywhere there were flowers.

All my ideals of beauty in women began with my mother. She was only eighteen when I was born; my father died shortly after. Mother moved to Europe to live. Her beauty was flawless and therefore in a sense one-dimensional. I have always, because of early memories of her, been fascinated by a stylized, model type of beauty. It was only much later, when my mother's beauty was altered by her life experience, that I came to understand and appreciate her inner truth, and found her in later life touching and vulnerable and not at all the ephemeral being who floated on the periphery of my childhood.

It is only when you reach the center of yourself that you can experience life, in a widening circle, as a person come full circle who is truly oneself.

From my childhood, I always felt alienated from the environment I was in. I had the feeling of not belonging anywhere. It took me a long time to discover and reach the center in myself and yet, when I did, it was with a shock of recognition, for there were and always had been bonds of steel connecting me to that core of self.

What ever is lost in the past is regained in memory. Memory for me is always something connected with the senses, perhaps not concrete or tangible but deeply rooted in experience. Photographs are so important to me because they catch that momentary, fleeting sense of things. They are indeed the frozen moment.

It's hard to separate memories from photographs. I find that the photograph sets the image into an outline. It floods the memory with light. A photograph makes it real to me, just as the printed word does for others. I find myself surrounded by photographs. I have them everywhere around me. And I'm constantly amazed by how much a life of its own each photograph has. Again a world contained and complete in that second when the camera clicked. In looking at a photograph, I often continue the action on into a fantasy of the moment after the click. The people moving apart, out of the pose. How they look at each other. What they said.

Photographs are invaluable for me in triggering the memory, the play of light on the grass, the child's hand reaching out, the mother's answering smile. Everything I respond to in any way relates to a whole complex network of things—and this is surely true for you too. The chains of memories and associations are interwoven with other memories and associations. If you pick a memory to trace it back to its sources, the associations go off in all directions. As Susan Sontag observes in her book *On Photography,* "A photograph is both a pseudo-presence and a token of absence. Like a wood fire in a room, photographs—especially those of people, of distant landscapes and faraway cities, of the vanished past—are incitements to reverie. The sense of the unattainable that can be evoked by photographs

Gloria with Cathleen Vanderbilt, her paternal half-sister, 1949. Photo by Jerome Zerbe.

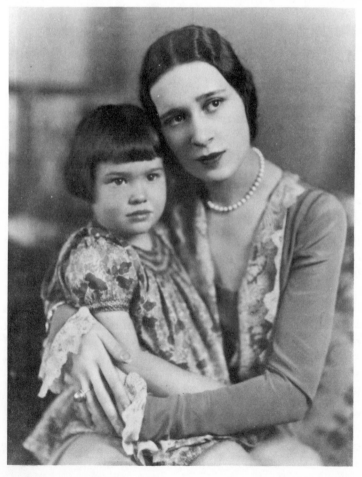

With her mother in Paris, 1928.

feeds directly into the erotic feelings of those for whom desirability is enhanced by distance. The lover's photograph hidden in a married woman's wallet, the poster photograph of a rock star tacked up over an adolescent's bed, the campaign-button image of a politician's face pinned on a voter's coat, the snapshots of a cabdriver's children clipped to the visor—all such talismanic uses of photographs express a feeling both sentimental and implicitly magical: they are attempts to contact or lay claim to another reality."

Driving to the Eiffel Tower, 1929.

So, more and more, I plunged beneath the luxurious surface of a remembered world of childhood memories. I found I responded to color, remembered color in the way I did because I longed to make contact with my mother on a deeper level, to respond to something real. Color made it happen. I had only the powerful memory of the lacquer box and the velvet gown but through the memory of that bright yellow I came to experience fleetingly the merging with her I so longed for.

Memories are feelings surrounded by light, color, and sound. I remember the room in Paris, high up under the roof, filled with colors and textures. Here Marie, the maid, worked tending mother's dresses for the parties ahead. It was here I would touch the long rows of pale-colored pointed-toe shoes, the crepe de chine slips frosted with lace and gowns that touched her skin, longing to be part of something forever out of reach. There in memory are rooted the dark, stretching roots of creativity.

Becoming an artist worked for me. As an artist, I found my world. I wonder, what are the keys for you? What are the origins of your likes and dislikes, of your "taste"? What are the colors in the bright garden of your memory?

Walking her dog, Paris, 1930.

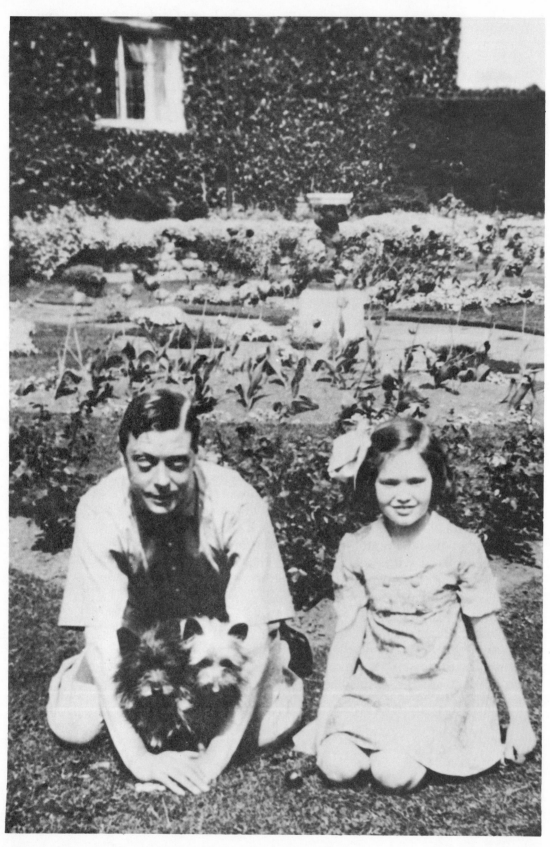

Gloria with her aunt's friend, the Duke of Windsor, 1931.

2
Fantasy-
Life-transforming

IF MEMORY IS AT THE ROOT OF TASTE, of many of
our sense responses, and therefore of our individual
style and creativity, fantasy can expand one's ability to
see new possibilities in things, and in people. Fantasy
refreshes feeling.

One afternoon in England during a Christmas holi-
day at Melton Mowbray (my aunt Thelma's English
country house) my aunt Consuelo Thaw picked up
Alice's Adventures in Wonderland and began to read to
me. I'm sure she had no idea how important the world
she had opened up for me would be, when the White
Rabbit disappeared down his hole and Alice followed
him.

The journey that began that afternoon has not yet
ended. My mother never had the time to read to me.
Nor had my aunt Thelma. But Consuelo told me about
Alice. (I often think of her house in Mallorca with its
tower so much like Faraway, my favorite house, which
I'll talk about later, and the well-ordered life she had
built for herself. Perhaps she listened to her stories as
closely as I did and also believed in their magic.)

I'm afraid the word fantasy has been often misused,
because for many people it now means an escape from
reality. In the past, part of the reaction against fantasy
was the general reaction against Romanticism and the

Aunt Thelma, 1930.

Gloria and Dody visit Melton Mowbray, Gloria's aunt's English country house, 1927.

role of the imagination, but the result has been to force us to accept a dreary and banal notion of the everyday and the ordinary. Perhaps some of this resistance to fantasy has begun to change since there is a renewed interest in fairy tales and their importance to children and to adults.

But even this development concerns me because it puts the value too narrowly on the therapeutic. I think fantasy can be a tremendous force enriching our lives, and our taste—not only in solving our problems.

Fantasy can take you anywhere. It can give you new ideas about yourself, how you look, your world. It can give you some clues about what you wear and how you live. It has no built-in conclusions. It can take life, and transform it. For children the promise of the fairy tale is that the world in fantasy changes endlessly and often magically. The deepest value is in the wealth of detail, the rich colors and the variety of sensations. They are a kaleidoscope. Each time you examine them the impression is different. Their strength is that they are open-minded.

Fairy tales give us a sense of a whole world available to us. The essential mystery they present is that any object, any person, any landscape has the potential to be something else. Don't trust reality, fairy tales seem to say. What you see is not necessarily what is; it certainly isn't what has to be, forever. Cinderella is not forever a Scullery Maid. The Frog may really be a Prince. The Tin Soldier can love deeply and passionately. The Ugly Duckling might also be a Swan. These paradoxes reflect life.

When I look back, I realize some of my true mentors were Arthur Rackham, Beatrix Potter, Pamela Bianco, Kay Neilsen, and stories such as A. E. Coppard's "Adam and Eve and Pinch Me" and novels such as *The Water Babies* by Charles Kingsley.

Fantasy for me is a direct window onto a truer world, and a point of departure from life as it is. The ancient world had that circular recognition, the belief that every tree and rock had its own divinity. The world of appearances was alive and charged with a luminous power.

Painting has given me a chance to express the world of fantasy through the sensation of color, and to summon up the enchantments of childhood discoveries.

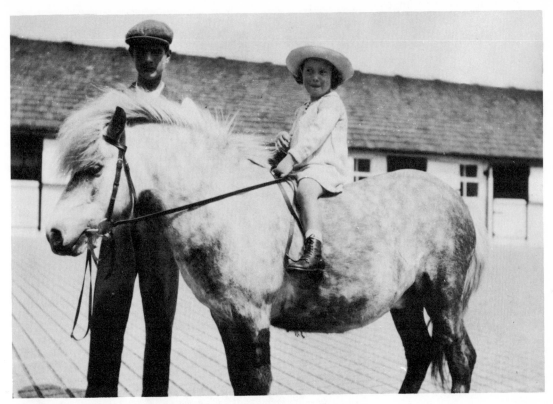

On ponyback at Melton Mowbray, 1927.

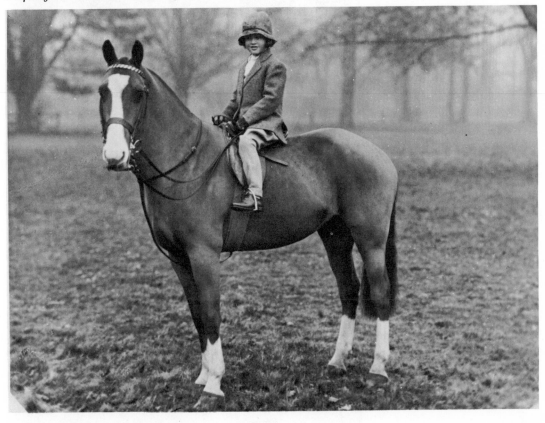

On horseback, Old Westbury, 1934.

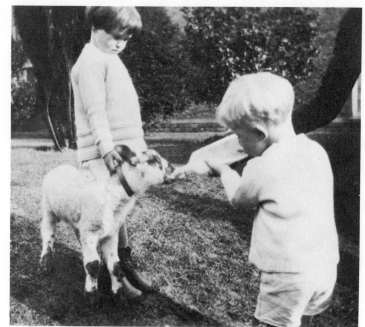

Supervising the feeding of a lamb at Melton Mowbray, 1928.

Gloria in costume in the gardens of Melton Mowbray, 1931.

I can recall one day in grammar school; I was standing up in front of the class to read a composition I had written about the South of France. When I finished reading, the teacher said he had felt that, as I read, I was standing in front of a screen on which whole fields of green and blues of sky and sea were projected. I was touched to hear that I had been able to share, in some measure, my feelings about light and shadow and color—feelings that come from memories.

There is another kind of fantasy that is perhaps more immediate. It is a way of storytelling that I invented for myself. But, more than storytelling, it is also an attempt to unravel the essence of other people. Another of my first memories of my mother is of her wearing a crystal-spangled white gown, looking more fragile and pale than any moon flower, disappearing down an endless hotel corridor. Was it Monte Carlo? Why do I remember that good-by with such persistence? I repeat the memory and I try to expand it, but no answer is forthcoming. That fragment of a memory is her mystery for me. I return to it again and again. But the secret has never been disclosed.

Gloria's paternal grandmother, Alice Gwynne Vanderbilt.

Life is full of those unsolved puzzles. That's why fairy tales are so much like the reality children experience. My paternal grandmother Vanderbilt was 79 when I was born, and I had no memory of her, as I had left America to live in Europe after my father died. Later, when I was eight, spending a summer in Newport, I remember playing at The Breakers one afternoon with my cousins. We ran laughing into the front hall, and, as we did so, my grandmother was coming down the marble staircase—diminutive, exquisitely dressed, a high lace collar framing her face, immaculate as Dresden porcelain. We stopped short, staring. She, too, had stopped and stared at us. We didn't know what to say. The moment seemed to last forever. Then she said, "Who are these children?"

I wanted to cry. I thought, she's my grandmother! Why doesn't she know me? Indeed, who *am* I?

Fantasy for me, then, was a way of expanding understanding. But I don't think I would have had the courage of my fantasies unless I had had the love that my nurse Dody—Emma Sullivan Keislich—gave me. Long before she came into my life she had been mar-

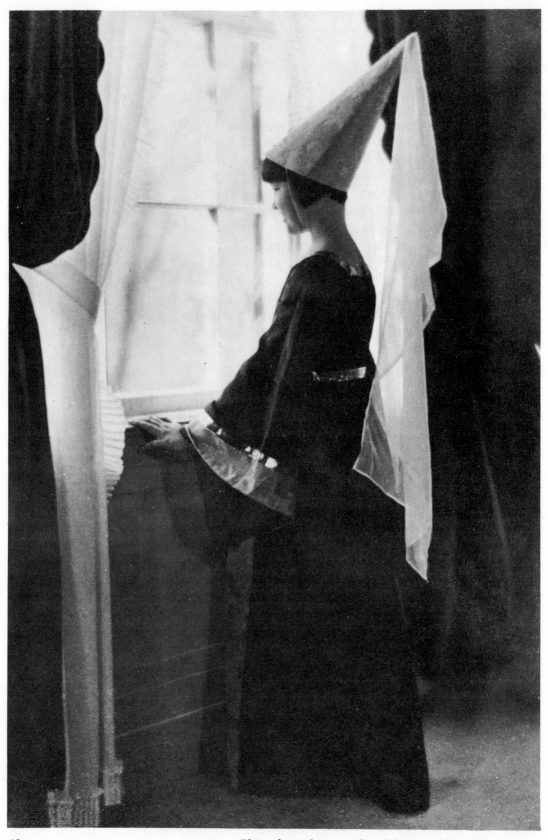

Gloria dressed as a medieval damsel, Old Westbury, 1935.

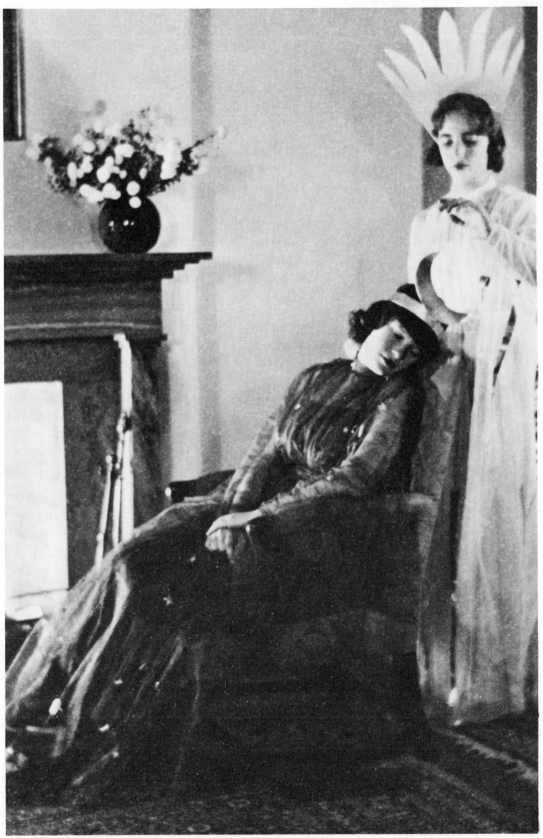

Gloria, in costume as "Night," with her cousin Gerta Henry as "Day."

ried to Ernest Ball, who was one of the composers who wrote, among many other hits of the day, "When Irish Eyes Are Smiling," "Mother Machree," and "Will You Love Me in December As You Did in May?" They had been married during a time when he had been friendly with John McCormack, the singer, and New York Mayor Jimmy Walker. When I grew up, it was interesting to think of Dody as a sixteen-year-old bride, when she became Mrs. Ernest Ball, socializing with persons so established. Shortly after their marriage, Ernest Ball had taken his bride to Ireland to live. Their son was born there.

Their marriage, arranged by their two families, had been untenable from the start. In those days divorce in Ireland simply did not exist. In desperation she left her husband, leaving her son with his father's devoted sisters, secure in the thought they would care for him. Having no known skills to support herself she followed her instincts and trained as a nurse. She graduated as a Registered Nurse and went to work in America. It was a tragedy when her little son died. I believe that her great love and dedication was forged out of this event in her life. From the day I came home from the hospital as an infant she was the person I was most involved with. And what was most important to me, she was there as simply as a rock, a tree, a cloud.

As mentioned, I have often been preoccupied in my paintings with Mother and Child. There is, for me, no more potent symbol of love and security. We often speak of the contribution of poets and artists but the role of the mother is of just as great and lasting importance. What a mother creates, how she nurtures, inspires, and fosters her offspring, is much more complex even than a poem or a painting.

I return again and again to the photographs I have of Dody because I hope to capture in a painting the essence of what she gave me. I sometimes think she was more a force than a person. In particular one photograph of the two of us on the beach somewhere—was it Biarritz? I am holding a sand bucket and shovel. She is kneeling beside me in the sand. Isolated from the world against a background of sand, sun, and clouds, we are two together. She is a presence that still protects and guides me.

Dody after her marriage.

What does all this have to do with fantasy? Fantasy captures us because of a specific longing we have for something more. Fantasy, for me, isn't some sort of free-floating stream of consciousness but rather an internal quest for new symbols and ideas that speak of our experience on all levels. The photographs of Dody, and the paintings that grew out of them are the result of a long effort on my part to understand what the sources of my feelings and imagination are.

How that process works I am not certain. But I understand that one reason it works for me is because I have worked to be true to what I love. I suppose one of the difficulties of being an artist is that all one does is, to some extent, a confession. In that way, I can state in my paintings with a high degree of certainty the conclusions of an experiment that has been long at work in my heart.

Hallmark Christmas card, one of Gloria's many works on the theme of mother and child.

Imagination, intuition, fantasy are qualities that are often ascribed to the feminine side of human nature. I am not sure what I make of that generalization. I do feel that women live closer to their feelings because they tend to be more closely involved with the real issues of life, birth, and death, than men are. Imagination, intuition, and fantasy are more available to women because, in general, they are more receptive.

Fantasy, for me, means never taking anything as it is. The mind is a playground. There, if even for a moment, all that is wrong and unhappy with the world can be put in order. How foolish that we think of fantasy as escapism. Fantasy makes a person more real, more intense, able to see more possibilities. Fantasy understands and establishes new connections.

I can't suggest any secret ritual that will liberate your fantasy life. A scarf or a scent or a song may do it. What concerns me is that we accord fantasy its ancient and magnificent power to help us realize ourselves. We live in a century that has stretched far ahead even of our ability to comprehend. But the imagination of the artist and the scientist has shown us that all things are possible.

Fantasy I feel is needed to deepen intimacy and enrich feeling. I don't believe that any of us live enough in this world, valuing and savoring its sights and smells. Fantasy returns us again and again to this

Katherine Mansfield who wrote, "I want to be a child of the sun."

world, to lift it up and make it real with recognition and feeling.

Years ago, I came across a volume of letters from Katherine Mansfield to John Middleton Murray. I identified very strongly with her and with her restless mind. How fiercely bright it burned until her premature death from tuberculosis! I read more of her stories and journals and I reveled in her exquisite sensibility and in her gift for seeing human beings as part of nature. Her perceptions, whether of a face or of a flower, were equally touched by a kind of intense rapture. I was moved by her vision.

But most of all, I responded to her way of seeing people as unique individuals.

And everywhere in her writing was that singular focus, that concentration, that captured the essence of a room, a person, a petunia or a bowl of soup, so that it lived on in the memory. Katherine Mansfield opened my own vision to how much of life is lived in the mind, how in one's mind fantasy and reality, world without end, are constantly merging with one another.

And she wrote, "I want to be a child of the sun." That is the pull of color and light for me. Many feel that they are not in touch with their imaginations, or perhaps that fantasy is something which is the ken only of others. I am certain that this is not so. Fantasy is the magical realm that belongs to us all if we are alive to it. Reach out and it is there. Fantasy can provide the energy that helps you connect the inner and outer you. It can help put you in touch with new ways of seeing, thinking, working, dressing, living.

3

Collage—
A Way of Thinking

ALTHOUGH I NO LONGER WORK IN COLLAGE except
when I'm designing, it was at one time for me much
more than a technique or a new way of working. It was
a way of thinking—combining the unexpected to cre-
ate the unusual. Collage—like memory, fantasy—can
be a way of seeing, your patterns of thinking—and
thereby affect dress, home, life.

One advantage of collage is that it's easy to start.
Placing various objects that please you together in a
design that pleases you can be a rewarding activity,
even for the beginner. Often I have conversations with
women around the country who express the fear that
they have no talent and don't dare try, but my advice is
to forge ahead, and create something that gives *you*
pleasure, without worrying about talent or lack of it. As
you begin to work, your fantasies, memories, yourself,
will begin to be called forth and released.

The spirit of the artist doesn't belong to one person
or another. It belongs to all of us. Don't keep its play-
fulness and generosity buried. Collage can help you re-
establish the broken circuit of creativity. It can get you
going. It is one of the first responses, even in children,
who will spend hours rearranging piles of blocks be-
fore they have begun to fingerpaint or color with cray-
ons. Collage is an unconscious technique in all of us:

the order of a collage is unique to each of us. Contact with the materials is direct and doesn't necessarily demand any particular skills.

When you rearrange a stack of books, a vase of flowers, a group of photographs, or objects on a table, you are making a form of collage. When you become conscious of what you're doing, you open up a whole new world of experience, and begin to tap a new level of creativity from within yourself.

I came on collage in quite another way, by accident, and it was only after that I realized how much the process of assembling a collage has in common with the day-to-day activity of arranging and rearranging things. I understood then that collage is a special and

Gloria's collage for the program of a gala performance of The Nutcracker Suite *by the Dallas Civic Ballet.*

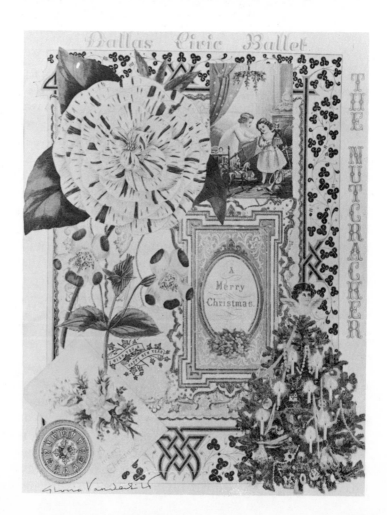

often profound way of arranging your perceptions of reality, and of affirming the world we live in—our families, our houses and our lives.

I also began to realize that collage is much like memory, because of the train of often unexpected associations it sets up, the flashes of humor and sentiment, and the way it can transform the commonplace. Working with collage, I began to recognize that here was a way of working that, at that time, brought into play everything I was doing and thinking about.

My first collage, in 1966, began with a paper lace mat, that had been lying around my studio. I don't even recall how it got there. But I've always collected things that caught my eye—another kind of collage, perhaps—and I was probably drawn to the paper so delicately worked into a Valenciennes pattern. It was shortly after I had had a very successful show at the Hammer Galleries in New York. After a show, there are usually weeks before I am able to start working again. I feel strangely bereft, for the paintings now belong to others and I may never see them again. Hoping to release the flow of work, I was sketching in my studio the head of an Alsatian girl. As I worked on the elaborate lace headdress she was wearing I connected it with lace-paper place mats lying under some magazines. Quickly I put the paper lace around her head and started cutting the mat into appropriate shapes. I could hardly hold myself together I was so excited.

A whole new world of possibilities opened up for me. That moment brought flashes of insights. I knew what I wanted to do. Ideas for pictures came flooding into my head. Dozens of them. There were so many that I knew that I'd never be able to do all of them. I felt that I was on the verge of something marvelous.

And indeed I was. I began to recognize that this was a technique I had long been drawn to. I had a particular fondness for the sort of collages that had been popular in the Victorian period—pressed leaves, dried flowers, bits of ribbon, cutout figures, and sentimental messages of all sorts.

The more I worked the more I recognized that collage was a technique I had been using for years without recognizing it. It had started with the miniature

47

ivory furniture I had carried with me as a child—and the all-white room in which I imagined the furniture in all possible combinations and positions. I had been doing collages on table tops ever since I could remember.

Collage provided me with an important breakthrough in my work but it also freed another sort of possibility. I understood that what made those early collages charged with feeling and vitality was not simply the unexpected and surprising elements I might include—the soap wrappers, magazine illustrations, photographs, gift paper, book jackets, greeting cards, pressed flowers, aluminum foil—but the inclusion of at least one object I really loved. More than anything I had done up until that point, I wanted these collages to be declarations of feeling and offerings of love.

That loved object meant that an important part of myself was included in everything I did. I believe that is a dimension that we too often leave out of our houses and the rooms we decorate, even what we wear. Too often, we're aiming for some sort of objective perfection and we neglect to add that most personal and subjective element that would make the rest come alive. Often, a certain kind of emptiness and sterility has become a style of its own—the idea that it's not what you put into a room that is important but what you leave out.

One's house should express the fullness of how one lives. What speaks more directly of feelings than the photographs of family and friends filling a living room? And I don't mean formal portraits, I mean everything from memorable snapshots to your children's first drawings. That is one way of letting a family understand its bonding warmth and continuity. How you frame and arrange these pictures is your touch. Do you make them a collage on end tables or do you put them under glass on the coffee table? What have you collected that you might want to share with others? I'm not talking about manufactured collections such as snuffboxes or paperweights, although they may be what most interests you. I'm thinking of a set of doll's china that you've garnered away or a china doll that belonged to your grandmother and deserves a place of honor. Or there may be a family quilt or a crocheted

bedspread that would make your room come alive.

I would like to help you become aware of just how distinctive and personal you can make your house if you begin to approach it as a collage. A bulletin board near the desk where you make up grocery lists or pay the bills can reflect the visual ideas you are most drawn to. At first, it may be no more than a scrap of fabric or a newspaper clipping. But you will be surprised how quickly your imagination begins to draw you on to other pictures and ideas.

I can't think of anything that will encourage children to think and invent on their own as much as bulletin boards. The bulletin board gives us a way of displaying our treasures and experimenting with the visual world. Soon, we begin to understand the process and experiment with colors and ideas. Unlike television, the bulletin board enables children to be active participants in learning to make choices between what they like and don't like.

You already have some sense of the interest and affection I feel for quilts and quiltmaking. Quiltmaking is of course another form of collage but with that added element so necessary to expression. Quilts not only express an idea of utility and beauty but also love. I think all of us, in our hunger for the new, overlook the wealth of material in our attics, closets, and spare drawers. The brilliance of the quilt is that it makes something new of what has been discarded.

These scraps, fragments, and leftovers more often than not have great feeling invested in them. Often, they express more individuality and spirit than any new object we may buy to replace them. The quilt is part of that aesthetic awareness. Quiltmaking has, to a large extent, become a thing of the past and the sort of care and thought that produced it has virtually disappeared.

When I think of the sewing basket, button bin, and scrap box, I understand how much richness is possible when we remake the past. I like painting an old piece of furniture white not simply because I need a chair or table but because I relish the interest and charm its shape and carved surface can bring into a room. In addition, what we hang on our walls for color and excitement can be more than mere decoration. But how

satisfying it is to preserve mementos that represent milestones or personal moments from your family's life and growth. Baby dresses, report cards, snapshots, valentines, notes, even a Little League sweatshirt can become your own individual objects of art.

I am often asked what is the secret of the unexpected combinations of fabric and pattern in the rooms I design. There is no secret. I always work without prejudgments. One color doesn't necessarily have to work only with another color. One fabric doesn't necessarily have to clash with another. One pattern may seem too strong for another but what if I repeat them both with variations? There are no foregone conclusions. The mind and eye are big enough for all sorts of unexpected combinations. You have to keep working until the "collage" seems right—something clicks in your mind when it is. Also, often unconsciously, we are full of preconceptions about what a room should be. That period won't mix with another period. That texture won't mix with another texture. Cotton and wool shouldn't be used together. Silver patterns shouldn't be mixed. Floral patterns shouldn't be used with stripes. The superstitions are endless. But they are just that—superstitions. They are rules that have been arbitrarily made up to provide "short cuts." There are no shortcuts. You know more about your needs than anyone else. Keep rearranging the collage until *you* like it.

Once you're tuned into this way of thinking, all kinds of ordinary objects will begin to take on new significance, and you'll begin to see your world in a deeply gratifying way. Textures, colors, shapes, postage stamps, greeting cards and hundreds of other familiar things that you see every day suddenly have a magic of their own. Your eye begins to see things in a new way. Looking around, I realize how many possibilities there were in things it would never have occurred to me to use. I found, for example, that I was able to make table settings even more unusual with this new way of thinking.

I've found that I tend to use the surface of the table more and more as a springboard for ideas that came to me out of collage and assemblage, the use of three-dimensional materials. Often a collection of objects will say more about an occasion than any flower ar-

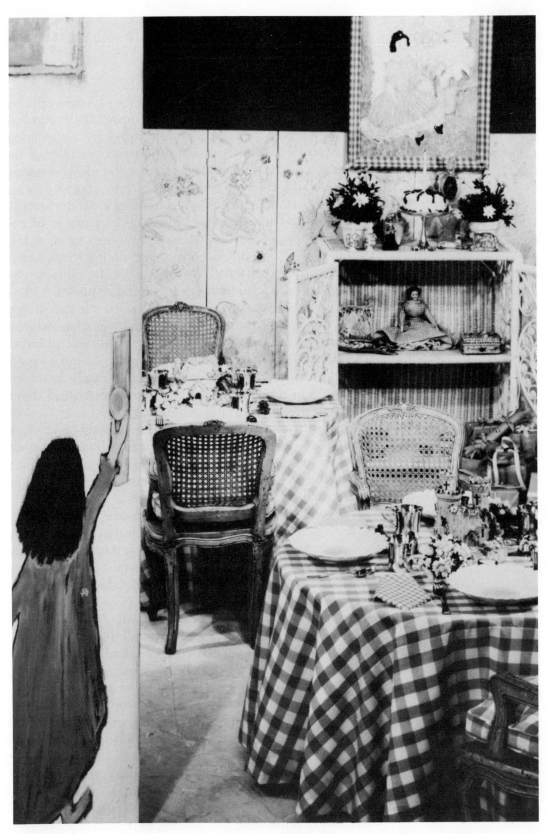

Children's party table setting created by Gloria for Tiffany. Door in foreground painted by Gloria, Fall 1965. Courtesy Tiffany & Company.

51

rangement. For one Christmas lunch, I arranged a series of crystal snowballs, flickering with candles, around a pointed crystal iceberg. But I let my imagination range beyond the centerpiece to include all the aspects of the table setting. I want the cloth, napkins, silver, and china to complement one another, rather than correlate in some rigid scheme. I want the surprising and the unexpected. Using the techniques of collage and assemblage, the themes are more subtly stated. They are more echoes and undercurrents than "tasteful" repetitions. Why shouldn't the table top be as varied and interesting as a painting or book is? Thus, what I'm composing is not a table setting but a collage.

Once you've started collecting in this expanded way, family and friends will become involved and add their enthusiasm. When he was five, my son Carter brought me the gold wrappings from chocolate candy coins and said, "For a collage, Mommy," and I treasured them. Now, I'm adding to his collections, too.

Specifically for the collages, I brought my whole collection together and started a file. Soon, I discovered I enjoyed accumulating for the sake of accumulating. But I also found that almost everything I collected eventually found its use.

I've always liked the Victorian concept of the ornate and the decorative. Anything Victorian has a certain sweetness and innocence, full of fantasy and imagination. I was constantly on the alert when I dropped into antique shops, old print shops, curio shops, even thrift shops to pick up odds and ends, bits and pieces of the clutter that marked the era. So it was a natural step to build collages around such memorabilia.

The Victorian exuberance opened me up to the exuberance of other periods. The Elizabethan collages I did were also reflected in the experiments with costumes that I did with Adolfo, but more about that later.

Probably no single era of history saw the adornment of self reach greater heights than the reign of Queen Elizabeth I of England. I suppose it was inevitable that once I began to put together the elaborately costumed figures of my collages that I would be drawn to the Elizabethan court. Portraits of the period show us costumes that are fantasies of lace, embroidery, brocades, passementerie, gold, and jewels, and these suited me perfectly.

I've always thought of "Elizabeth the Queen" and "Cavalier," the two most widely reproduced of my Elizabethan collages, as a pair. The creative procedure for both was not that much different from what I used on the other Elizabethan collages that were done at the same time.

Elizabeth was actually inspired by an old remnant of lace fabric big enough to do the skirt for a large figure in one piece. I painted the skirt area in lavender and cut the fabric to size. I appliquéd it with red and green paper bows and circles. The other bows were made by crossing small bits of lavender and blue ribbons and fastening a silver flower to them.

I decided on an aluminum foil floor for Elizabeth and cut it out so that it ran to the very edge of the skirt. I painted the sleeves pale blue, and, in order to make the skirt seem to stand forward I decided to have a cape of the same blue run the length of the figure on each side. I used the blue paint on gesso until I reached the area where the silver foil started. Foil, of course, did not take the paint in the same way, so I cut composition paper approximately the same shade of blue and glued it over the foil. I then applied gold paper lace to the entire cape and sleeve area.

The thing I enjoyed most about "Cavalier" was executing all of the architectural details using only the materials of collage without any painting or sketching. I drew *in* paper instead of *on* paper.

I cut panels of raspberry paper to represent the top surfaces of the steps on which the cavalier was standing—and I used striped magenta for the sides of the steps.

The wainscoting was aluminum foil bordered by blue and magenta paper. To give the walls texture and definition, I used alternately the front and rear sides of the foil.

Doing the stockings was particularly satisfying. After I drew the figure, I contemplated covering the legs in a patterned fabric or paper cut to their shapes. But it occurred to me that it would be more visually interesting to create my own pattern.

I cut out many paper diamonds in different sizes and I covered them with smaller diamonds of colored paper, leaving enough margin to do india ink curlicues around each of them. Using the small dark red pieces

along the sides gave the legs the illusion of rounded shape. The garters were crescents of red terminating in gesso balls.

I mounted and ironed the hat and shoes before placing them on the gesso. Ironing on these large pictures was rather cumbersome. I found it was best to back the pieces with heavy paper before pasting them into the collage.

At the very start I drew the face and with an orange crayon colored the beard, hair and brows. As the costume grew more brilliant, the face diminished in its power. Sandwiched between hat and ruff, the features tended to disappear. To bring them back into focus, I cut pieces of orange paper to highlight the hair. With the addition of the simple collage element, the face was able to hold its own.

It is difficult for me to reconstruct a working process. I work with total concentration and therefore there is no way, while working, to analyze *how* it's happening. However, I've tried to describe in some detail what went into these two collages because I have been asked so often about the intricate effects of the final work. When I had a show of collages ten years ago at the Hammer Gallery, it amused me when I was told by a gallery attendant that a visitor, after looking closely at each picture and the detailed work involved had said to him, "Did she do all these herself?"

The imagination is excited by the most simple of things. A color, a fabric, or something that catches one's eye from a taxicab window. Collage-thinking helps you see, create in new ways. Collect things you like; think collage in the way you dress or arrange a table top. Let fantasy, memory guide you. Respond and the imagination takes over. One of the best things about collage-thinking is that it is never truly finished. You can continue experimenting and changing your ideas; whether it's a room, an outfit, or a table top, be sure you put into it something you really like. Take that one aspect and use it as a springboard. It expresses you, or something about you, and out of it emerges your individual style.

4

Dreams—
"The Only Things
That Really
Happen to Us."

FANTASY, THEN, is a way of expanding one's understanding of one's feelings, to be alive to inner worlds. And collage is a way to expand one's way of seeing, thinking, putting things together. And memory, the key to it all. There is more, much more to say about these things but I want to sketch them in quickly, to indicate some things about the roots of my work and my life, the foundations for what's to come in this book about how a woman dresses, decorates, entertains, works and lives. I hope what I've said, and will say, will apply to your experience too.

Feeling and thinking often resist one another; fantasy and collage are techniques we can all use to make our feelings and thoughts come into clearer focus. One of the ways you put them together, really make them work, goes on, on quite another level. Dreams help to do this for me.

Dreams have always been enormously important to me, they are always vivid and in color. Sleep stitches

together a lot of wear and tear. I feel lucky that I am always able to sleep.

Diana Vreeland, the great fashion editor, once said to me, "Dreams are the only things that ever really happen to us." Dreams happen because they put things together in a way that is never possible in waking life. Dreams can be compelling because they demonstrate that life *does* work and things *do* fit together. They help us realize what really is happening to us—how we really live and work. They are important because they transform reality in a way that nothing else does for me, except possibly my work.

Dreams are perhaps the most discredited and most misunderstood of the ways we see experience. But I'm sure that you already understand from your own life how much they mean—much like a melody that gives shape and form to other themes. You need to trust your dreams. Let them hum in your head and heart. Let them amaze you with their poetry. Let them reveal what is truly at your deepest center.

I often have a rather strange dream just at the moment before falling asleep. It's called a hypnogogic experience: it occurs sometimes at the edge of one's field of vision once our eyes are closed and we are three-quarters of the way asleep. My repeated dream is a scene projected on the retina of the eye rather like a scene in miniature on a small globe. I am a child with long hair much like Alice's in Tenniel's drawings for *Alice in Wonderland*. I run eagerly toward a door in which I think is the house we once lived in in Paris, and peek through the keyhole into a room. What I see there is repeated again and I open the door, running into the room to be a part of it. Always, at precisely the same moment, I become aware that it's a dream—the thread is broken and I am wide awake.

Dreams, like fantasy, seem to me one of the most important ways in which we express our profound longing for something beyond reality. I think one's longing for perfection and beauty takes many different forms in our dreams and often that dream-expressed desire can be acted out in everyday life with tremendous effect.

One of the most reassuring types of dream is the dream of disguise or mistaken identity. I suppose this

might be taken as a desire to be someone else but I see it more as a need to amplify who we are. I know from my own experience that wearing costumes has had an incredibly freeing effect on me. I take it as a signal for myself and to other people that I want some aspect of myself to be recognized more fully.

One of the most important turning points in my fantasy and dream life was represented almost simultaneously by the creation of the patchwork room in our former home on Sixty-seventh Street. And also the explosion of collages, and the experiments with romantic costumes that I did with Adolfo, making patchwork skirts, and wearing ruffs inspired by the Pierrot figure in the *commedia dell'arte*. My involvement with patchwork was a recognition that there was a whole world of art with its own techniques and expression that had been created by women. I was fed by that understanding in a way I had never been by what strikes me as the more male-oriented European tradition. And it also expanded immeasurably what I had been doing in painting.

The sudden abundance in my work came from a deepened sense of myself as an artist; there came to be a more direct connection between what I saw and felt and what I did. We experience that flow of energy often when things have come together.

Also, I believe that costumes created with Adolfo were a reflection of a new maturity I had found in myself and a certain authority I had discovered in my work, and in being a woman. I was literally wearing what was inside. I was putting on what I was creating in the studio. Certain strains coalesced in those costumes: an affirmation of being American—the patchworks. A delight in the ornamental, the Elizabethan. And a romantic return to the stylized sad smile of the Pierrot.

I didn't really understand all of this then. It was as if I had dreamed it. But I felt it all the more because I lived it rather than analyzed it. It came out of a fullness in the way a dream comes rather than being something I had thought out. Dreams are milestones in much the same way.

Costumes have always seemed to me a confession as well as a disguise. The question is, does the mask

reveal the person to the world or does it reflect the world itself? Costumes are absolute necessities. Nothing gets us more outside ourselves into a realm of dreams. I love to see my sons Carter and Anderson dress up.

Anaïs Nin was very much involved in the psychology of what she wore and used descriptions of clothes a great deal in her diaries and novels. I was always fascinated by our conversations about her wardrobe and make-up. Anaïs never thought of costume purely as an act of seduction but as an aesthetic necessity and essential to the totality of our lives. She wasn't so much involved in how she looked as in what she revealed about herself in her appearance. She had an instinctive sense of how she wished to communicate her femininity. Having studied herself with the care of an architect, she was careful to control the impression she made. This might be thought of as vanity—many of the early surrealist photographs of her now may seem to some extreme—but to me there is poetry in it. Anaïs constructed for herself in the waking world the dreamlike effect she hoped to have in another's unconscious.

She told me about a young friend she had with whom and for whom she was delighted to dress up. Her friend would also dress in new and unexpected costumes to delight Anaïs. In this way they extended communication and were a poetic mirror for one another.

This is the sort of insight that could only have come out of a dream. And I suppose that more than creating a new and larger identity than the dream it is also an attempt to enlarge reality, to make the world something more. To show a dream-self. That's what moved me in the spareness of St. Bernadette's room when I visited it at Lourdes in France. How touchingly simple the selection of things that went into that room, and yet how full of style, with bright blue gingham on the bed and a draped wall canopy. Surely a room created out of her deepest hopes and dreams about herself.

And I see dreams made real in the castles of Ludwig of Bavaria, with their extravagant towers and turrets and grand parodies of European architecture set in romantic Bavarian landscapes. No wonder that Walt Disney latched onto Neuschwanstein for Disneyland, the fairy-tale castle that introduces Disney's tele-

vision show and that exists today in Disneyland, California. Ludwig was able to make over his world into the image of his dreams. He also lived at a moment when everything around him seemed to correspond to his wishes. He and Wagner seemed tuned in to one another's moods and feelings. Wagner saw his dreams contained in the theatre but Ludwig carried them out in the light of day. He redid the France of Louis XIV and the castle of the German fairy tales. He created a Venusberg and a sparkling grotto complete with a swanboat gliding through it. They called him mad a century ago, but now the tourist audience attracted to his castles helps to support the economy of Bavaria.

Not all dreamers who dreamed on such a scale were so eccentric. When I was thirteen, visiting with my mother in California, I remember spending the weekend at San Simeon. What William Randolph Hearst created there was also a dream. And it wasn't just the unusual mosaic of buildings, but the people he brought together there as well. Hearst seemed to have all sorts of sorcery at his command—fairy-tale gems, Aladdin's lamps, magic carpets, and the silver screen. At this special weekend Loretta Young and Dolores del Rio were among the guests, and I remember meeting them and thinking them the two most wondrous apparitions I had ever encountered. San Simeon became part of my deepest fantasies of childhood. It was a storybook castle come true, with real people living in it. I could believe it all. How strange it was to return with Wyatt and our children years later as tourists. How changed it seemed to my adult eyes, almost unrecognizable, more like an empty Hollywood stage set.

Nothing has come closer to that feeling than the movies, and what is closer to the way dreams work than the movies? That's why we are so unceasingly involved with them. They are our shared imagination. They give a sense not so much of what the world is as of what it might be. It's the longing again. I'll never forget, as a child, seeing Jeanette MacDonald and Nelson Eddy in *Maytime*, singing with apple blossoms floating down all around them. I believed every moment of it. As they sang "Sweetheart, Sweetheart, Sweetheart, will you love me ever?" the tears were streaming down my face. When I saw the film as

Gloria riding on her aunt's Long Island Estate, 1935.

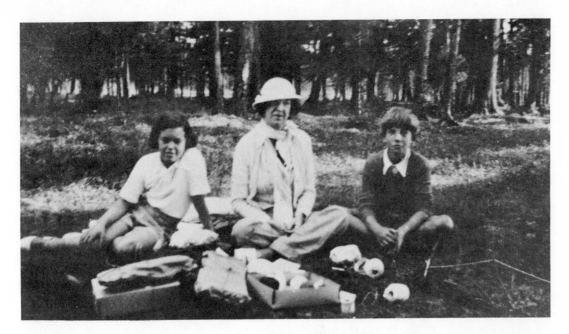

an adult, it struck me as humorous and satirical. (I wasn't surprised to discover the script had been written by S. J. Perelman!)

Gloria picnicking with her aunt Gertrude Vanderbilt Whitney and cousin Harry Whitney in the Adirondacks.

We want to be lifted out of our skins, and today, films like Resnais's *Providence* and the films of Fellini do this for us. We want our dreams expressed in something that is more real and more beautiful, something that is larger than we are. That is inevitably what all art is about. I find there is less and less room for that kind of dream in the world. But our hunger for dreams never stops growing.

We probably don't do enough in our schools and with our children to encourage an understanding of the worth of dreamers and dreaming. Every child is a human possibility that should not be wasted. With all the acceptance that is given out, little recognition is given the artist. Why do I link the artist and the dreamer? Because I feel that artists are most often the ones who do the dreaming we all should do. I know from my own experience that one can never be certain when a contact or an impression will bear fruit.

The evolution of one's personal style often takes root when we don't know it's happening. I remember the first room I decorated—although "decorated" only meant adding a few things that fascinated me at the time. I was fifteen and living with my aunt Gertrude at Old Westbury, Long Island. I asked her if I could redecorate an unused room in a part of the house called "the cottage." Nothing elaborate, I only wanted to add a few things here and there. She gave me permission, and I proceeded with great enthusiasm to change the

ambiance of the room, then decorated mostly with early American furniture. After much searching I found a patterned Sphinx fabric which I draped over the sofa; later, a round inlaid copper tray set on folding supports became my coffee table, a spirit lamp over which I made powdery Turkish coffee in a brass pot for friends. The final touch—incense burning.

It took only a few things, but in my mind's eye the room was transformed into an Egyptian fantasy. There were cozy parties contrasting with exotic atmosphere I had hoped to create, with Glenn Miller music playing on the portable phonograph and dancing to "Moonlight Serenade."

Perhaps more than any other experience, the dream captures that persistent need I feel in myself to make order out of chaos. Not to straighten things up or tidy them, but to impose the order I have found in myself through my work. I want to keep pressing always closer to the roots of my creativity. I want to get it all out before I die. That is my work. That is my dream.

In the world of dreams, the past, present and future are strangely present, strangely commingled. I have discovered something very similar in my work. I keep pressing with my imagination to find a relationship with the past that is easy for me. It has been a major triumph for me that I am able to live with all my memories and that I continue to include them more and more in my life. I understand why some women destroy all evidence of the past, but I am grateful that the past is no longer painful for me. My work and my dreams have redeemed it.

I have described at some length the role of memory, dreams, fantasy, and collage in how a woman lives and creates because in no small way they revolve around a mystery that I now know I can never solve. So much of my work and so much of my reading and thinking has been a meditation on that mystery. My mother was beautiful in a haunting and intangible way that made almost bearable the sense of loss I experienced at never seeing enough of her, and therefore never really knowing her or feeling that she belonged to me. Her presence fills my memories and dreams, and what was incomplete and unfinished between us I have overcome in my work. What was painful and destructive I

have made into something of my own, changed the sorrow into something vital and accessible.

Dreams, fantasy, memory and the technique of collage, then, I see as keys to understanding and realizing one's own creativity. They help us express ourselves more fully in the everyday facts of our lives. Now, how do we put them together, and make them work for us?

In the sections that follow, I'll describe some of the ways these things have helped me build the collage of my life, and how you might develop yours. We'll talk first about fashion—my fashion journey, how I learned to look beneath the image that my mother and grandmother had given me of how I should dress to a self-image that was deeper, more real, more fun, and more mine. I'll try to give you some ideas about how to achieve the look *you* want, some suggestions about what to wear and how to develop and express your own image, with the help of your memory, your real and fantasy self.

Then we'll talk about where we live, and the way in which where we live can express more fully who and what we are.

"The Heart of the Matter," Part IV, is about some of the crucial matters that are the bedrock of our lives— love, marriage, men and women, parents and children, how to handle money, what I do about loneliness and being alone.

Then in "Sharing People, Parties, and Pleasures," Part V, I recount some of the wonderful times, the events and experiences I've shared with family and friends, and some of the ideas about entertaining that have come out of my life.

In Part VI I've tried to tie the rest of the book together with its main theme—"Sharing Yourself—and Your World." This section is about what I think is most important of all—learning to trust yourself, to discover yourself, and share your creativity in all aspects of your daily life. It's about why a woman has to give herself time to do these things—and why I think time is in many ways the greatest secret of all.

Part II

SHARING IMAGES: DISCOVERING OURSELVES - IN OUR FASHION

Gloria in 1941.

Early Me

FASHION IS A VEHICLE. It's a means of expression. The real quest is much deeper, as we've been discussing, and that question doesn't change from year to year or season to season. Fashion, dress can be the outward sign of growth, of the inner journey that determines the real style of a woman's life.

You start out with certain ideas about yourself—things you have learned, accepted, or that have been told to you—and you spend a large part of your life sorting out what is really you and what isn't. What is right at one stage may change in another. Women are enormously involved in the personal equation of everything around them, how the clothes they wear, the rooms they move in are an expression of themselves. That's why we're so vulnerable about what we wear and how we look. Men are provided with certain masks for their roles and they can live contentedly within them. Women are more tortured by conflicting demands. And this of course is something of which the fashion industry takes full advantage.

When I started designing clothes I decided to try and work only in the realm of what made sense to me. I tried to underline a sense of beauty and comfort that I could identify with and that I thought other women could identify with. On my trips, I find that women often confide their hopes and problems, and I am certain that I have learned a great deal about what they want to wear. And of course we share the same prob-

*Stepping out in
Hollywood, 1941.*

lems. We all want to express our individuality, but at reasonable cost and maintenance time.

Often the real tension each of us has about how we should look is the discrepancy between how we are told we should look and how we really want to look. (For me, this tension stemmed from the ideas of my grandmother, and my governess, which clashed with my own.) How we *really* want to look is sometimes made up from fairy-tale movies and dolls. The debate between the two points of view can go on endlessly. Perhaps, at certain points in our growth, we relate to certain men because they confirm one or the other view of ourselves as the right one.　•

But finally, we need the freedom to think of our lives as individual experiments—to find a style that expresses each of us.

How you look is what you share with the world. Your look should say as much as it can about who and what you are. It's a form of communication. For that reason, I don't think we talk enough about the psychology of clothes and make-up. I've had the same struggle with myself that others have told me again and again they've had with themselves, and I'd like to go into what I wear—what I've worn before, why, how I dress now—and also how I do my face, to show how one woman's dress psychology evolved. And also, to show a little about the history of how society has seen women, and encouraged us to look, in the past.

When I was seventeen, I went to Hollywood to rejoin my mother, with the hopes of creating a new bond with her. That summer, I wanted desperately to look at least forty, older than my mother was at the time! I tried out gray streaks in my hair and wore bare-midriff dresses. I used "rats" to make my pompadour the highest possible. Looking back, I can almost feel mother of the child I once was, and I now find it rather touching. But then, I couldn't have been more serious. All of my fantasies revolved around the way women looked in movie magazines. That was real sophistication to me.

At twelve, I had begun trying to copy Katharine Hepburn. I wanted to talk and look and act like her. I cut bangs and rolled them up over my forehead as she

did. I longed for a "perm" so my hair on the sides and around my face would billow out as hers did. I had the perm, but it was hopeless!

At sixteen Gloria on the brink of Hollywood. Photo by George Hoyniquen-Huene.

My cousin Gerta and I saw *Little Women* with Katharine Hepburn as Jo, Jean Parker as Beth, Frances Dee as Meg, and Joan Bennett as Amy—the pretty one. Gerta immediately decided she would be Beth. I had already stated with great authority that I was Jo. We called each other by our new names and insisted that our cousins and school friends do the same. Our intent was taken so seriously that to this day we call each

other Jo and Beth, as do our cousins and school friends whenever we meet.

I kept elaborate scrapbooks of my favorite movie stars. By the time I was seventeen, my sense of movie-star glamour had changed and expanded. I tried all sorts of experiments with my hair and make-up. I wore big, black picture hats, black dresses, and black fishnet stockings (inspired by an Alice Faye movie) whenever I could find a pair. To look like a teen-ager had for me some kind of ambivalent stigma attached to it. It meant not being grown-up. It meant not knowing the secret adults knew. It meant not belonging.

Sketch of Gloria at the age of seventeen.

In 1941, I met Rita Hayworth, who immediately became my idol. I wanted her to be my mother and tell me what to wear and how to look, although we were only six years apart in age. Age, of course, has nothing whatsoever to do with such fantasies. She was then married to Edward Judson and there seemed to be a Pygmalion-like relationship between them. She was dazzling, with her tawny, creamy skin and her auburn hair—like a gorgeous mannequin wearing clothes from Howard Greer and jewels that Judson borrowed for her from Paul Flato, the jeweler, to wear for an evening and return to stock the next day. She rarely opened her mouth, and this silence which I interpreted as knowledge so special and mysterious that no mere mortal was worthy to be let in on, I now realize may have come from nothing more mysterious than incredible boredom.

I went to nightclubs almost every night. It felt grown-up and important. We hummed songs like "You Stepped Out of a Dream" and "Elmer's Tune," and I can remember Carol Marcus and me laughing over having to replace a pair of sandals worn out by a week's dancing. And what I wore was all part of this. Ciro's and the Mocambo were the two biggest nightclubs and I went often, especially on Saturday night, the big night. Night after night, I would see Rita making the rounds with Judson. Every Saturday night, Louis Scher, the agent, escorted Maria Montez (in a full-length white fox cape, and carrying a long cigarette holder) to Mocambo. She too seemed very mysterious with secret knowledge. The rumor was that the cape belonged to Scher and was lent to every women he escorted out on the town. Perhaps *that* was her secret.

I went to Howard Greer for my clothes because Rita went to Howard Greer. Greer had worked for the famous designer Lucile before World War I and had come out to Hollywood in the early twenties to be a designer for Paramount. He was the first of the movie designers to open his own salon. He designed for everyone from Gloria Swanson and Pola Negri, in the old days, to Greta Garbo, Joan Crawford, and Norma Shearer in the thirties.

His salon was on Rodeo Drive next to John Fredricks, where Carol and I tried on many hats. Greer was extroverted and articulate; he talked a lot and what he said made a great deal of fashion sense. He had been around so long that he had great authority. And he had an unexpected sense of color. His way with fabric was inventive and innate. He could touch a piece of fabric and drape it as if he'd been studying that one piece of fabric for years. He also invented what he called "the tabletop dress"—a dress that looked spectacular from the waist up, as seen from behind a table when the woman was sitting in a restaurant. That of course was essential for the life we were leading. I, too, started borrowing Paul Flato jewelry to wear with my Howard Greers. It was massive, heavy, set with huge cabochons, ruby and emerald, very ornamental, and totally inappropriate for a seventeen-year-old girl.

There was another look I was also fascinated by at that time. I thought of it as carefree and innocent, but it was just as much a product of the movies. I wore a lot of clothes by Lanz of Salzburg, the Austrian designer who specialized in peasant blouses and dirndl skirts. Walking into his shop on Rodeo Drive was like stepping into Bavaria or Austria. He used eyelet embroidery and lace with black velvet ribbons running through, square necklines, and skirts gathered at the waist with wide cummerbunds. Even the petticoats were made of eyelet and covered with ruffles.

Nowadays, fashion has opened up, and there is a place for anything and everything. However, this has happened only within the last few years. Looks I am now describing do not in any way seem all that extreme today, but back in the forties they were considered so by those who were preoccupied with what was "good taste" and "bad taste."

I was drawn to anything that had the aspect of cos-

tume and fantasy. Ilona Massey singing "May I drop a petal in your glass of wine?" was the height of glamour and luxury to me, and I was preoccupied with her unreal beauty. As yet, having no real sense of myself, I wanted desperately to feel I belonged and to know who I was. Being able to identify with what I felt was beautiful, in this fantasy way, gave me a sense of security.

I could never find heels that were high enough or spiky enough. I took lots of bubble baths and wore Schiaparelli's Shocking toilet water. It came, as it still does, in a bottle shaped like a dressmaker's ·dummy and I thought·it the ultimate in sophistication—a word I loved, by the way, ever since I heard Duke Ellington's music and the lyrics of his song "Sophisticated Lady." I used the brightest red lipstick and piled my hair as high as possible. I can remember George Hurrel, the photographer at M-G-M, taking my photograph for *Vogue* magazine. I had taken particular pains with my pompadour and choice of dress—a turquoise-blue, square-shouldered, bare midriff. He was no doubt stunned into silence, as he said very little during the sitting. All of this was later very agonizing for me to recall.

One of the most glamorous evenings was attending a premiere at Grauman's Chinese Theater. In those days one had "dates" and mine was a rising young actor, George Montgomery. I wore the same bare-midriff turquoise-blue dress, the great pompadour, and, in a panic at the last minute, added a lei of real gardenias. I felt very grown-up and almost a movie star.

I remember discovering Adrian's ready-to-wear collection in a Los Angeles department store. Adrian had been the designer at M-G-M and had left the studio to go into business for himself when his three big stars, Garbo, Shearer, and Crawford, had departed almost at the same time.

It was still the custom to give each dress in a collection an atmospheric title or name. I can remember one from that first Adrian collection that stuck in my mind, "Dramatic for Him." What did that mean? Not only that particular dress but all his clothes struck me as very "dramatic." I puzzled over the label a lot; I never got the dress. However, the Adrian look planted a seed in my mind.

I had arrived in Los Angeles in early June. Suddenly the summer was over. On December 7 came Pearl Harbor and life changed for all of us.

I returned to the West Coast again in 1945. Adrian had opened his new shop in Beverly Hills. It was unlike any I had ever seen, for upon entering one felt one was inside a miniature theatre. Adrian seemed uninterested in the business, not really happy with what he was doing. I remember an improbable dress I got there that was a bumblebee print. It was shocking pink with the bumblebees in brown and yellow. It had what I call bread-cutter shoulders, as they are so sharply squared you feel you could cut a loaf of bread on them. (In retrospect, I think Howard Greer's rounded shoulders, which he always used, instead of the then fashionable square ones, were much more becoming than Adrian's square, padded ones.)

Looking back, I understand that I was searching for a movie-star glamour that would provide me with the identity I felt I lacked. I had gone to Howard Greer because he dressed Rita Hayworth, my idol: And, as

Gloria appears as a bridesmaid in a 1942 Palm Beach fashion show, along with Richie Farrell, as the bride, the future Dina Merrill, second from right, and Vivian Stokes Crespi, right.

well, he seemed to be able to speak with some authority about how to look. I wore some designs by Adrian because he too had dressed movie stars.

I had fantasized and dreamed of being grown up. How would it be? Would I feel like Ginger Rogers, in her marabou dress, dancing cheek to cheek with Fred Astaire? What I had wished for as a child had come true. I had gone to Hollywood in my seventeenth summer and I met them all—all the stars I had worshiped on the screen—and I went out with many of them. You can imagine the fantasy of that!

What I slowly discovered was that what I wore had very little to do with how grown-up or how sophisticated I was. The movies had given me an imagination of something bigger and more real than anything that was possible. I suppose I felt that if I looked glamorous it meant for certain that I *was* glamorous deep, deep down where it really mattered and that would mean that I was grown-up, and everything would be all right.

I can remember seeing Rita Hayworth again in New York just before Pearl Harbor. She was still with Edward Judson, but she was obviously dying to break loose. She seemed so bored with him; by then there wasn't even a pretended politeness between them. *Look* was doing a spread of her on a night on the town. It was actually photographed over a period of five nights, and this meant that she had to wear the same Greer dress over and over again. Her studio publicity had taken over her life and she seemed to get through the week as best she could—as silent and exquisite as ever. I was delighted for her when—shortly after she fell in love with Victor Mature—she kicked over the traces and started having some fun.

Rita Hayworth was twenty-three and I was seventeen when I first met her. I admired her looks and wanted to be like her. Now, I realize that a lot of the fascination I had with movie stars was that I felt their self-images had jelled. In many cases, this was an illusion.

6
Learning More About Myself

DESPITE MY SEARCH in those early years to find out more about myself, to develop an image, surprisingly enough I was somehow instinctively sure of many aspects of my fashion taste. Even in boarding school I remember wearing wooden sabots with red leather tops which were much admired and copied. And even during that Hollywood summer when my taste went in all directions, I still enjoyed each and every thing I chose to wear (even though many things seem unthinkable to me now). So, really, because it worked for me then perhaps it was somehow "good taste" after all.

A large part of my search for identity sprang from having experienced a scattered and unbiased frame of reference in childhood. There had been no opportunity to find out about myself through the supportive base that a rounded family relationship can provide. By necessity my imagination and my feelings about myself developed on their own.

From the beginning that secret side of myself was important to me. My public self was the least meaningful part of my development. In truth, even as I was trying to look the sophisticated nightclub glamour girl, I preferred the simple Austrian folk costumes I wore when I came back to the West Coast to live in 1945. And later, too, when I grew my hair to the waist, wore

Posing for <u>Harper's Bazaar</u> in a Leslie Morris dress. Photo by Richard Avedon.

sandals and long skirts with a silver concho belt and blouses that had round necks and could be worn off the shoulder. I was after the freedom of a gypsy look. Still later, when I discovered the Fortuny dresses, they fitted into this same frame of somewhat archaic, somewhat Mediterranean, somewhat classic simplicity.

When I moved to New York, in 1949, I went into a much more conventional period. I wore clothes by Leslie Morris, who designed for Bergdorf Goodman, although I felt much less secure in them than I had in my peasant skirts and blouses. I remember once running into Leslie in the street when I was wearing brown gloves with one of her tweed suits. "No, no, no," she said emphatically, sternly tapping my hand, "Butter yellow, butter yellow." I hid my hands in my pockets until I could get home and replace the hateful brown with "butter yellow . . . butter yellow."

Two dresses by Leslie Morris stand out in my mind. One was a short silk dress in a red-and-white print with sleeves that twisted around, after you had it on, to look draped. It was a new way of looking at a sleeve that had been around since the beginning of fashion time.

The other was an Edwardian-inspired dress that might have come out of *The Importance of Being*

Photograph from a fashion story for <u>Vogue</u>. Photo by Frances McLaughlin Gill, © 1962 by The Condé Nast Publications, Inc.

Photograph from a fashion story for <u>Vogue</u>. Photo by Frances McLaughlin Gill, © 1962 by The Condé Nast Publications, Inc.

Earnest. Expertly constructed, its shimmering lavender silk taffeta flowed to the back in a train. The off-the-shoulder neckline and sleeves were clustered with sprigs of white and lavender lilacs looking as though they had been tucked in. I wore the dress for so many years (even on stage in a Molnar play) that Bergdorf's replaced the lilacs again and again.

My whole life went through a series of changes at this point which both my looks and my home at 10 Gracie Square reflected. This was an abundant working period for me. I was painting. I was writing; a book of poetry was published. And I was acting on both stage and television. At that time I felt that each aspect of my career nourished the other. When I gave parties in my studio I would wear black leotards and over them a voluminous white cotton Tom Jones shirt. Or the leotards with a high black turtleneck sweater over them. Or long, opaque pink or red stockings and over them poplin skirts, a turtle-neck sweater, over the sweater a cotton blouse unbuttoned to the waist, the silver concho belt tying it all together.

At about the time I discovered the Fortuny dresses, I got to know Richard Avedon. He had photographed me with my first child and then he began to photograph me for *Harper's Bazaar*. He was very influential in giving me an image of myself.

Working with Dick is not like working with any other photographer. Some photographers make you feel as though all the lights have gone out. With Dick they all go on full blast. It's a revelation. You become litmus paper. You feel and do things you've never felt or done before. You participate in an emotional experience. He communicates his energy, his enthusiasm, his vision of beauty. His life spirit transforms you into becoming a feeling, a mood, the moment. A lot of people relate only to the lens when they're being photographed. With Dick that's impossible. That is his vision as an artist. That is his genius.

The nature of photography is to capture the elusive moment. The great photographer knows that he is constantly looking for moments that otherwise are fugitive. That quality is particularly true of the portraits that Dick took of me wearing a Chinese kimono at 10 Gracie Square. In a certain sense, those photographs are a

Gloria in a Chinese kimono at Ten Gracie
Square. *Photo by Richard Avedon.*

Gloria in 1953—in a publicity photo for
"The Swan." *Photo by Gene Moore.*

At Ten Gracie Square. Photo by Richard Avedon.

confession. Dick caught an atmosphere in those moments that exposed a self not yet formed. He sensed a sheer moment-to-moment sense of being alive. Avedon captured a joy I felt at the time. The room and the objects became part of this—perhaps why it has been said that more than photographing a woman, Avedon was photographing femininity.

In speaking of Mainbocher I can only use the word Perfection—everything about him was first rate, not only in the quality of his work, but in the quality of life as he lived it. He represented to me all that was elegant and beautiful in work, and in the loving trust he inspired in his friends. His influence on me was far reaching and will always be a part of me.

I went to my first Mainbocher showing with Avedon. His showings were fascinating because of the tension they generated, as well as the mystique because of the money involved. The showroom—with chocolate-colored banquettes and painted clouds on the ceiling—added much to the ambiance. Opposite us, seated all alone, was Mrs. Charleton Henry of Philadelphia, a fixture at Mainbocher's showings and one of his major buyers.

I suppose, in a way, in my fashion odyssey I had been working up to Mainbocher and that he had always been in my mind. I first met him at Elsie Mendl's, in Beverly Hills, and was immediately drawn to him. He was round, like a loaf of crusty French bread. In contrast he had an authority that radiated worldliness. Since Leslie Morris, I had been wearing clothes off the racks. Mainbocher's represented not only perfection, but mystery, for clothes were then much more of a mystery to me than they are now.

Mainbocher never was present during the fittings of his clients and I considered it a singular honor when on occasion he and Douglas Pollard, the great fashion illustrator, would supervise my fitting and we would chat and gossip. To go there for a fitting was somewhat like participating in the split-second timing of a ballet. The hours of a fitting were like a rehearsal for the opening night when one would appear in the grande finale. Natalie Wilson, Princess Paley, his *grande vendeuse*, always assisted the fitter when Main and Doug-

las were not there. Often Mrs. Wilson would say to me, "With this, you can wear your emeralds or perhaps your peridots." And I remember her once saying to Cynthia, the *vendeuse* who worked with me, talking in front of me as though I were absent, "With this one, she'll wear her diamonds and rubies. Oh, those jewels! And yes, she has them—she has them!" I was too embarrassed to admit that I didn't.

When Mainbocher came to my house for dinner, he always gave me a wink as if we were in on something. It was cozy and conspiratorial, like two children playing a game, and it made me smile. I always invited him with his great friend Douglas Pollard. Douglas was a very important part of Main's work and I think he played a more important role in Main's designs than we will ever know.

Douglas is deeply caught up in the theatre, possessed of exquisite sensitivity and a rare visual perceptiveness. He once told me that I reminded him of Rachel, the French tragedienne. Of course, I immediately started looking for biographies and photographs of her. He believed that to be successful in the theatre it is of vital importance to have just one person in the audience concentrating only on you, someone who responds totally to what you are doing. Katharine Cornell had Guthrie McClintic; Mary Martin had Richard Halliday. Mainbocher, who had dressed both off the stage, understood this.

Of course, that was also very much the relationship that Douglas had with Main. Douglas was able to stand up to Main, and he often took a different tack. Douglas writes the most extraordinary letters and to receive one gives the feeling of having been bestowed with a treasured gift. I remember one special one, written to me the day a photograph of me arriving at a theatre opening night with Wyatt Cooper appeared in the New York *Times*. I was pregnant with Carter at the time and Main had designed an evening dress of pale green brocade inspired by Tiepolo paintings. In the letter Douglas told me how enchanted they were with the photograph, which had been taken as I descended from the car, with Wyatt holding my hand. From the angle of the shot, with me leaning forward—it did look like the Tiepolo paintings, and Douglas said it was exactly the

vision they had had in mind. And there it was, as he opened the morning paper.

Just recently I received from Vienna another letter from Douglas, a part of which captures what a joy it is to know him: "The weather is summery and cool and I am going out to take a slight journey into the past and see if I can't find Marie Therese's breakfast set, because it was always a dream souvenir of Main's and mine. It is a beautiful gold rococo tray, in the most elegant shape, but wide enough to span the considerable imperial lap. Everything is gold, the curved legs of the tray, delightful coffee pot, cream jug, sugar box, all in delicious shapes and lightened with white ivory handles, ornamented with ebony blackamoor heads wearing white ivory turbans! It is the ultimate in style and magnificence and yet somehow very cozy and such fun, like an inanimate miniature ballet. All this and seventeen children too, it's too much!"

Now, a letter such as this is like receiving a present!

I remember the first time that Main came into the *cabine* while I was having a fitting. The dress was ballet length, with a full skirt made of a white sari with an apricot-and-gold band. He had designed it especially for me. It was the most unexpected combination of East Indian mystery and straight on American. "That dress," he told me, "is how I think of you." I was delighted to have inspired this image.

Mainbocher's vision was that of the consummate craftsman. His sense of perfection included delicious details—the black velvet headband with its flat bow on top, strands of creamy pearls, and crisp white gloves. And his fragrance, White Garden, in its simple crystal bottle with the white-and-gold embossed label—what magic it evoked! I still have half a bottle and need only to open the top to feel the images crowding in. This scent mingling with the tiers of hyacinths in his showroom, the atmosphere of luxury and serenity. The rococo touches. His audacity in combining gingham with gray flannel. Of putting the fur in a coat as a lining instead of on the outside. His rain suit made of poplin with a matching babushka. And his sense of drama which he saved for dresses such as the one he did for Libby Holman for her on-stage performances—long trains sweeping the floor which she handled with ease

The famous Sphinx photograph—Gloria wearing a Mainbocher gown. Photo by Richard Avedon. 83

and authority as she sang torch songs. Then there were the clothes he did for Millicent Rogers now in the permanent collection of the Metropolitan Museum of Art in New York City. Voluminous puff-sleeved blouses and full, taffeta-petticoated skirts worn with her primitive, beaten-gold jewelry.

It was then that Main's clothes became a fantasy look in themselves. One of the most striking Avedon fashion photographs is of me wearing a Mainbocher black-and-white dress. With it Dick suggested that I wear an Egyptian wig. It was totally unexpected, worn with a Mainbocher dress, and immediately made it unique, exotic, and unconventional.

Mainbocher had a vision of himself and of life and of what he wanted fashion to be. He imparted his artist's vision to anyone whose life he touched. He was also a master in perhaps the greatest art of all—the art of living. I often look at the photograph he inscribed to me—"Dearest Gloria—Main," and remember him and Douglas with heart's love.

Norman Norell was a different sort of master. Mainbocher remained devoted to the ideas of fashion and couture that he had encountered in Europe. Norell pursued a particular American kind of elegance that had its own authority and glamour—even using red, white and blue over and over again in his designs.

The Norells I bought were off the rack; it was rather late in his career that we became friends. He was gentle, with great warmth, easy to be with—dedicated. I especially recall dozens of purple carnations that he brought to one of our Christmas parties on Sixty-seventh Street. It was the first time I had ever seen carnations with that coloring. All of his career had been developed in New York and his presence had given Seventh Avenue its special cachet.

He was intrigued by the Dana Pond portrait of my mother, and would speculate about who had designed her dress. It became a game we played when he came to visit. Was it a Doucet, a Lanvin? The riddle was never solved.

The Romance of the Self: Fortuny, Karinska, and Adolfo

SOMETHING HAPPENED when I took my Fortunys
out to look at them again. It was as if I had rediscovered
a forgotten possibility in myself. Through those dresses
I understood the real function of fashion is to make a
woman feel her best self. Anything else, anything less,
diminishes the essence of what fashion is all about.
The choice of what to wear is deeply individual.

Developing a true personal style comes through a
natural process of selecting, choosing, and discarding.
In fashion, one should have the security of knowing
that all that matters is satisfying your own instincts and
imagination.

The Fortuny dresses are as timeless today as they
always were, each a full-length silk or linen chalmys,
inspired by the finely pleated tunics of ancient Greek
characters. The chalmys were based on designs pro-
duced through a patented system created by Mariano
Fortuny, a turn-of-the-century painter, designer, and
inventor.

Each dress has an exclusivity, a nicety of detail that is
at the heart of its desirability, and the unique texture of

the fabrics gives each one a remarkable simplicity and, at the same time, a luxuriousness. The dresses are held together by beads, each fragile as a drop of candy, made from Venetian glass. These beads are colored according to the dress and have flecks of gold or stripes of another color going through them.

Fortuny's concept was that a woman's face is a flower. The dress is the stem, so to speak, cascading to the floor and curving slightly around the ankles.

Fortuny's dresses epitomize sensuous femininity, voluptuous because they mold themselves to the body and are fragile, delicate, and tender. Designers today have tried to imitate a Fortuny dress but none have come even close to discovering the secret.

The body ornaments of Rita Delisi lend themselves to a Fortuny dress. The jewelry was masterfully tuned as well as designed. A Fortuny dress is as soft as though a woman wore a second skin.

Less well known but equally effective in a different way are the cotton pleated dresses he made. I wear one often with a necklace of shells and coral chain ending in small brass tablets; for the violet silk tunic-robe, a pendant of carved ivory ornaments and Greek vermilion worry beads schemed with scarlet silk cording; with a sea-green silk, a jeweled tippet of carved green Jordanian stones and carved ivory beads suspended along gray silk floss from Mexican silver ending in German silver hieratic figures; and for the sun-gold silk gown, a gold chain necklace with small carved teakwood plates centered by a heart-shaped Victorian locket and a Peruvian *figa* talisman, ending in polished brass arrowheads.

The Fortuny dresses originally interested me because their colors and style brought to mind the world evoked by Proust in his writing. When I looked at them again they summoned up a much more primitive and primordial world. Through them, I glimpsed a femininity that had been part of my costume fantasies since the age of fifteen when I loosely converted the room in my aunt's Westbury house to an Egyptian room. The Fortunys seemed to represent a world in which women were both a power and a force.

The dress that Madame Karinska made for me in the early nineteen-sixties embodied another sense of ro-

mance. Madame Karinska's involvement with Christian Bérard and costumes for the ballet was intriguing to me because among the neo-romantics of the thirties—Pavel Tchelitchev and the brothers Eugene and Leonid Berman—Bérard interested me the most. I admired his ability to convey excitement to everything he did, from the sets and costumes of the ballet to the fashion illustrations and magazine covers that seemed to pour out of his talented imagination. Bérard's lushness of vision and high spirits made me feel that if we had met we would have been immediate and lifelong friends.

Bérard's sketches were so fleeting that in someone else's hands they might have perished. Madame Karinska seemed to understand every nuance of his intention. She could turn a flying line into a scarf or drape. She could change the flames that seemed to be consuming a ballerina in one of his drawings into a flurry of net or tulle. She began to work with Bérard in 1932, but through the years worked also with Balthus, Raoul, Dufy, and Jean Hugo.

Her origins were improbable for a designer. She had started out editing a radical socialist newspaper in Russia with her first husband. She had supported the Bolshevik Revolution, but as the climate for artists changed in the twenties, she fled under the pretense of studying museology in Germany.

Almost immediately, she applied to study painting with Sovely Sovine, an artist in exile, but he strongly rebuffed her, only later admitting that he had been wrong. When she expertly repaired the tutu of a dance friend, she found a much needed source of income and began her famous career as a designer for the ballet, stage, and movies.

Madame Karinska is one of my heroines. Her devotion to Jeanne d'Arc seems particularly appropriate in light of her story. St. Joan and the Blessed Virgin were two of the few feminine figures of mythic proportions Western civilization has allowed to emerge. Joan radically changed dress for women and liberated a side of the feminine nature that is strong in all of us.

The dress Madame Karinska made for me is made of palest lavender satin. During a fitting she once looked at the mirror image and exclaimed that what she saw was very like Natasha in *War and Peace*.

A photo by Francesco Scavullo.

88

My collaboration with Adolfo began when we met in 1967 and brought into play all the most romantic and fantastic elements with which I already had been preoccupied. Adolfo shared much in common with my grandmother Morgan, and his eye and taste represented a continuation of her Spanish tradition. Also, Adolfo had grown up in pre-Castro Cuba and had worked, before coming to New York, with Chanel on the 1954 collection that reopened her salon. Thus, he had the feeling for comfort that I admired, as well as a gift for the fantastic.

I remember one of the first dresses he did for me for a big party at Henri Soulé's Pavillon in 1968. Adolfo made for me—the first of a whole series of capes and long skirts—a red felt skirt that I wore with boots and a white crepe blouse with a cravat, topped by a floor-length cape. I felt at home wearing this and both Adolfo and I were surprised when it became popular.

When I worked on my exhibit of collages on Elizabethan themes, I showed Adolfo what I had been doing and asked him if he felt drawn to them. He was inspired and made up a skirt and blouse with a ruff that seemed to come directly out of them. This was the costume Cecil Beaton included in his collection for the Victoria and Albert Museum in London.

By 1969, we had begun thinking of dresses that were sheer fantasy. I had liked the Elizabethan ruffs Adolfo had done and showed him some shots from the London production of Jean Anouilh's *Ring Around the Moon,* a marvelous romantic recreation of the *commedia dell'arte* Pierrots and Pierrettes. It was a hectic afternoon in Adolfo's workroom, but suddenly he thought of doing a Pierrot, using the ruff.

During this period, I also came to know Francesco Scavullo, who photographed me in many of Adolfo's designs, including the Pierrette dress for the cover of *Town and Country.* Francesco has sensibility to his fingertips. His perception is unerring. His talent to manifest the best of someone in his work comes from certain unique qualities in Francesco. He has curiosity about women and their world. He recognizes not only their inner self-images but also the images that they project to the world. When you see the results of Francesco's work, it's as if a woman had fulfilled the secret of her best self.

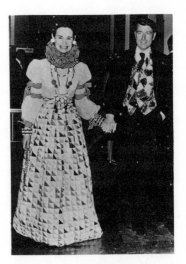

Gloria, with Wyatt Cooper, in the patchwork skirt and blouse Adolfo designed for her, 1969.

89

Francesco is a technical magician—with lighting, with the camera. When you're photographed by him, you feel you're surrounded by a glowing cocoon of warm light. Francesco makes you feel beautiful.

I encouraged Adolfo to try some of the languid and sensuous things I remembered from childhood when I haunted movies in the nineteen-thirties—dresses on the bias in crepe de chine and jersey.

When I began to work as a fabrics designer, Adolfo did some suits with snappy blazers, that I wore with vests and a boutonniere. One of my favorites was a red plaid vest and jacket, worn with a white skirt. Adolfo also began to use my fabrics. I can remember one evening dress he made from the "Log Cabin" print. This was a pattern I had designed directly inspired by the classic "log cabin" patchwork quilt, and it came at a moment when quilts had just begun to provoke my interest in our American heritage.

Later the most extraordinary things he made for me were from the quilts I collected. In 1970, Adolfo began to adapt the quilts into skirts, blouses and corselets. This of course was the most intricate kind of job since the quilts had to be opened up and rebuilt so that they would drape. Adolfo and his staff did this with the greatest technical care, saving the leftovers to make the blouses and corselets. I kept bringing in books on Byzantine art and Cecil Beaton photographs of Dame Edith Sitwell and her brother, Sir Osbert, for Adolfo to look at.

The quilt costumes were among the most memorable of the things that Adolfo did for me. But I must mention one more special dress—a costume fashioned out of swansdown, a replica of a gown worn at a masquerade ball at the Winter Palace in St. Petersburg. Adolfo derives much of his inspiration from the biographies he reads and this surely sprang from one of them. It spoke to something in my dream image, too.

8
Working as a Designer

FASHION FOR FASHION'S SAKE doesn't interest me in the least, but how women live involves me enormously. When I'm designing I have beauty and comfort in mind rather than fads of the moment. Whether I'm working on clothes, sheets, fabrics, table linen, china, glassware, stemware, wallpaper, eyewear, watches or needlework kits. I hope to do something that will convey delight. I feel that a creator should make something that gives permanent joy rather than one season's novelty. Quality endures. Fads come and go. All fashion is fantasy. By fantasy, I mean an individual style that we each come to on our own, by freeing our imagination. We dress to dramatize the roles in which we see ourselves. Our clothes, like our homes, should be projections of our personalities.

When I first began to work as a designer in home furnishings, manufacturers were concerned that what I was doing was "too childlike." The first time I worked for a textile company I did a group of designs inspired by patchwork quilts; this was before others had begun using the patchwork; at first the company was unresponsive about it, and as a result they missed the chance to be first. Luckily I was able to move soon afterward to a company that had imagination and vision. I used basic colors and experiences of beauty I

Gloria's fabric design, "Victorian Bouquet."

Gloria designs her own version of calico.

thought everyone could share. My designs brought an unexpected response. Manufacturers who had, from their point of view, gambled on a fresh approach, found reorders coming in. Wherever I traveled, women thanked me for doing things that fitted so well into their lives. They were no longer interested in the safety of "good taste" or some form of "sophistication" that seemed to be removed from real life. I was delighted that ideas I had first explored in my paintings, then used in home furnishings, found such friendly and enthusiastic acceptance. The circle of creation began to widen.

I understood—largely because I recognized it in myself—that women want every aspect of their day-to-day lives to be touched by color, and feeling. Also, I found that when my collages were translated into fabric or china they expressed a complexity and richness of design that one was unable to get in a more traditional way. Women wanted designs that had something to say about their femininity.

From the beginning, I had a strong sense that I was communicating directly with the women who bought my designs. When I made store appearances, they would tell me about what they saw in my designs. They asked my opinion about the problems they were having with getting their homes together. They told me about their lives and their families. I learned from them and they learned from me. When I told them to stick to their own spontaneous feelings and express themselves, a look of relief would pass over their faces. It's what we all really want to do—and should. We all want to trust ourselves but often everything around us dictates that we should project a certain look or a certain taste or a certain way that is not our own.

As an artist, I had already learned what it was to strike out on my own, but these trips outside New York confirmed in me a conviction that all of us must believe in, and understand, the strength of our own individuality. Those often intense conversations with numbers of American women taught me more about my design work, about how we all create, than I could have learned in any other way.

I also found that the women I talked with were relying on me to help in whatever way I could; to do

my part in at least suggesting a way to transform their exterior lives, by expressing something about our inner lives. Gradually, because of this, I came to believe that I must ask myself two questions when I'm working: Does this please me? and: Will it make a difference? I try to make everything I do as personal as possible, because what other way is there to create? It's what we all must do. My hope, of course, is that the things I create will speak to your creative eye too—will open up a possibility for you to enlarge and express yourself, in dress or home. I live day-to-day with the things I create. I wear my own clothes, eat from my own china, and drink from my own glasses. Even if you don't design fabrics, clothes, this principle—of living with one's own expressions of self—might enhance your life.

An artist works alone and it is a privileged experience when objects and ideas that stirred one's own imagination, hopes and dreams are shared by other people in other places.

During my lifetime, fashion has gone through a series of surprising upheavals; even before I began to think about clothes, innovators like Chanel and Madame Vionnet had left their mark. Chanel had gotten rid of the corset and showed women how to dress elegantly and comfortably at the same time. Think of what that cardigan sweater jacket and her man-tailored trousers have done for all of us! Madame Vionnet let fabric do the work and simplified the whole question of cut and shape with the use of the bias-cut. She pointed toward the current interest in the untailored look.

The couture no longer exists. No one cares about clothes in the way they did thirty years ago. No one spends the money or has the time to go through the ritual of fittings. Some look back on that era with feelings of nostalgia. I can think of nothing more limiting or rigid. The idea of status and class is over. Then, women were protected by the labels they wore and everyone seemed content to look like everyone else.

In the sixties, of course, all that changed. For the first time, we felt free to experiment on our own without the backup of the designers. The freedom of the sixties gave us the chance to value individuality once again.

Also, one single Look was no longer possible. Simultaneously, American women felt a new strength to live their lives and make their own decisions.

I grew with these changes myself. I felt more and more forcibly that I wanted the way I dressed to reflect the way I lived and thought and felt. I wanted what I wore to express myself. And so I came into the fashion field after a long involvement in designing for home furnishings. Evolving not only because of my closeness with Adolfo, but, because for many years, I was in a sense designing my own daytime clothes, creating a look by combining separates. Blouses off the rack with an unrelated skirt, accented by accessories, often a tie borrowed from my husband to complete the look.

In designing a collection I don't believe in seasonal changes. Or in winter or summer colors. And because of air conditioning and central heating, with the layered look to tide us through the energy crisis, fabric requirements from season to season do not vary that extensively. Whenever possible I work in colors and fabrics that work all year round. I work in fabrics that pack easily and travel well. Most of all, I believe in clothes that a woman will enjoy wearing again and again because they are the staples of her wardrobe.

You and Your Look:
From One Designer
to Another

MY FRIENDS, their daughters, and the women I meet
and talk with as I travel across the country, often ask me
about what to wear, how they can develop a unique
and individual image.

Those questions I feel, come not from any lack of
fashion knowledge—the newsstands are full of such
information—but rather from an insecurity about them-
selves and how they should look, a hesitancy about
expressing themselves. Somehow, all the available
fashion expertise conspires to give American women
the impression that they cannot trust their own judg-
ments—that fashion magazines, sales clerks, and
friends are more knowledgeable about what their im-
ages should be than they are themselves.

Without exception, I am certain that each of us can
be in touch with what is most pleasing and beautiful
about her appearance. But because of outside interfer-
ence perhaps too frequently we listen to others' opin-
ions rather than our own.

You have to be your own designer. Look around the
rooms in your home and you will see evidence of your
own creativity and originality. Your imagination,

dreams, memories and sense of organization have surely given the rooms some of their character and flavor. You are its designer.

The same is true of the way you look. You may be short or tall, thin or full, a blonde, brunette, or redhead but you can have a clear sense of what works for you— the dress, the hairdo, the scarf, the perfume that brings you compliments. Perhaps you are only half conscious of the techniques you have perfected to project your image but, with care and honesty, they can be strengthened and expanded. Listen to yourself, and what you know about your inner self from memory, dreams, fantasy. Then create an outer look that reflects this.

Most of us, I'm afraid, attach much too much mystery to clothes. We let what we are wearing rule us, rather than making what we wear serve as a form of self-expression. You know already from what you've read in the past chapters that I learned a great deal from what I wore and what it expressed about me.

Your wardrobe is one of the most revealing aspects of your autobiography. What does your wardrobe tell about you?—about how you spend your time, what colors you respond to, how you see yourself, your image? And even more important, how can you change and supplement your clothes style to bring out truer, or unexpected aspects of yourself?

Once again, my idea of the collage may be useful, as a way to expand your vision of the way you might dress. What you wear is made up of many elements that go together to make a whole. What is the totality you are aiming for? Which elements work, which don't. Where is the one item you really love?

Are you letting what you think of as your *defects* dominate your thinking about how you dress—rather than your assets? Wide shoulders, a short waist, or heavy legs may become an asset if you work with them, rather than trying to disguise or eliminate them. They may impose real restrictions on what you wear. But they are not necessarily handicaps—especially if you play up your assets, too. Stress your strongest points— they will make you feel, as well as look, better.

Remember there is no one way to look. Your solutions to your problems and your estimate of your advantages are part of your personality, past and present.

That is where your instinct as a designer can come in handy. Your look is a collage of you—who you are, how you spend your time, your past, your memories, your dreams, your sense of color, and of self image.

Here are a few suggestions of steps toward organizing a fashion style that more positively reflects you:

1. *Analyze how you spend your time.* What you do should play a great part in determining what you wear. Do a loose budget of your time. You may be surprised to see how much of your time is committed to work, family routine. How much is leisure, how much is free for yourself? What hours are you neglecting in your fashion plans? Does your wardrobe show what aspect of your life you value most—or is it copied item for item out of a magazine? How seriously do you take what you wear for leisure? If you spend most of your clothes budget on work, but value most your time alone, perhaps you should work out a supportive leisure wardrobe. Those hours alone should be expressive of you—and this can be done at low cost, since leisure clothes are among the most flattering and least expensive available.

What is the degree of formality in your working situation? Perhaps you are dressing up when the uniform of skirt, jacket, and shirt, varied with scarves and accessories, might be just as suitable, more practical, and leave you more money to spend on other things. Analyzing your time will put your fashion needs and commitments in better perspective.

2. *Analyze your figure.* How your clothes fit is often the most decisive element in your appearance. If you want to achieve the maximum effect, be careful to learn both your defects and your best features. What are your defects? How can you turn them to your advantage? How can you enhance them? If you're small, you don't have to think of yourself as a little girl. If you're tall, don't be shy about making a statement. If you're overweight, don't feel you're bound to be conservative in the styles and fabrics you choose.

But most important, of course, is to buy clothes that suit your figure as it is. Fit is all important because it also determines comfort.

What are your best features? Feature them.

3. *Analyze your color sense.* Some colors work for you and others don't. Trust your own instincts and don't be taken in by the colors that are popular in any one season. You may live in a section of the country where the days are filled with sunshine; you may need strong colors to keep from looking washed out by the intense light. Or you may live in a section where the days are often cloudy and rainy; you may want dark, dramatic colors to accentuate your presence, or bright ones to convey cheer.

When you think of your color sense, try to remember where it comes from. Also, try to analyze *where* you spend your time. What sort of artificial lighting is there and how will it affect what you wear and what make-up you choose. Colors are integral to the image you project; they convey you, come from you. Let them work for you.

4. *Make an inventory,* every so often (at least two or three times a year) of the materials in your closet and drawers. Arrange the inventory so you see what goes together to make your fashion collage. Certain basics are essential—a good skirt, jacket, pants, or multiples of these basics if you can afford them. Then, the blouses, shirts, sweaters that make them come alive. Again, as with the collage, don't be afraid to rearrange a little, to add an element of surprise: the accessory, the bag, belt, boutonniere, or pair of shoes that makes your look come alive or gives a distinctive twist, an exclamation point to what you are wearing.

When you've made your inventory, you'll see how much you already have and as you take inventory regularly you will realize that a surprising amount of what you buy is worn only a few times. Each of us has a secret indulgence we need to curb—shoes, scarves, or jewelry perhaps—and a regular inventory can help you to shop more realistically. And also, it can remind you to wear items you forget, or to make new combinations.

I even go so far as to write down what I have, to make my buying decisions more realistic. Are one winter coat, a lined raincoat enough? How many shirts and blouses do you need to stay one step ahead of the cleaners? Do you need a glamorous and expensive dress or will a pretty blouse and long skirt do? Project your needs for the next six months both in terms of real needs and also convenience.

5. *Make a sort of clothes chart*—materials for your collage. Which blouse will go with which skirts? Which shoes? What about your stock of underwear, stockings? Am I spending too much on work clothes? Do I need a splendid new robe for leisure? (At-home clothes are unfortunately too often a low-priority item on most women's budgets—and it's the attire in which the people closest to us see us most often.) What small touches can give variety to the standbys in your closet?

6. *Make a list of what you need*—in order of necessity.

7. *Shop early in the season when the selection is best*—August for winter. March for summer. Plan when you'll shop and do it at a time of day when you feel fresh.

At the end of the book, I make some suggestions about how to shop on a budget, but the logic of budget shopping actually holds true for most purchases you make.

Here are some things to think about as you shop:

1. Buy some things (blouse, sweater, belts, even a blazer) that will work for more than one outfit. This will not produce monotony but rather will expand the scope of what you wear.

2. What accessories will create change and excitement with each outfit? What would make the dress look uniquely you?

3. Be conservative about the basics and then orchestrate the effect. Many outfits should serve more than one purpose.

One of the great fallacies about shopping for clothes is a carryover from the past when a new wardrobe was required for each season and there was a much stricter distinction between formal and informal, between sports and business wear. I see no real reason why anyone's wardrobe should necessarily include a long dress or a cocktail dress, for example.

4. Don't buy anything unless you feel really comfortable in it—if you don't, you won't get lots of wear from it.

5. Don't shop competitively. Just because someone else has bought a certain dress or coat or pair of pants doesn't mean you have to follow along.

6. Don't buy anything you don't need or love. Check your list. The money you save on unnecessary

or make-do purchases will come in handy for things you really want and need later.

Your personality, your size and coloring, what you do and how you live, what you can spend should be the factors that determine your wardrobe. Your work, your social life and your location are other factors that also should come into play. If you plan carefully, you can do your shopping at one time, if possible *before* the season, so that your choices are not limited by what's available. Again, let your choice be dictated by what you need, and your feelings of what items would express you, your life and style, best.

What each woman needs in her wardrobe will be different, but here are my suggestions for how to make what you buy work:

Structure your wardrobe around a basic three-color scheme. Buy basic pants, skirts, dresses, shirts and sweaters in one of these three neutral color teams.

I. *Natural or white with medium-to-dark beige and chocolate brown:* These colors can be accented with bright or pale tones of yellow, orange, blue or pink.

II. *Cream or ivory with gray and black:* These tones also look well with bright and pale tones, especially pretty with red, claret, and gold.

III. *Navy and white with a deep wine shade:* Besides being good mixers, these three colors have a freshness which is appealing for all seasons.

Each of these three color teams works well for every coloring and every age. The accent colors play up your particular skin and hair.

What follows is a checklist of the items I've found most useful in my own wardrobe:

At Home

I put this category first because it is the most important and the most often neglected. Don't think of your time at home as a rest between acts. How you look can determine the spirit of your family, the happiness of your husband, and, if you're alone, your feeling of self-worth.

Underwear: Find out what fits you and stick with it. Comfort is the key word. Buy in quantity, if you find a fit you like.

Leisure wear: A pair of jeans or casual pants and a pair of sneakers are absolute essentials and they travel admirably.

Bedclothes: The word is old-fashioned, but I like the idea of dressing for bed. You want ease and warmth but even your nightgown should reflect your individuality. I find my white terrycloth robe serves a multitude of purposes but I also like to dress up in long robes and caftans, often adding jewelry. House slippers should be the best-fitting shoes you own.

A Word About Fit and Fabric

If you want to get the most out of the clothes you buy, you must be doubly careful to be certain they fit and that they can be laundered or cleaned easily. I learned from Mainbocher that the real test of how a dress fits is how it feels when you sit down in it. He understood that most of the life of what you wear will be spent in sitting. Don't buy anything that wrinkles easily. Give pants the same sort of test. Are they too tight to sit comfortably in, and will they wrinkle too easily at the knee? Also, notice what happens to the length of the skirt and the drape of the pants when you take a seat. Are they still flattering?

Read the label carefully. The care of a garment is part of its cost. You can usually figure that dry cleaning and laundry over the life of an article of clothing doubles its cost. Are you choosing a color or problem fabric, one perhaps that collects lint, that will require extra attention, cleaning, or pressing? Don't buy anything whose upkeep will become a worry.

Daytime Staples

The basics for any wardrobe are skirts and pants, jackets and blouses or shirts. No matter how much you can spend, it makes sense to co-ordinate them in terms of color and fabric so that they are interchangeable. I would start out with a light wool blazer in a solid dark color and then add jackets of other colors and weights. Light wool can be worn year-round. Pants and skirts should be plain and take into consideration your unique figure. A slightly gathered skirt or pants with generous pleats are kind to every shape.

Blouses and shirts will give real dimension to your

wardrobe. Be certain however that each blouse or shirt you buy works with at least three other elements in your wardrobe. Blouses can give a skirt and jacket the allure of a dress. A man-tailored shirt can be turned into something special for evening with the accessories you add to it. I would also add two or three blouses that are distinctively yours in their look. An old-fashioned fabric can add another dimension to a tailored jacket or make the most simple skirt romantic.

Sweaters can be as important to your look as jackets. Stay conservative unless you can afford to buy two or more. I find a sweater vest is a terrific touch to add to a long skirt in the evening. Crew necks and turtle necks double nicely with both skirts and pants.

The Dress

Obviously, I believe in separates, but I also believe that the right dress can create an effect that can't be surpassed. I've discovered that for an important business meeting or a grand lunch, a dress is much more effective than a suit or a skirt and jacket. Somehow, a dress conveys extra care and concern. It is a compliment to the person you are meeting. The less complicated the dress is the more you can make out of it.

The Suit

The suit is again extremely popular, but its use can be limited if you don't purchase it in a lightweight wool or garbardine. A four-piece suit-skirt, jacket, pants and vest—can be even more useful if the fabric you've chosen is not extremely conservative. In spite of what writers about women in business have to say about the pinstriped suit, I've found that a dress is finally the most suitable and flattering apparel for the boardroom.

Coat

A waterproof topper or slicker can also double as an evening coat. But the most important investment in terms of cost would be a wool coat in black, beige, or possibly red, treated as neutral color.

Evening

Here again, I feel that separates are much more workable than an expensive dress that might only be

worn a few times. An extravagant blouse can add rich-
ness and elegance to either a short or long velvet skirt.

Accessories

These are perhaps the most important in putting
together your look. Accessories are your signature, they
speak for you eloquently, yet without words. The care-
fully selected scarf and the way you tie it, the piece of
jewelry with green stones that match the color of your
eyes, the belt complementing the purple silk of your
blouse—all add up to create a look that can be unique.
Accessories can be on a long-term plan—the good ones
have a long fashion time span. The fun is in collecting
them and imagination is the key.

What To Carry

Perhaps the greatest problem when you're on the go
or working is what to carry. I try to buy handbags that
go with everything, in case I don't have time to change.
And I've found that a large basket works better for me
than a briefcase or attaché case. The size of what I'm
carrying is not restricted, and I can keep two or three at
the ready with their particular contents for each of the
projects I'm involved in. For traveling, I haven't found
anything to replace a black zippered duffel bag made of
parachute fabric. Collect smaller bags that are special
for different occasions. I found one made of fabric from
Guatemala. To carry it immediately adds spice. My all-
time favorite evening bag is black satin, large enough
for a small brush and eyeglasses. It has a detachable
shoulder strap and goes with everything.

Umbrellas

I would splurge here and buy *one,* the best you can
buy. Comparison shop and wait until you find one with
an unusual handle.

Belts

A silver medallion concho belt will last forever. So
will a rhinestone sliver of a belt to wear over evening
dresses or pajamas. Sometimes a simple ribbon in the
right width will be perfect for your chiffon blouse.
Whatever, give it thought and you'll find it.

Scarves

Gradually build up a wardrobe of scarves. They will never go out of fashion.

Jewelry

Today there is every conceivable kind of jewelry available. It's terrific! You can find the most elaborate rhinestone necklace or the most primitive African bead one and a whole range of choice in between. Select and enjoy.

Shoes

Shoes, I'm afraid, are my weakness. Whatever their color, they should be well fitted with comfortable heels, made for walking. But for evening I prefer a much higher heel. Never skimp on shoes. If your feet hurt, nothing works. And don't forget sneakers. They are the best shoes for your feet and never go out of style.

Vests

A vest can be a special signature which you will enjoy forever. If you have the patience and talent, needlepoint one. Or embroider one with your favorite motifs. Collect swatches of silk and make a patchwork one. Otherwise, collect as you go along.

Jackets

These are in the same category as vests, especially for evening. A Chinese silk unlined jacket in an unusual color, such as cyclamen can be worn over black pajamas, or a skirt of whatever length. To work, it should be in either a special color or fabric—lavender Ultrasuede for daytime or perhaps a sweater jacket of the softest wool you can find. All add to the creating of your own look.

Luxuries

I'm sounding perhaps more practical and organized than I really am! Often, the best parts of your wardrobe are the temptations you've not avoided. Here are a few of my favorite luxuries with timeless quality—fit for any secret dream!

A fur-lined raincoat.

A full-length fisher coat.

A crystal-embroidered chiffon evening dress the color of the inside of a sea shell. (I have one by Thea Porter made from fabric my mother got in Paris.)

An antique Chinese jacket richly embellished with fantasy birds and flowers.

A silver-threaded embroidered lavender Kaftan. (Mine is a treasured present from Judy Peabody, which she brought from Morocco.)

A pink pleated long evening skirt and a lace blouse. (I have a skirt by Sybil Connolly and a blouse made by nuns in Ireland.)

A voluminous black cape (Madame Karinska!).

Brussels lace-edged handkerchief, embroidered with your first name.

Wonderful shoes. (Favorites of mine are by Helene Arpel.)

Jewels (my favorites are from Cartier in Paris).

Fur-lined gloves for snowy days.

A burnished gold compact. (Mine is shaped like a pear, is from Tiffany, and has a sapphire on its stem.)

Caramel-colored suede boots. (Mine are embroidered with pale-pink roses and apple-green vines—and they're perfect to wear to an autumn lunch in the country.) And I will enjoy them forever because every time I take them off I stuff them with a rolled-up copy of the New York *Times.* Keeps them in shape.

Gloria in 1971—"the past few years have greatly expanded our sense of what we can be." Photo by Cris Alexander

10
Sharing Images

MANY OF THE INTENSE SOCIAL CONFLICTS of the
past few years have been concerned with roles—what
it means to be female or male. And with that conflict
has come an expanded sense of images, of what women
and men can be. We are now moving through a period
of extraordinary change in our ideas about what it is to
be alive. This breakthrough in roles and sexual im-
ages—and its results do show it to be a breakthrough—
is occurring at every level of our consciousness. We are
doing more than changing appearances, exchanging
one mask for another. We are, with great rapidity, gain-
ing in knowledge and wisdom about ourselves.

Something commonplace reminds me again and
again of how my own life has changed. Twenty years
ago I carried a small bag with a comb, a handkerchief, a
compact and a pair of white gloves. Today I carry an
enormous bag, "a walking office," that helps me organ-
ize my day so I can work on the run—redoing my
make-up as I go from the office to lunch or changing
entirely for a store appearance or business meeting.
What has changed, of course, is not simply the size of
my bag but the scope of my life as well.

The real revolution in our lives, I feel, has occurred
in the obliteration of the boundary between our private
and public selves. Not that I am saying that privacy has
entirely disappeared. We must fight all the more
fiercely for that. But rather that the old split between
the inner and outer halves of our lives is being mended

Gloria at work in her studio. Photo by Jack Robinson, © 1972 by The Condé Nast Publications, Inc.

Gloria's maternal grandmother—an early force in creating her image.

and more and more we are expecting the tenderness and courage and concern that was too often confined to our private lives to be expressed in public as well.

At first glance it may seem strange to conclude this section about the evolution of my "look," and ideas about putting together your own look, with a discussion of image. But I do so because I believe the issues of how we look and what we wear are psychological ones. What is ending are the stereotypes that have bound us to one idea of what a woman should look like. What is ripening in our culture is a deeper, expanded sense of self, in which our outer image can match our inner vision of ourselves.

The growth process I experienced from the image that my mother and grandmother gave me to my own vision of self was not easy or immediate. And that process is not over, by any means. The sense of identity that propelled it was always with me. It was the one fact about myself that I trusted most completely. That trust moved my life in directions that were totally unexpected and truly exciting because that faith made me look beneath appearance—to find a way of responding to and sharing my image of myself.

What I mean, then, by image is far more than what you do with your hair, or whether or not you look well in red. Your image is the presence of all that you have felt and been—the sum of all your experiences of yourself. And equally significantly, it is the victory you have fought and won between what the world has asked you to be and what you've made yourself.

Women are constantly beset with models of what they *should* be; how sad it is to recognize the loss in the faces of those who have succumbed—those who have taken on the face prescribed by mother, husband or friends. But the potential for growth never leaves us. The change can begin at any moment, even today.

The purpose of this book, however, is not only to share my personal history but to help you to understand the importance of sharing yours. Your presence doesn't stop at the tip of your nose or with the rustle of your skirt or the aura of your perfume. Your image is one of the most significant things you can create—and share.

Most of us have little objectivity about what that image is, what has made it and how it can express more of who and what we are. See ourselves as others see us. In this regard, I sometimes think that there is a startling fund of objective information available from family albums and snapshots; they show the intricate plant of self that is there, from the beginning, and grows from bud to bloom. What tells us more about our sense of self than our first gestures, in prams and bassinets? What reveals more about our inklings of self-importance than party frocks and tiny muffs and almost grown-up hats? What uncovers more the wishes of our parents than the get-ups and costumes they provided for our parties and masquerades—the fairy-princess tutu, the cowboy chaps, and the clown suit? What augurs more for what is to come than the stiffness or freedom of our poses, the smiles and frowns? And there, bathed in the sunlight of the past, are the tiny hands reaching forward.

More than a journal, photographs of a child can show the archaeology of self. In them, we can begin to understand who we are and how we came to be. In old snapshots, we can see the birth of our personalities, the beginning of image. Study photographs of yourself as a child; what does the child's image tell you about yourself? Image, for me and for you, is the source of understanding and consciousness. Not just what was given to us then, but what we have chosen now.

You can research this for yourself. What each of us becomes is an organic process that wells up out of an identity that is continually unfolding.

The secret of beauty—and we all know it—is not a matter of make-up or clothes but of the poise of knowing who one is.

The human potential movement has made much of how little most people realize of their innate possibilities. Most of us, they say, develop only a small percentage—less than 10 per cent for many—of what we are capable. I do not agree. Most lives I know are stories of real courage and fulfillment. The problem is really one of image, how to communicate who we are in our dress and surroundings. How to carry over our creative solutions into our lives, and share them with others.

Gloria at eighteen months— "the intricate plant of self in bud."

A photo in 1954—"not just what was given us but what we have chosen." Photo by Milton H. Greene.

Sharing your image, then, is a question of spontaneity, how willing one is to live in the moment, act from knowledge of self and give directly of oneself. Dress is one way; one's home—which we'll talk about next—is another. Listening, conversation, is a third. The strongest person, the person whose image is open and accessible, is usually also the most tender, the most warm and loving. If we are to love ourselves, we must support the images of others—for the image we have of a friend only reflects, too, the image we have of ourselves.

A photo of today—"beauty is a matter of sharing." Photo by Cris Alexander. 113

Part III

SHARING PLACES: HOME IS WHERE THE HEART IS

Gloria's playful fabric design "Ziz Zag."

11

A Doll's House

BEFORE I CAME TO AMERICA at the age of eight, I had collected a few treasures that were important to me—some ivory miniature furniture that I always kept with me and have to this day. Built around the tiny furniture, I imagined a tiny room with a black-and-white marble floor—miniature but large enough to live in. French windows with billowing lace curtains on the sea. Patterns of light and shadows spilling onto the lozenged floor. This room lived in my mind's eye, serene and perfect.

Surely it was this memory that caused me to admire Florine Stettheimer's lace boudoir at the Beaux-Arts; I saw a photograph of it years later, and was drawn to the witty extravagance of this artist. Decorated by Florine Stettheimer herself, it is one of the most personal rooms I have every seen. An interior cocoon created out of her deepest fantasies of herself as an artist and a woman.

A great deal is made of how we learn things, but very little is said about how we learn to live in the visual world—how we make colors and objects our own by relating to them in personal ways. I think that is why dolls, and doll houses, were so important to my growth. I love the sensation of handling a doll house, having absolute control over what is inside. There is nothing chaotic. Things remain as they were left. Dolls, too, for me, are one of the most profound forms of folk art. What says more about the hopes and dreams of the thirties, for example, than a Shirley Temple doll? The perfec-

One of Gloria's many drawings and paintings in which dolls play a part.

tion of a doll's beauty is what I'm charmed by—and the reliability. Dolls are *there* and they are unwaveringly beautiful.

I had a doll house, a conventional American country house, painted white, with staircases and square rooms. But it was never quite the doll house of my dreams. I longed for fantasy. Not a large doll house like Colleen Moore's, which I had seen when it toured America, but more like the doll house that is now at the Museum of the City of New York. That doll house grew out of how the Stettheimer sisters lived and how they thought.

I have thought some day of making my own doll house—building it from nails and wood, painting the wallpaper and needlepointing the rugs. Painting pictures especially for it. Lighting it softly (I've yet to see a doll house well lit). However, I doubt that I have the patience necessary to build tiny things, and also, I like to work on a large scale, as I do in my paintings. But I enjoy dreaming about the doll house and how it might be decorated and furnished.

The first house I lived in, on John Street in Connecticut, had the quality of a doll house. It was really three small houses close together—the main house, my studio and a garage. It was next to a forest with a stream and waterfalls cascading over steppingstones. I had a chance for the first time to experience making a home mine. The one-room studio also doubled as a guest house. It was here that I first experimented with interior design, covering the floor with a chintz of huge cabbage roses, then lacquered over. It was like walking on roses! When working I protected my "garden" with drop cloths.

Each small house was a salt box painted barn red, the windows trimmed in white. The living room overlooked the water and, using high-gloss enamel paint of deep forest green, I painted the walls and floor. It reflected the greens of the forest outside—giving, I hoped, the illusion of being part of it. (Also I had responded to that particular shade of green ever since I saw a suite at the St. Regis that Elsie Mendl had decorated.) In the main house, a small staircase led up to the one room on the second story, and the walls and floor in that upstairs room were painted a raspberries-and-cream color. A door was placed over the staircase,

closing the upstairs area off and creating an attic bed-
room. The bathroom floor I also covered with chintz.
Each room I tried to make warmly perfect. Sunlight
streamed in through forest trees and at night there were
candles. It was romantic and named "Innisfree" after
Yeats's poem.

The idea of putting fabric on the floors came from
Juliana Force, who was a great friend and colleague of
my aunt Gertrude Whitney. Juliana lived in an apart-
ment above the original Whitney Museum on Macdou-
gal Alley in Greenwich Village. On her hallway floor
she had strewn a chintz of primrose pattern, calling it
her "primrose path." Much of her furniture was Victo-
rian and she had collections of porcelains—cottages,
griffins, snow leopards, and Staffordshire flowers. The
wood of her Belter-like furniture was painted bright
colors and covered in garden prints. Hers was one of
the first places I had seen that was alive, cozy, and
expressed a woman's own unique point of view. This
became my goal—as I believe it is for every woman.
That apartment was an inspiration to me—to live in a
home that reflected my self-image, dreams, activities.

One other object comes to mind in recalling early
ideas about rooms. It stems from Christmastime at my
aunt Thelma's house in England, Burrough Court at
Melton Mowbray. My favorite present was a child's toy
tableau of polar bears, icebergs, and mountains—a
landscape molded from *papier-mâché*. I can remember
the feeling of being in total control as I placed the
animals, mountains, and trees exactly where I wanted
them. My interest in arranging and rearranging rooms
surely started there, and today I look with curiosity
when my children become involved in their play, ar-
ranging and rearranging their soldiers, castles and cars
with complete absorption and concentration, and I
wonder into what areas of productivity it will lead.

Over the years I have done numerous paintings re-
lated to my interest in dolls and doll houses. One is of
two children, leaning against a doll house. Inside the
house is a mother holding a baby and standing beside
them, the father wearing a Lincoln top hat. The house
belongs to the children. Their parents and the baby are
exactly where the children want them.

There is perfection in anything that has been scaled
down to a self-contained proportion. The city of Bruges

in Belgium has that kind of perfection. Faraway, a house I once lived in in Connecticut, might well have been a house in Bruges because of its scale and the harmony of the house in relationship to the nature around it. Most exceptional houses approach that sculptural feeling. Sometimes houses in Ireland, with thatched roofs and whitewashed stone walls, capture a similar emotion but in the context of another country-side. The little village of Gandria, hugging a hillside surrounding Lake Lugano, has it. Taxco in Mexico has it. The Rancho de Taos in Taos has it. It is something similar to the sensuousness of a Brancusi sculpture, the feeling that the buildings are a complete entity in themselves.

This quality of integration—wholeness—is too little talked about in regard to houses. A real home has secrecy—is intensely private and personal. Those houses in Ireland have thick walls, windows that are quite small and set back into the wall. They have a great sense of mystery. You can't imagine what it's like until you go inside.

One aim should be to capture this kind of fantasy, mystery in the environments in our lives.

There are other places that, while airy and open, still capture that illusive secret mystery and privacy. A most extraordinary one belongs to Alfred Browning Parker, in Miami, Florida. It is always fascinating to see the house an architect builds for himself, surely the culmination of a dream. At first sight you seem to have entered what is a jungle, alive with exotic trees and foliage. Suddenly, rising out of the green and yet part of it, is a house, or rather numerous houses, each structured of bleached mahogany with huge, glass-walled sides. A natural stream with its series of waterfalls flows into a canal separating one living area from another, with curved bridges connecting them. At night, the interior lighting makes almost no reflection on the tall panes of glass—bringing nature into the house, eliminating the usual boundaries that walls impose. This house is called "Woodsong." It can be experienced as a treehouse on a jungle island or as a technical contemporary masterpiece of functional living. No matter what your choice, "Woodsong" still exists as a fantasy, a reality, a dream.

The designer Madam Karinska's house has the kind of magic that you expect in a fairy tale. It has the atmosphere described in *The Secret Garden*—a brick wall surrounding a world contained within itself—or the same feeling in the descriptions of furniture, Persian rugs, and other things that create the atmosphere in *A Little Princess*.

We are all gratified by a place that has a feeling of completeness. We relish a strong and secure boundary between the inside and the outside, although, often paradoxically, one can merge into the other. But even more, we are pleased by the sensation of plenitude when we are inside. We love the feeling of being surrounded and warm. I think that is the hidden link between "The world is my oyster" and seeing "the world in a grain of sand."

I am fascinated by all those childhood gadgets that seem to contain a world within themselves. I am thinking of the snow flurries, the Easter eggs that have a tiny scene hidden in them. Or the jack-o'-lanterns with slides. The wooden dolls that open to reveal a yet smaller doll. The tiny night lights by the bed. Or kaleidoscopes. Japanese paper flowers that blossom in water. I have an ivory strawberry the size of an egg that has a scene in it of carved figures traveling over a bridge and beyond trees. A whole world is created within its circumference.

The mystery and unending magic of shadow boxes—all rooms and all architecture should have much more of that mystery and fascination. Houses need stairs and attics and cupboards to make them live in the imagination. We don't keep enough of our surprises hidden. Nothing adds drama to a room as much as drawers and doors. Even a box on a table is a source of potential surprise. Or a book that is a door to another world.

We all long for completeness. We want this world somehow to partake of the perfection of dolls and doll houses. We should be willing to play tricks with scale and color in our homes, and detail that will allow us all to be little people. Rooms are for playing.

And even more, I feel we must be willing to reveal that child inside us to one another. For that is where dreams and hope, the past and present, and love come from.

Gloria in the Ten Gracie Square days. Photo by Milton H. Greene.

12

Gracie Square

I THINK EACH OF US HAS AN IDEA of a perfect house—a house that would satisfy all our hopes and dreams. Part of a dream house is a desire for roots, for a place to belong; and it's also an aesthetic longing, a desire for perfection that is sometimes never fulfilled. Sadly, the desire for roots and that longing for perfection seldom come together. Often, we begin as child brides, putting our nests together, and before we know it we are swept along by work and children. All that we experience today is part of what we become tomorrow and this is also true of the homes we live in and the homes we create. My first important lessons in decorating came from my experiences with 10 Gracie Square, my first real home in Manhattan.

The south penthouse of 10 Gracie Square runs along the East River. New Yorkers are often not too aware of this river—you realize it's there mainly when you fly into New York's La Guardia Airport. New York is of course a small island, and there's a whole world happening on the East River every moment. The river is constantly changing as it flows both ways, according to the tide.

I was in my early twenties when I came back to live in New York. I hadn't lived in any one place long enough to call it home. Ten Gracie Square became my decorating education.

It was a great home for parties. High ceilings, parquet floors, fireplaces, terraces, a roof garden and lots of

space. Large rooms, the blaze of light, and the river view with its constantly changing atmosphere gave me new ideas and inspiration. I seemed always to be changing the apartment around, not so much refining as transforming it, while I grew into it and made it my own.

At first, in my mind's eye, I wanted to make it like a castle in a Cocteau movie. The first objects I found toward this goal were two eight-foot candelabra made from metal by the Philadelphia craftsman Yellen. Gnarled roots formed their base, rising into a tall tree trunk and then flowing out into branches and leaves. Each branch had holders for innumerable candles. They were much like Rackham's illustrations for a children's fairy tale, with surrealist touches. I painted these candelabra white. They flanked the door entering the living room and were lit every evening along with many other candles. In the fall and winter at every opportunity there would be fires glowing. The surrounding terraces and roof top were then as yet unplanted.

We saw very few people and gave infrequent parties despite the apartment. But on one special evening, Georgia O'Keeffe and Dame Edith Sitwell, with her brother, Sir Osbert, came for dinner. In those days I rarely talked, only listened. Both women looked like mysterious nuns to me, infinitely wise as oracles must be, without gender. Dame Edith's hands supported wondrous jewels and she had great warmth. Georgia O'Keeffe studied a painting of mine on the wall, a landscape of a village scattered on a mountain on Lake Como, the water coming down to the bottom edge of the canvas. "Very daring . . ." she said, "to do that . . . with water." In painting it *that* had never occurred to me and I was tremendously impressed.

The next day Dame Sitwell wrote me a letter saying, "Osbert and I will always remember our evening with you—one of the most delightful we have ever spent— indeed perfect from every point of view." She sent me two of her books and hoped we would come to England—"and that must be soon" so she could have "a luncheon party of musicians, painters and poets." I was enchanted.

In those days, I lived quite differently from the way I

do now and had a larger staff. A butler named Orlando took care of the day-to-day operation of the apartment and my beloved Nora Marley, who had come to me in October 1948, helped me with the general housework.

The walls were painted white and the parquet floors left bare. In the beginning, there was very little furniture. I enjoyed the wide areas of space. Later, driving the car to a quarry on Thirteenth Street, I found an uncut, unpolished slab of gray marble. It was just able to fit into the open trunk of the car and I transported it home. Four sturdy logs were cut to sofa height and placed under each corner. This stood in front of the living room fireplace and was our coffee table. Centered on top was a large candelabrum made from driftwood branches, similar in feeling to the Yellen but more primitive. The dressing table in my bedroom was a long, narrow glass top supported by a pair of sculptured plaster blue and mauve hydrangeas clustered into flowered bouquets.

I had long hair down to my waist, partly pulled up from the sides and held on top by a comb. I wore Fortuny dresses and I remember my surprise and delight when my friend Charlotte Gilbert told me I reminded her of Rima, the Bird Girl, in *Green Mansions*. It had never occurred to me that anyone would see me in that way.

Lois Long had written in the New Yorker about Fortuny dresses. Sara Bernhardt and Isadora Duncan wore them. I went to Elsie MacNeill's shop, which carried them. There were drawers to the ceiling of the long, pleated silk dresses. Each drawer held dresses of a different hue—one drawer would be reds, from pale rose to crimson, another drawer blue, and so on, until there was seemingly no shade omitted from the spectrum. Fortuny dresses existed in Proust's time and he described them in *Remembrance of Things Past*. They were only two hundred dollars when I first saw them, but now they are rarely available except in museums, as part of fashion history.

I changed. The apartment changed. English Chippendale replaced the castle furniture. The walls of the dining room were covered in an antique Chinese wallpaper with a chocolate-colored background, alive with birds and trees in brilliant mauves, reds and greens.

Over the mantel was a Venetian rococo fantasy, rubbed a soft coral color with gold-leaf overlaps. It had carved faces and sconces which held Chinese perfume bottles. An Aubusson rug echoing the varied hues of the Chinese wallpaper covered most of the parquet which gleamed around its border. No matter what future changes took place, this paper and rug remained throughout and even followed me when we moved to our house on Sixty-seventh Street.

The library was painted a deep shade of crimson with castered ladders reaching up to the high-ceilinged bookcases. From then on, this room was always called the Red Room and was much enjoyed and lived in. So, the apartment, starting out rather bare, changed almost entirely as I came into my own. As it evolved into a much more conventional look I found myself attracted to Leslie Morris clothes, conservative and constructed with care.

My life opened up more and more and I met many people, became involved with committees, and went to parties. I talked more and felt freer and wasn't so afraid of expressing my feelings. I had a studio on Sixty-sixth Street, and as I worked there my life again changed. I met other people who were working also and I felt myself a part of a new world that was more truly my own. As this happened the final metamorphosis took place at 10 Gracie Square. White tiles covered the parquet floors, with black bearskin area rugs scattered about. The white walls of the living room were covered with my paintings, and along one wall was another fantasy piece of furniture—a long, narrow Sphinx sofa covered in green and aquamarine brocade. The bedroom had pale yellow and white damask covering the walls. The bed's headboard and footboard were carved with birds, fruits, blossoms and ribbons. The dressing table, a red-lacquer chinoiserie with its three-way mirror, I have to this day in my bedroom.

I learned a great deal from my experience in this first home with my two older sons. Looking back, one of course sees many things from a different point of view, and I often wish that I had talked with them much more openly. My instinct was always to protect them and this can on occasion inhibit communication. I tried to do the best I could, and Stan and Chris were and are

Gloria's first stage appearance in "The Swan," Pocono Playhouse, 1953.

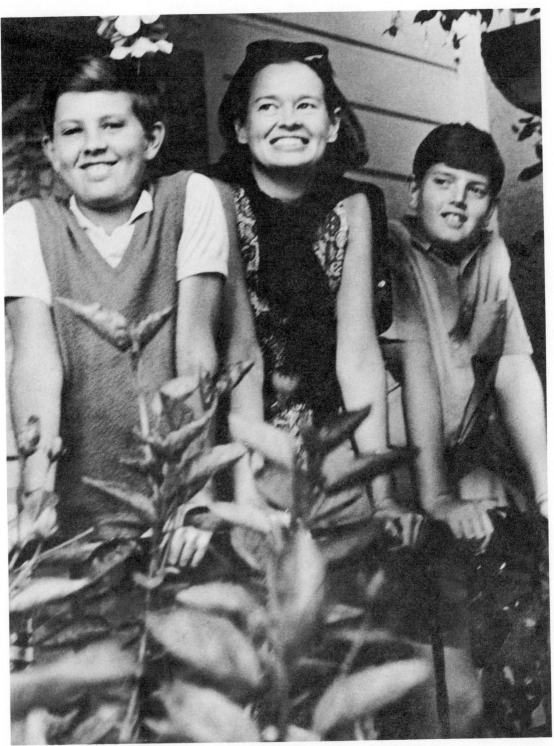

Gloria with Chris and Stan Stokowski. Photograph by Wyatt Cooper.

127

today a great happiness to me. As it was situated in the apartment, their nursery separated me from them by a hallway. I immediately cut a small door in the wall between my bedroom and theirs. They determined the scale of this door and called it, "our teenie door." Through it we were in instant communication.

High above the river, the terraces were now filled with evergreens and seasonal flowers, and later, when I moved my studio to 10 Gracie Square, a wall fountain, with stone angel heads and dolphins, splashed outside the french doors leading onto the terrace. Upstairs

Gloria says goodnight to Stan and Chris. Portrait of Gloria is by René Bouché.
Photo by Richard Avedon.

*Carter Cooper, age four. Beadle Photo
© 1969 by the Condé Nast Publications, Inc.*

*Stan and Chris dressed for
Halloween on the terrace of
Ten Gracie Square. Photo by
Gloria Vanderbilt.*

*The Cooper family, Christmas 1969. Beadle Photo © 1969
by the Condé Nast Publications,
Inc.*

were two more bedrooms and the south roof with its circled view of the entire island.

If I try to describe what I learned about homes at 10 Gracie Square, it would have to be in terms of myself. The world a woman creates is an expression of the way she feels about herself. The bathroom, whose walls I covered by embossing a mosaic of shells into plaster while the walls were still wet, is, by the way, the one room that remains today as I left it. Ten Gracie Square was an important part of my life, and of my development as an artist and as a woman.

Gloria in her bedroom at Ten Gracie Square. Photo by Richard Avedon.

13
Faraway

FROM THE FIRST MOMENT I SAW IT, floating up from the sea of trees, I knew that Faraway had been living in my heart and dreams before time, before imagination. Everything was complete. It was as if I were returning to the tower and the house that I had left slumbering only a fairy tale ago. I was not a stranger. This was my home.

And that was the magical sense of every day I passed there. Faraway did not seem to have been built but to have grown there in the forest, as natural a manifestation of that place as the trees or the river or the wind that sighed and spoke in the leaves.

There was no inside or out at Faraway—only a seamless tapestry of possible idylls and pleasures, of picnics and pastimes. Faraway was one long, golden afternoon, of birds floating low over lawns, of river passages of shimmer and sound, of trees rustling and dancing around us. Faraway had about it that profound, sustained music of Monet's water lilies, of Proust's and Ruskin's descriptions of Venice. And the flow of life and mystery that was the sea for Katherine Mansfield. The Grand Meaulnes, but real—cut loose from time, drifting free, dizzying in its beauty.

Faraway was everything I had ever hoped for or dreamed of in a house. Faraway was a wish come true. The house, with its ivy-clustered tower and the cottage close by, the river with its waterfall and the vast tent of trees that sheltered it, gave the feeling of a secret

garden that had been hidden away in the forest. One day, I came up the road through the trees and there it was, just as if I had imagined it, complete with an Arthur Rackham apple tree.

I had learned all the back roads around Greenwich, Connecticut, when I was pregnant with Stan and I would drive for hours exploring. I discovered it then. The first thing I saw as I drove up the road was the ivy-covered stone tower. I later learned it had been built about seventy years ago as a gatekeeper's cottage. I fell in love with it, but it was not until ten years later when we had rented Joshua and Nedda Logan's nearby house on Long Ridge Road one summer, that I learned quite by accident that it was for sale. If you're lucky sometimes you find things without searching for them, especially if they're already in your imagination.

The spirit was there, but to make it perfect I made changes. The house had a dining room that curved, with its roof providing a terrace for our bedroom. There was a greenhouse off the cottage bedroom and, between, a stone fountain with water lilies and cherubs holding fruits and flowers. A well found at auction centered the garden; it was inscribed with the motto, "If as Heraclitus hath said truth lyeth at the bottom of a well—best batten down the lid lest the long-nosed jade break out and work a mischief." The garden had standard rose trees and Peter Pan sculpture by Wheeler Wilcox set against the tall cedar trees separating the garden area from the pool. In this Beatrix Potter garden there were beds of mignonette, cabbages, tomatoes, peas, and carrots. Major improvements were made in the cottage close to the house, for the children; we put in a swimming pool surrounded by a terraced rock garden and gazebo. On the highest point of land I built my studio.

The year at Faraway began when the dogwood came out. The house had an other-worldly feeling nestled there among the trees. You entered through a black door into a slate-flagstoned court which contained a splashing corner fountain with goldfish swimming in the pool. The walls were thick, whitewashed stone. The sound of the fountain emphasized the quiet of the woods and the river which could be heard in every room.

Everywhere one looked there would be quick visual delights. Two white swans on the river. On one wall, small windows set deep, three in a row. On the front door an iron stone knocker with FARAWAY engraved at its center and over it a Botticelli-faced angel. Close to the river an iron gazebo, painted white, festooned, with wisteria, lavender, and growing every moment. Two peacocks wandering on the lawn. The espaliered fruit trees against the garden wall.

Inside the house, much pale orange and lemon yellow, set off by a red lacquer Queen Anne desk, red lacquer chairs and small tables. The living room had a fireplace, a wall of books, a bay window suspended over the river and French doors that opened on the world outside. At Faraway, as in a Bonnard painting, the indoors and the outdoors were constantly communicating.

Also on the first floor was a guest room, one of my favorite rooms anywhere, with a bay window and French doors. Over doors and windows here, and throughout the house, I added shelves for books. A door led out to the lawn, sweeping down to the river with the gazebo at its edge. Originally the house had no dining room and so we built one opening out onto another curve in the river. Everywhere the sound of water as the river wound merrily through the forest.

But the essence of the house was the tower. Ivy covered the thick Canadian stone, right out of a fairy tale, with Rapunzel windows and a red brick chimney with slanting roofs, paved with hand-crafted tiles. Inside, up the spiral staircase leading to the one room which was the master bedroom, I hung the framed drawings of Pamela Bianco, who did them when she was·a prodigy of twelve, with princes and princesses in fantasy Spanish court costumes. It was a special moment when Pamela came to visit Faraway. She walked up the steps of the tower, pausing on each to look at her drawings, done when she was a child. It was as though she was discovering a lost part of herself and I was very moved.

The landing had a window that looked out onto the river's curve. I put my writing table at the top of the stairs because it was unexpected and turned the small hall landing immediately into another room. The mas-

ter bedroom was the coziest room imaginable with its door leading out onto the red-tiled balcony where we had breakfast every morning. I created Faraway out of deepest dream and fantasy and it was a fulfilling experience to live in the reality.

A great many things set that house apart for me—its magical existence, the long summer evenings that seemed to flow in and out of the house, the way that the house, the woods, and the river became a part of one another. Somehow, the house made everything compatible—even the flowers and garden vegetables seemed to belong together in bouquets. And the juxtapositions of straw baskets and sea shells, of candles and flowers, of wood and wicker were part of the fullness of Faraway.

I have always believed that the truly successful decorating just *occurs*—and at Faraway this happened. Put down a tablecloth and suddenly you have a dining room. Sit on a bench and you have a living room. Stretch out under a tree with a book and the forest becomes your study.

The metamorphosis works in reverse as well. Bring in pots of geraniums and nestle them beneath an overhanging table and you have an indoor tree and flowerbed. Fill a basket with white roses, broccoli, zucchini, and lettuce and you have a garden. Nestle a conch shell in the divide of an open book and you have the sea.

How Faraway fed the imagination! There I came to understand more and more how much our minds need to be free to roam and discover themselves, and how much our environment encourages, or discourages us.

The children enjoyed their own separate cottage; Chris and Stan would have us over for eggs or pancakes. The cottage had two baths and the boys' rooms looked into the greenhouse with its flowers and ferns. Because of the trees, there were many spots to be alone. One of our favorites was the fountain with its cherub, and the garden surrounding the pool with its green-striped roof gazebo.

Everywhere there were surprises—the daffodils and lily-of-the-valley that came up in the spring, the wisteria hanging from the bedroom balcony, the giant begonias in terra cotta pots. The white and purple lilac trees. The path through the forest to reach the extraor-

Gloria, with Carter Vanderbilt Cooper, wearing one of her Faraway coolie hats. Photo by
Toni Frissell

135

dinary waterfall. And at night Japanese lanterns and spotlights on the trees.

From my studio, with the river below, one stepped out on a terrace, surrounded by trees. It was like plunging into a pool of green. The terrace floor was a mosaic of sections of logs set into the earth. The studio, with its high ceiling and skylight, was divided into a living area and a work area. The living area had an alcove that contained a long table suitable for work or dining and a large Gothic sofa with sides that could be let down. This is still my ideal of incorporating my working life and day-to-day life into one unified whole. I have not yet achieved it but I hope to one day.

The touches at Faraway were always unexpected, very different from the life we lived in town. For the table, I used lattice-wood place mats and square plates of a dark wood that I had found in a market in Puerto Rico. There was also a huge wooden food platter that José Quintero had given me and an oversize wooden salad bowl from Aunt Consuelo, made from a scooped-out root of a tree in Mallorca. The glasses were emerald green and were used with amethyst-colored finger bowls. And at night there were lots of green and yellow votive lights. Champagne was always the favorite drink at parties.

Another lovely touch was the Porthault linens throughout the house. I appreciated the soft, blurred colors and I had been buying them since we lived at 10 Gracie Square. I even had some parasols made up from some of the Porthault fabrics, and at 10 Gracie Square had put worn-out Porthault sheets to good use by lining a terrace awning.

Faraway also began to influence my choice of what I wore. In the fall and winter, long wool skirts with wooden beads, combined with jade, turtle necks, and the same silver concho belt. In late spring and summer straw coolie hats from Azuma, but throughout, even in the daytime, kaftans of unexpected textures—mattress ticking, seersucker, and mohair.

The experience of Faraway was very much like inventing your own private world and then living in it as if it were your dream. To some extent, at least, I think we can all do this in our environments. Every moment there was an adventure; Faraway was a house that encouraged you to develop new sides of yourself.

14
45 East 67

THE WILLIAM CHAMBERS HOUSE on Sixty-seventh
Street, where we lived for a while after 10 Gracie
Square, was built in 1910; it was an exception for us in
that, unlike any of the other places I have lived, it
carried its own style. Forty-five East Sixty-seventh
Street was an Edith Wharton house, and we decorated
it very much in period. I missed the sun during the day,
but at night the house came alive. The high point of the
year was our Christmas party, which the house seemed
made for. Months would go by, and then we'd have a
big party.

The happy, pulsing heart of the house was my
quilted bedroom on the third floor; it seemed in many
ways to contradict the formality of the rest of the house.
The room was dizzy with patterns and even the floor
was covered with patchwork, but it had the feeling of a
Byzantine chapel or a treasure trove that might have
belonged in fantasy to a pioneer woman or, paradoxi-
cally, to Catherine the Great.

Isn't it extraordinary how something as simple as
quilts from America suddenly begin to relate to Russia
and the East, to become exotic and mysterious when
used in a certain way?

We used some two dozen intricately figured, hand-
made American patchwork quilts that we had collected
over the years, to create the mosaic effect of the walls
and ceiling. We were making a tapestry. It was not
unrelated to doing one of my collages. Each touch we

A family portrait at 45 East 67th—back row, left to right, Stan Stokowski, Wyatt Cooper, Chris Stokowski, Anderson Cooper, in Gloria's lap with Carter Cooper in the foreground. Photo by Cris Alexander.

added suggested—almost demanded—what should follow. It evolved as it occurred. I found that the contrasts made the difference.

I put a gingham fabric next to a Coromandel screen, an Elizabethan jewelry chest atop an English-made, Chinese-style red lacquer table, a modern suede couch beside a fourteenth-century statue of the Virgin, a seventeenth-century bench beside a brass bedstead—piling layer upon layer, texture on texture.

The room grew into a place that was lovely to fall asleep and awaken in.

We began by quilting only the areas inside the molding—bordered wall panels of the room. The moldings served as frames. Later, we covered all the walls, leaving only the moldings which we painted a high-gloss-enamel white. Then, we used the same treatment for the ceiling, enameling the ceiling's plaster frieze-work.

The floor presented the biggest problem. No rugs seemed to be right. At first, I thought the only solution was to paint the floors white as we had in the country house. Then one day, I noticed some scraps of cloth lying on the floor; that solved it. We began putting down pieces of cloth. If pattern on pattern worked with patchwork quilts, maybe it could work on floors as well as on walls! Technically, no overlap of fabric should exist, so each patch was carefully fitted and trimmed with razor blades to achieve the desired effect. It took seven coats of varnish to get just the right gloss. The floor turned out to be a collage of patterned patches of cloth that because of the varnish shimmered like terrazzo.

Once the walls, ceilings, and floor were completed, we thought of how we would finish it. I chose a brass bed and glass-topped tables so the floor would shine through. Most of the pieces were things we already owned.

We found ourselves taking things from all over the rest of the house, leaving great gaping spaces everywhere. Somehow, there seemed to be spaces in my bedroom for all the things we loved.

It was interesting how taking things we liked—useful, impractical, familiar, rare, old and new—all sorts of things that seemed unrelated in themselves, when put together in the patchwork room, suddenly became complements to one another.

Two lions flanked the entrance to 45 East Sixty-seven. Inside the outer doors, with red ropes on either side, a red carpet led to the inner doors flanked by two wrought-iron espaliered pear trees. The downstairs hall was patterned with a checkered floor of black and white marble. A stone fountain with carved turtles and flowers supported an oval urn that spilled water to the area below. We would float flowers or put pots of them into the bowl of the fountain and mass flowers around its base in the pool. Directly as you entered off the hall was a small reception room with a parquet floor, and walls covered in a cerise silk. It was intimate and had a fireplace. A curved, lace-curtained window looked out onto the tree-lined street. If circumstances had been different it would have been the room I would have chosen to live in above all others. In the hall were mirrored archways hung with emerald velvet curtains much like the portieres Scarlett O'Hara used to make into a dress.

The curving staircase was papered between the moldings in pale green Chinese wallpaper with birds and flowers. The halls were large throughout the house and there was even a fireplace in the hall on the second floor landing where we placed a cozy seating arrangement. At the entrance to the living room, there were sliding glass doors with the panes set in molding. A pair of Chippendale mirrored consoles elaborately fashioned, each marble top supported by splendid carved and gilded eagles flanked either side of a huge, comfortable sofa. In the bay of the window, which looked out onto Sixty-seventh Street, there was an Empire table with a round green marble top supported by brass Sphinxes. There was an Aubusson rug on the floor and lacquer coffee tables, cream-colored and red, ranged in front of the sofas. On either side of the fireplace were the Dana Pond painting of my mother and the John Carroll painting of me. Also, I had two favorite Louis XVI chairs, rubbed white and covered with magenta silk, so delicate they reminded me of gazelles in flight. Two Queen Anne chairs with needle-point by my aunt Thelma were placed on either side of the fireplace. Under the two paintings a pair of gold-leafed Louis XVI settees, upholstered in Nile green

silk brocade. (The Waterford chandelier from that room now hangs in Southampton.)

At the other end of the second-floor landing was the dining room, papered in the Chinese paper from the 10 Gracie Square dining room, with its vivid birds, insects, trees, and flowers.

At the top of the stairwell was a skylight of opaque glass with a frieze of carved roses in high relief running along the molding from the third to the fourth floor. On the third- and fourth-floor landings, we built bookcases because the mahogany-paneled library couldn't hold all of our books. The fourth floor belonged to the older boys, Stan and Chris. The fifth floor was flooded with sunlight and it was here the young children had their nursery with its wallpaper covered with soldiers.

As splendid as the house was, I never found it wholly satisfactory. I am a perfectionist, and to maintain it properly demanded time I did not have or want to give. Before a party, it would take a lot of time to get each detail in order. In addition, the house was designed for a much more public kind of life than interested me. It was perfect for large gatherings such as the one we had for Senator Eugene McCarthy when he said he would run for President.

Forty-five East Sixty-seven was a phase that we grew through together. The experience of that house made clearer what we wanted in terms of privacy and freedom.

The house was never more alive than it was at Christmas time. People have told us that they would remember their Christmas visits as something out of a storybook. For our open-house party at Christmas we would ask about two hundred people—their families and children—filling the house from the nursery to the entrance hall. I wanted the house to be radiant and fresh, with the lights and the scent of thousands of cypress candles. We interwove the crystal chandeliers with evergreens and velvet ribbons. Cypress garlands festooned the curving, carved iron staircase with its padded red velvet banisters.

For open house each year we used our traditional cloth, which we had found in Florence, and which was appliquéd with angels and Christmas wreaths and

One of Gloria's Christmas settings at 45 East 67th Street. Beadle Photograph © 1969 by the Condé Nast Publications, Inc.

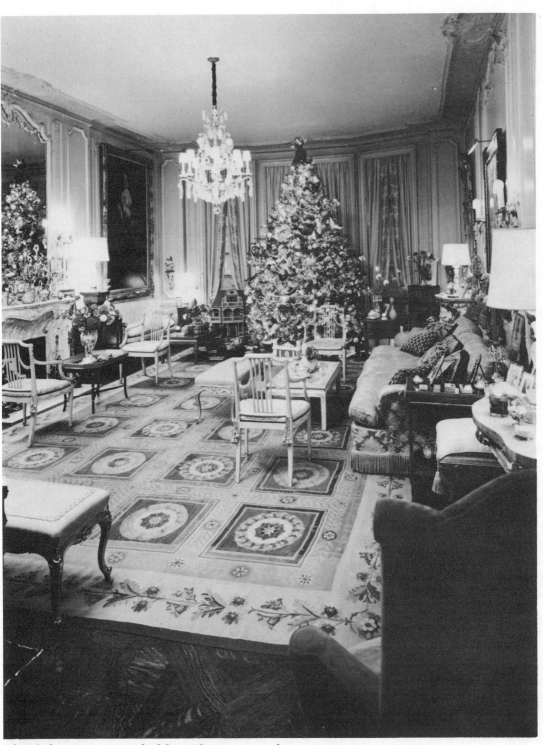

*Gloria's drawing room readied for a Christmas open house. Beadle Photograph © 1969
by The Condé Nast Publications, Inc.*

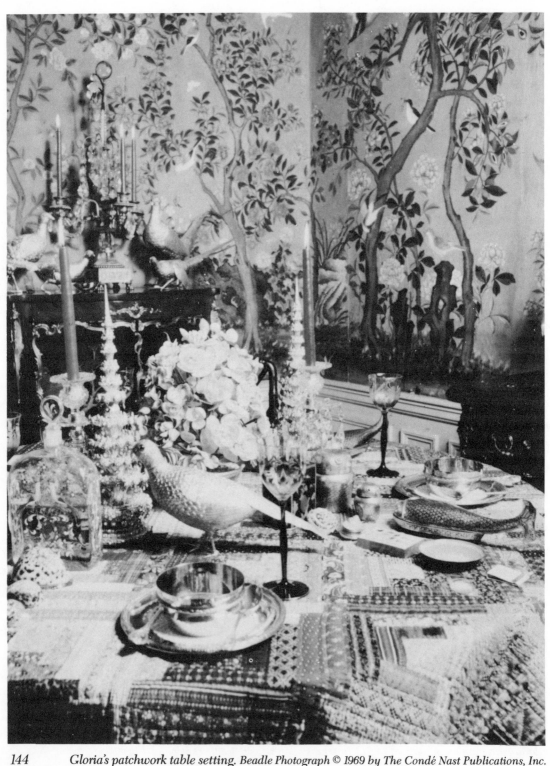

144 *Gloria's patchwork table setting. Beadle Photograph © 1969 by The Condé Nast Publications, Inc.*

trees. At either end, a pair of Italian carved angel candelabra. In between votive candles sparkled. Gingerbread cookies, candy canes, nuts and Lebkuchen spread on my grandmother Morgan's Victorian silver.

Even when December was over I tried to bring that Christmas feeling to all our entertaining. For a dinner for four, I might spread the table with patchwork and set it off with a bouquet of shell flowers, jewel-encrusted spires from Thailand, and a pair of huge, vermeil-feathered pheasants. I used gold plates and finger bowls that once belonged to my Grandmother Morgan. In painted Bohemian decanters, I put both red and white wine and in gold-lacquered owl canisters I placed candied violets.

I enjoyed arranging and rearranging still lifes, placed all over the house, so that a guest's eye always alighted on something unexpected. The impulse is the same as the impulse behind creating a collage—there are hundreds of possible arrangements. In a collage, you choose one of those possibilities and glue it down. On a shelf or table setting, you can change it as often as you please.

For one small Christmastime dinner, I covered the table first with silver paper, then with a Mowry lace tablecloth to set off the mix of candles, crystal paperweights, and Nativity figures I put on the table. Then I used a Victorian Christmas tree as a centerpiece, crowded with tiny horns, silk roses, and, at the top, a tiny wooden angel's head.

For a much larger dinner party, I used place mats and floated a school of silver and jeweled fish down the bare polished wood of the table. I used the gleam of the silver and the red candles to highlight the setting, with horn-handled silver cups at each place. The dinner plates were shell-shaped, with natural shells for bread-and-butter plates and the butter molded into shells.

I have always done my own decorating. Too many people are encouraged to have the right thing, to own a particular status object. But really, it is only your own inner eye and feelings about form, color, and comfort that matters. Trust your eye, and experiment.

I also had to learn that my need for perfection couldn't extend to the five men in my life, my husband and four sons. Chris's and Stan's rooms most often

looked to me like hippie pads. Wyatt Cooper took over the library, spreading out work on his ornately carved Victorian partners desk, similar to the desk that President Kennedy used. On all sides were stacks of books, manuscripts, with many photographs on every available table top.

Every woman experiences her house as an expression of herself. It is an integral part of her identity and each room makes a statement about her happiness and health. For that reason, it's doubly important that she make space for others as well. And that involves encouraging her sons and daughters and her husband to experiment with their environment. Often, that involves both disorder and discussions about taste that may seem to go entirely against the grain. Let the exchange strengthen and challenge yours. Inevitably, I think, the freedom you give others will be returned to you.

15
Southampton

THE HOUSE IN SOUTHAMPTON, a short walk from the ocean on Long Island, was quite a different story from the house on Sixty-seventh Street. When we bought it, it was a wreck—but an elegant one. Built in 1895, and designed by Stanford White (some say for his mother), the house curves to follow the path of the sun so it is filled with light all year round. Because it was falling apart when we moved in we've been making improvements ever since. It had to be jacked up and all the undergirdings repaired before we could proceed with the renovation. The advantage of a house over an apartment is that a house is never finished!

Because so much reconstruction had to be done, we had the opportunity to make a house almost totally our own. Inside, we started out by painting the floors with eight coats of paint. Over this went several coats of polyurethane varnish. Then, we put white shutters on all the windows. With this framework, on the walls and upholstery, we used "Jordan almond" colors—pale pink, green, and lavender—to open up the interior and to act as a foil for the paintings, objects and furniture. There was an added bonus in the house because much of the original furniture was included with it—oversized, overstuffed, and ornately carved. White paint brought it all together—the best I've yet found, a Swedish paint called Emalj that is as pure white as possible and will not yellow with time. This luminosity gave a lightness to the 1890s swans' necks, lions' heads,

Gloria with, left to right, Anderson, Wyatt and Carter Cooper in the living room of the Southampton house. Photograph by Jack Robinson © 1972 by The Condé Nast Publications, Inc.

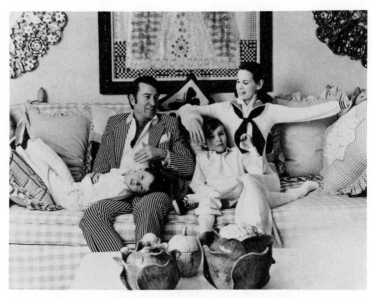

intricately carved ball-and-claw feet, relating these pieces throughout the house. We reupholstered everything in my fabric designs of calico blossoms, prints of tulip cups or ribbon flowered stripes; the third-floor halls and rooms are covered with wallpaper I designed. The house was fused together with color and pattern. Perhaps, I would use only one design in a room, or I might use half a dozen. Occasionally, a pattern would start in one room and flow into another, or start inside and then go outdoors to the porch. There's no right or wrong way. It's your way that matters. Inside and out, the use of color is joyous and gives a lift to the spirit. My husband and children have always delighted in my sense of color and design and enjoy the results of the way our rooms are decorated.

At Southampton, I was working inside the same world of color and light that I try to evoke in my paintings. I also found I was working on quite a different scale than I had worked on before. Rather than thinking room by room, I was thinking of the whole house at one time. All the elements—furniture, objects, the paint, fabrics, wallpaper, the walls and the floors—everything had a kind of continuity that unified the house, made it seem almost like one large room.

Of course, we adapted the house to our own way of life. There are twenty rooms, including four maids' rooms. This sounds like a difficult house to run, but

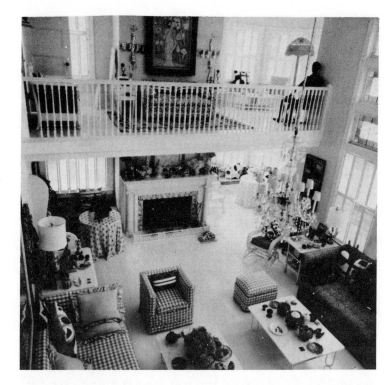

The two-story living room of Gloria's Southampton house. Horst photograph © 1971 by the Condé Nast Publications, Inc.

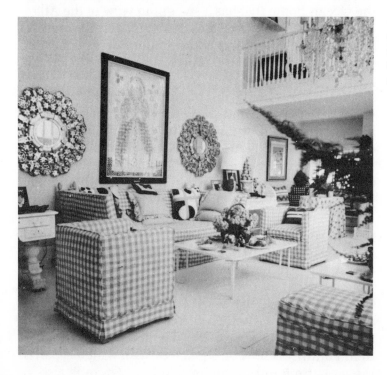

Gloria's use of gingham as an upholstery fabric in the living room. Horst Photograph © 1971 by the Condé Nast Publications, Inc.

oddly enough, it's not, thanks to Nora's talent for organization. Each room has a fireplace. The lime-green living room contains a balcony at one end over the fireplace; you get to the balcony by a spiral staircase. What had been a sitting room was turned into a dining room; we covered the walls in "Log Cabin," the first textile print I conceived. This fabric covers the walls, and also is the tablecloth, at the bottom a ruffle, on the chairs matching cushions. At each end of the table were placed two hall porter chairs fashioned of bleached wood, stenciled with mauve patterns of abstract shapes. Over the dining room table a painted chandelier, metal-crafted into a wicker basket filled with lilies.

The house is big, but it doesn't have the formality of a big house. If Stanford White did indeed build the house for his mother I can well imagine it, because for children or grandchildren it's a child's dream, perfect for playing hide-and-seek on rainy afternoons. It is a house with unexpected nooks and crannies—places to be alone and to think. There are three stories, and on the top floor I made my studio in one of the rooms that has north light. Also, on the top floor is a room we call the Ocean Room that has a sweeping view of the Atlantic. On occasion we use it as a guest room. The second floor, back of the stairs, is the Hideaway Room. Here you can write in peace or have moments to dream, plan, and think.

There was almost no planting around the house when we moved in and we were discouraged by every nursery; they told us nothing but pines would grow so close to the sea. My husband Wyatt Cooper decided to follow his instincts, and now, because of his expertise, the house is surrounded by a jungle, not only of pines but also of many other trees as well. The house is on one acre of land, but when you're within the driveway you are so surrounded by the privacy of the trees that it gives the illusion of much more space. A friend visiting called the garden atmosphere Chekhovian, with its wooded aura and, for its size, unexpected secluded areas. We planted many areas with masses of blue and purple hydrangeas which thrive on sea air and bloom throughout the summer. The Heraclitus wishing well from Faraway is now on a patch of lawn which is part of the view from our bedroom window. There is also an

unexpected swimming pool, hidden behind tall trees like a secret garden. Honeysuckle, vines of white roses and grapes cover the white trestle surrounding the pool area. Also, there are many isolated spots where you can sit undisturbed.

The exterior of the house is painted robin's-egg blue. On either side of the front door are two carousel horses, found in a local antique shop. They had been painted a drab gray and we immediately brought them to life with white paint. Then I started embellishing them, decorating each one with colors and patterns. I enjoy taking time and working slowly on this project and almost hope it will never be completed. Just as you enter the house, to the left, is a sitting room we call the Gingham Room, decorated with lavender-and-white gingham on the walls; along one wall, built over the fireplace, are bookshelves going up to the ceiling. The room grew around each of the collages that hang there, which have gingham and varied patterned backgrounds.

In the master bedroom, there is the influence of multi-patterned quilts. With pink and white gingham walls, this L-shaped room looks out on the ocean, is Mexican in feeling, with hot pink walls and Victorian wallpaper, patterned floor of brilliant colors on a black background. Quilts hang at the windows, bright splashes amid the gingham on walls, and on ceiling and doors, where the pattern is varied by slanting it on the bias. The Victorian sofa at the foot of the bed I painted white and had covered with a fan-patterned quilt with a pink background. A side chair is upholstered with the classic "Dutch Girl" pattern. I used my "Little Quilt" pattern as a contrast to the gingham. Above the bed, we hung a brilliantly stained wooden Mexican triptych of the Madonna, centered among groupings of icons, Pamela Bianco drawings, and framed cards I designed for Hallmark.

The bath-dressing room is like entering a bower of lavender and white violets nestled among green leaves. This wallpaper is on the walls and floors, the fabric glued on the washbasin counter and shirred in the white framed shutters. I also have a wicker chaise longue that is covered with the same fabric and a footstool with horns for feet. Bookcases again cover the

wall over the fireplace and windows. A white painted dressing table, with echoing violet patterned fabric covering the table top under the glass.

The technique for applying paper to the floor was one we perfected on Sixty-seventh Street. First, the floor must be perfectly smooth. Since it was not, in Southampton, we first had to put down plywood over the floor to make a flat surface. Then the wallpaper is "hung" exactly as if it were going on a wall or ceiling, only it is pasted onto the plywood floor. When the paper is dry, coat after coat (at least eight) of a clear polyurethane finish is applied until the surface is sealed.

There are touches throughout the house that add spirit—the Lincoln bed in one of the guest rooms, the Victorian full-length mirror with marble ledges, the fireplace catty-cornered in the entrance hall, another catty-cornered in a guest room, a living room sofa from Faraway covered still as it was in the same silver-and-gray Fortuny fabric, the fireplace with Delft tiles under the overhang of the living room balcony, the white shutters throughout the house; standing on the balcony, the mannequin of me that Henry Callahan created for the windows of Saks Fifth Avenue. It makes my family and me smile to have it there as a piece of Pop Art sculpture. All the bathtubs seem to be for seven-foot people and have claw-and-ball feet. The wicker swing on the porch is piled high with pillows to sink into. Tubs of geraniums, on each step as you enter the house, also border the porch way.

The staircase has the unexpected irregularity often found in Stanford White houses. The hall walls are covered in a William Morris wallpaper that Cecil Beaton did for *My Fair Lady*. From the second-floor landing, the signature of a pair of stained glass windows depicting stylized art nouveau angels with flowing hair and lilies. We found these at the Stamford Housewreckers, an extraordinary place which sells all sorts of unique things, mostly from buildings being torn down. These fit to perfection two narrow six-foot high windows placed on either side of a wider window, now covered with heavy Brussels lace. Sun streams through until the evening. On the second floor we hung Stan's life-size poster of *The Pilgrim* that he did when he was

in grade school. It's a spontaneous expression much like primitive folk art. The hallway floors are covered with black straw matting used as carpeting. Over them are scattered antique hooked rugs, many from Claude Rains's collection. One of my treasured ones was presented to me by Wyatt Cooper for a birthday present. It depicts children dancing around a birthday cake with "The Children's Party" written in one corner, and was found in Mrs. Norman Rockwell's museum in Stockbridge, Massachusetts.

We go out to Southampton as often as we can during the winter. We try to cut down on the amount of baggage we haul back and forth; however, once the children are piled in with the indispensable soldiers and other treasures they *must* take with them, we always look like a caravan of gypsies. In summer we move out as soon as school closes.

Wyatt and Gloria. Photo by Toni Frissell.

Nora cooks special things for us when we're in the country because there always seems to be more time. She makes special dishes and chili cornbread, which is biting hot. We particularly enjoy her baked hard-boiled eggs and shrimp in curry sauce. She also makes unique desserts, like cream cheese cherry pie, fig pudding (although this is a winter dish, we enjoy it in summer, too, served cold with a Zabaglione sauce), or perhaps Dundee fluff. In fall and winter, we usually eat on trays in front of the fireplace and afterward roast marshmallows on long branches gathered from the garden, over the open fire. Then there are evenings in summer when we skip dessert and later drive to the Southampton Fudge Company in the village for the best ice cream you ever tasted.

In winter we use Southampton to recover, sleep, eat, and read, and in summer I treasure having the continuity of working time I so long for. There is also the immediacy, the luxury of being able to go into the garden, fill the basket with hydrangeas and bring them to my studio to paint and to live with a succession of days of almost unbroken sunlight. On Saturday night, we take in a movie, accompanied by jumbo containers of popcorn. On weekends, whether in winter or summer I find a walk on the beach to be the great leveler. All problems are immediately put in their perspective. Nothing can loom so large or unsolvable when you

walk along a beach and become part of that vast force of nature and limitless horizon.

The boys are outside most of the time, riding their bicycles or exploring the beach. They have friends nearby and there is much visiting back and forth. Also they often bring friends from the city for the weekend. But if one thing could be said to pervade the house it's the joy that comes from knowing that you are stretching time, making the most of each moment and therefore experiencing it.

Part of this comes from the atmosphere of the house. What moves me the most is the freedom this house gives the imagination—like Faraway did. The Southampton house works because it has grown so directly out of our feelings. The way you put together the things you like should always come from the way you feel about them.

As you can tell from my descriptions of our homes, I believe it is important to understand the necessity of feeding the eye. People like to find something that delights or amuses them, as they look around. Attention to detail is needed for more than just table tops. It can put your stamp on each thing you touch. Learn not to think in the conventional way about the inside and outside of a house. The furnishings for a porch have as much to say as the furnishings for a living room. Break down the usual way of thinking of rooms as existing solely according to function. The bedroom is not just for sleeping. The comfort of sofas, chairs, tables, and books are needed in every room. Why should one sort of room be less "decorated" than another? Why should a bath-dressing room be less joyous than the living room or the dining room?

The language of a house should be as rich, complex, and inexhaustible in its expressiveness as a painting or a poem. It should reflect you—and extend you. Your house should be your bouquet of sights, surprises, and secrets.

16

The Glass Bubble

LIVING IN A BRAND-NEW BUILDING is quite a change from any of the places I have previously lived—a focus of ideas and interests, a startlingly different frame for our lives. With this apartment, suspended like a glass bubble high above the city, looking out on the United Nations and the East River, there began a new period of my life. No other place has been so distinctively representative for me of my life and my work. Being surrounded with my work is a way of being true to myself.

The apartment is high up on the south side of a building built about ten years ago, overlooking the river; my studio is on another floor on the north side. I am always bringing paintings up from the studio and hanging them at home as a continuation of my working on them. I also find myself rethinking work that is hanging in the apartment. Living with them, seeing them at different times of day often makes something shift into place that I may have missed before. Often I will rework a painting that I did in the past. The basics of the apartment remain the same but there is always change. I often bring things in from the country and exchange them for pieces in the apartment or the office.

The rooms in our apartment building are small but the glass walls provide an extended dimension. It's as though another huge room existed beyond, because at night the apartment is reflected outside. The reflections go on and on to infinity because of flickering

candles, and because the lights of the city outside become part of the rooms inside.

From the first, I chose to ignore the actual scale of the apartment itself and let it wrap itself around the furniture and paintings I put into it. The sofas are overscaled for the living room but I don't think in those terms, for they provide the comfort that I want in a room. I like tables in a room to share the same level as the sofas or chairs they are next to, and night tables to be on a level with the top of the mattress. This exists in our New York living.

I'm not bothered in the least by the mixture of silhouettes—the more mixed up the better. I've never been interested in the history of furniture or objects in the sense of sticking with a period. I've always wanted to go for comfort and color and interest. But that doesn't preclude one unusual chair—spindly or delicate or made of horns—the unexpected touch that sets a room off. In the living room in New York, I have two French chairs upholstered in lavender velvet; somehow they remind me of marshmallows because of their squashy plumpness, entirely different in scale from the other chairs. And there is also another miniature chair covered in claret-colored velvet. I enjoy the visual surprise it gives in contrast to the large-scaled upholstered chairs and sofa.

Using my sheet, "Pastel Patterns," to cover the walls in the living room takes away some of the hardness of the basic structure. It surrounds with an ambiance that glows. But I chose a geometric pattern of black and white for the floor because it helps to ground the room, since there is so much going on inside and outside. As in most New York apartments, there is never enough wall space for paintings and books. New books read in the city are eventually taken out to Southampton. Some of my paintings from my New York studio will rotate between the country, my office, and the apartment.

Moving from a house into an apartment involved an interesting paring down and eliminating of furniture and objects. What is finally brought together is representative of one's favorite things. The first pictures hung in the new apartment were two life-size portraits—the Dana Pond portrait of my mother and the John Carroll portrait of me. These were hung on either

side of a sofa covered in my black tulip garden print. Over the sofa hangs one of my most elaborate collages, "For Wyatt"—my Christmas present to him in 1970. Both portraits cover the wall space from floor to ceiling and again I enjoy the unexpectedness of this overscaling.

My first impulse, because of the sharp contrast between the interior of the apartment and the New York skyline, was to make the apartment as warm and cozy as possible. I brought in several big trees and put a doll house on the window ledge to give the room some proportion to the heights outside. Later, after living with it, I changed to a different point of view and found that the vastness beyond was an added dimension. A large part of the delight of living there is to feel a part of the river and city, only a glance away. The trees are now in the country and the doll house in my studio.

I never design a room from a floor plan. I like to find out what to my eye is right by letting it occur, by living with a room and discovering gradually the best place for the sofa or the miniature chair.

As it turned out, our living room now can seat ten comfortably in a free circle. I like the thought that when friends come to dinner each can settle in comfortably and have general conversations or settle into small groupings as it occurs.

My impulse for rewallpapering, repainting and reupholstering is done in actuality now and then, but most of it takes place in my imagination. I have great fun working out in my mind alternate and unexpected rearrangements. For example, as the living room has no fireplace—the center of the room is really the view outside—furniture needs a center to circle around, and I'm often tempted to make groupings by placing a sofa close to the window, and using the window as a fireplace, so to speak. But this would mean that when entering the room you would be greeted by the back of the sofa, and it might seem rejecting. Having worked it out this way in my mind's eye, I no longer feel the need to make an arrangement I know wouldn't work. In the dining room the tall standing painted Venetian chiming clock magically replaces for me the missing fireplace.

My favorite rooms are the small ones, and the one we

live in the most is the library off the living room, filled with family portraits and mementos. Here, we watch television, work at homework or gather after the day's activities. We enjoy having meals together and there isn't much that would persuade one or the other of us to be away. We're very much involved in one another's work and meal times are often filled with the boys' sharing their latest enthusiasms.

I often imagine what the apartment would be like if turned into one big room, knocking down walls between dining room and library. A dining room today is often a waste of space. In the restricted areas of an apartment, dining rooms frequently seem unnecessary, and opening up and extending the living room space by eliminating the dining room may be more to the point. On the other hand, I think in our case this is one of the rearrangements that will take place in my imagination only, for the second that's done we would lose the coziness the dining room surrounds us with. Despite my reservations about the uses of a dining room, I am certain our family would miss it.

We eat at a round table, which is much more flexible than eating at a rectangular one, and there's that circular flow of communication that happens when people sit together at a round table. Also, it makes it easier to add a second table if it is needed. We use the refectory table along the south windows as a sideboard or, because of the view, often enjoy having lunch or breakfast there. Great, too, for spreading out homework, writing letters, or sketching.

I've learned a number of visually expanding possibilities living in a much smaller place. I use a lot of glass because crystal adds an airiness and glitter that is just the right touch for the rooms. I stow stacks of books under glass-top tables because books can have the vividness and freshness of bouquets of flowers.

I always have chairs slipcovered after they have been upholstered. If expertly done, slipcovers have a casual look I like and, of course, they contribute much towards the just-laundered freshness so important in the maintenance of a room. I also tend to ignore the structural details that are a distracting part of any modern apartment. I use every available space for hanging paintings. Throughout the apartment, I've thought of

structural beams as extra wall space, using them to hang paintings.

Small apartments always present storage problems. I have to keep very close tabs on my wardrobe to fit it into the closets that are available to me. Except for rare occasions I now wear only the clothes I have designed. My Mainbochers and the dress that Madame Karinska did for me which should eventually go to a museum, are stored elsewhere. My Chinese jackets and a Thea Porter one, made of velvet ribbons of varied textures and colors, I intend to wear forever. They are timeless and look equally well over skinny black jeans or a satin skirt. My Fortuny dresses are curled up in the Queen Anne red-lacquer cabinet in the living room. It gives me a sense of serenity and order to weed out drawers and closets, making them as uncrowded and perfect as possible.

What I relish most is the independence my apartment gives me. Maintaining rugs and furniture in top condition is one of the keys to the art of living and this can be achieved with minimum effort here. It has given me hours more of the time so precious to me, freeing me to work.

My particular delight is in being able to fill the apartment with designs I have created. It startled me once when someone suggested it was a way of advertising myself and my work. What an odd notion! Could *you* imagine designing prints, wallpaper, china—whatever—and then not using them if you could? Why would I live surrounded by designs someone else has created, when to me my work expresses my deepest feelings, not only about myself, but my joy and sense of beauty?

We seldom give large parties and enjoy gatherings of not more than eight—to my mind the perfect number for a dinner party. Our dining room can hold twelve comfortably, at two round tables, and we enjoy these evenings as well as more cozy dinners of four or six. My work makes it necessary for me to travel a great deal and so I especially treasure my time at home. It's the quality of time that is important and how it's spent. Large gatherings are rarely conducive to communicating. However, through my store appearances and lectures I've now traveled in forty-eight of the states and

met thousands of people. And although these meetings are fleeting, I feel a bond of communication with many. It is an extraordinary experience to meet strangers whose lives I've touched because work I have done has become part of their lives. I want to know their feelings about what matters to them. This inspires me and touches me deeply.

Many American women rightly think of the home as something they give to their families. But the home should also serve the purposes of the American woman as well.

My husband and children have helped make our life together a co-operative venture. All the success I've had has been augmented by their support, recognition and understanding. They know that consideration or comfort or pleasure for one can be for all if it is well thought out and shared. They think of me as a partner in what they're doing and I look at them as a partner in what I'm doing. But those are insights that we had to work and fight for as a family. It seems like second nature now, but it has taken many years, many experiences and many ways of living to have achieved it.

17
Sharing Your House—and Your Heart

I HAVE MANY OF THE SAME FEELINGS about decorating that I have about fashion. Both decorating and fashion can get bogged down in ideas of what is suitable, ideas that are imposed from the outside—principles not of beauty but of acceptability. My own experience of "decorating," like my experience with "fashion," was uniquely personal. I was concerned finally with pleasing myself, and expressing myself. The first room I did, as I've described earlier, was my Egyptian room in my aunt's house in Old Westbury, Long Island. With that room, I expressed many of the elements in putting together an environment that have remained most satisfying until now. They are the qualities that are important to me in any place I live—fantasy, color, personal atmosphere, and, above all, a moat of silence and comfort to surround those I love.

What has remained in my consciousness from that first room has grown in each of the places I have subsequently lived. It is a deepening understanding that each space we occupy should reflect our color sense, our instincts about ourselves. Decorating is an interaction between our hearts and our minds and four walls, windows, a ceiling and a floor. There can be no rules for "decorating" because each room has its particular character, its source of light, its function; and its

One of Gloria's fabrics for the home.

special occupant. There are no set answers. What matters most is your freedom to respond to let the room speak for you.

When someone speaks of "doing the house over," I find it difficult to understand what they mean. I find with myself that I can only proceed room by room and at times corner by corner. Your house is as complex as your personality. Don't try to simplify or aim for big effects all at once. Those grand effects may prove to be impersonal, and come off cold. Aim for closeness, intimacy, warmth.

Start small. A scrap of fabric, a porcelain figure, an illustration from an old book may set you off. Looking at these diminutive objects, touching them and letting them reverberate in your mind's eye may spark your imagination. Suddenly a new color scheme may emerge or a new way of looking at an old piece of furniture or the idea of a fabric design may come to you. Again, it's creating a sort of collage. When this sort of thinking is most fruitful, whole families of ideas come, but, more often than not, the process may continue for weeks or months. No room is ever finished.

And because no room is ever complete, it is more productive always to keep your eye and your mind open. A mirror may not be quite right but hang it until you've found another or perhaps another spot where that mirror does work. A chair may seem stiff and unyielding until the right pillow or fabric has transformed it. To keep your house alive, it must keep growing and changing with you. For myself, I find that a room becomes static unless I continually change its elements. Moving a lamp may have just as much effect as dragging a sofa from one wall to another. Also, living in a room, you will find that there are constant refinements to be made—relationships between objects and furniture, the play of light, the mood that paintings or pictures lend. I discover I am always making adjustments. Perhaps this is the reason that I find it hard to believe that there is only one right way to do anything. Where we live has to be as alive to life as we are—and to change and evolve as we do.

That of course is a quality that is more likely to be found in a house full of people, of children, than a Regency drawing room with its shades drawn against

the night. I am troubled when I look at photographs taken in a house all dazzled with glass and chrome because, more often than not, it looks as if it has been abandoned. What we can assert in where we live is that we do indeed live there.

I am always fascinated by women who take great care about themselves but guard against expressing one iota of personality in the house in which they spend their time. Your house deserves to be as painstakingly dressed and groomed as you, but it should also be as expressive of you. In that regard, style and personality are indistinguishable.

Where you live should please you, and reflect you and your family—what you do and are. Before you make any decisions, whether you are buying furniture or painting or wallpapering, you should be certain that you are doing it because you wanted to do it, because it expresses you. If you are married, you will want your husband to participate in these decisions; talk with your children about how their rooms are done and help them anticipate what their special needs are in terms of play, collections, hobbies, storage and comfort. For your husband, for your children, and most of all for yourself, always include a private spot that is that individual's alone. If your space is limited, even a large drawer in a desk can allow you to have a private world for your thinking and your dreams.

Household purchases cause great consternation because they are as costly as any purchases we make. Be sure you are not spending too much on a sofa or hoping that an expensive wallpaper will bring light into a room or that a pair of crystal vases will add swank to an otherwise too carefully budgeted room. Such purchases too often inhibit your creative responses.

When you are planning the budget for a particular room, take into consideration what you want it to express and allow some leeway in your expenditures for the relatively inexpensive effects that will transform the room into a coherent whole. Too often plants, pillows, prints are thought of as extras when they may be the details that make a room memorable. When Colette couldn't afford flowers she put a bowl of fruit on the table because a room always required something living, redolent of nature, to make it complete.

What elements are necessary to make your house uniquely personal, truly your own?

The secret of sharing your house is also comfort. If comfort is your standard, no room can go wrong because real comfort grows out of a consideration of what is appropriate and also what is pleasing to the senses. A room should be an embrace to all who enter it. Everything in it should work to support its function. All great rooms have comfort in common. Tastes and styles may differ but, if they are great, they aspire always to comfort. That is the loving denominator of all truly great furniture design whether it is Shaker restraint or Louis XVI excess.

If you work always with the idea of comfort in mind, you can't go wrong. Comfort expressed in the furnishings of a room will radiate your desire to share. And comfort will give you the liberty to express yourself with far greater flair and confidence.

Your first steps may be timid ones. Making a room your own may begin with nothing more than the gesture of putting out some of the photographs you value most, framed attractively. Already, you will see how powerful the introduction of anything personal can be. Anyone who visits the room will be moved by what you have chosen to share. Conversation will be more direct, more lively, more intimate.

Next, you may venture to put out a favorite quilt, a bowl painted by your grandmother, or an ashtray stamped with your son's handprint. Such gestures begin to accumulate. Recently, I was surprised to visit a friend after her mother's death and find one of her dolls sitting on a tiny chair near the coffee table. "Mother had saved her for me all these years and I found her carefully packed away in Mother's things."

Your collection of tiny boxes may suddenly find a place on an end table. Flowers, books, photographs seem to belong in *every* room.

These touches I regard as far more potent than adherence to a particular period or doctrine of decorating. Every room in your home should speak of your life, your memories and your dreams. I am always interested that men seem far more willing to mix their private lives and their business lives. How many working women have photographs of their families on their

desks *and* their mementos from work hanging on the wall at home?

What your house expresses—what it shares—is an orchestration, then, of comfort, your personality and the personality of your husband and children, and charm. Comfort; personality, charm. Charm is a word no longer much used, perhaps too vulnerable in its connotations, but it is an absolute necessity if the eye and the heart are to be at home in a room.

Charm can rescue the darkest, most unpromising room. Charm is a lightness and humor and a care that gives a room the grace of a smile and the mischief of a wink. I know one heavy Victorian room in a Manhattan townhouse that almost roars with laughter. Lions of all sorts gather on tables, peek out from under sofas and stand guard on the mantel. The woman who lives there couldn't resist the family antiques—ponderous and unfriendly though they were—but she was also a very outgoing Leo. Charm did it.

Once, at the end of a serious dinner party, I was surprised to find that the plate on which I was being served fruit and cheese also carried a bawdy and irreverent cartoon of Louis Philippe, the pear-shaped monarch of France. Next to my bed, I have a night lamp that is inhabited by an improbable family of hedgehogs gathered around a fireplace in their tiny living room.

Charm is seldom calculated. It is more the result of accident or happenstance, but it can make a room glow. It may be no more than a tiny etching of a portly eighteenth-century man or a pillow with a saucy observation or a jade caterpillar crawling along a Japanese pea pod but it can tantalize and tease a whole room with its possibilities. That is, after all, why the elegant eighteenth century was so amused by a whole artistic menagerie—a witty mirror of human foibles. No room is a truly happy room if it takes itself seriously.

Perhaps the most telling consideration you will have about your home is the degree of formality or informality it will have. If your life centers around your home, it may be foolish to reserve one room for formal occasions. Your living room should be for living. On the other hand, if you entertain frequently, you will want to keep part of your house always at the ready. Even if you're living in a one-room apartment, you will want to

assign special functions to each area of the room and organize your storage and other support functions carefully.

As you will shortly recognize, the function of each room is to a large extent self-contained. Each room, according to its degree of formality or informality, should be planned to function on its own. What can you do to make the bedside table, the bar, the hall closet, the guest bathroom totally self-contained so that they satisfy one's needs? If you plan in some detail, a room can support any number of functions. I was impressed when a friend who collected eighteenth-century French antiques decided to give up his large Manhattan apartment so he could spend more time traveling. I was alarmed when he told me he had bought a studio apartment that was no larger than the living room of his former apartment. When I visited him, I discovered that by careful planning he had been able to place some twenty-three chairs around the room, along with two couches, one of which opened into a bed. He had not altered his style of living—he liked to have large groups of people in—but he had adapted the formality of his life to new circumstances, making a virtue of what I had feared would be a defect.

There is another aspect to the question of formality that can be an invigorating and enriching element in your life. As mentioned, I find having a dining room essential to our shared life. It makes the times we are together occasions. Also, I am sure that we look forward to those meals and add a little distinction to how we look and what we have to say. Even when I am alone, I try to make meals a high point. Often, I find we all cut corners where personal expenses are concerned. Why not share day-to-day pleasures even with ourselves?

Above all else, give yourself time. Where you live is one of the most vital parts of your experience. How you shape it is part of the quest of self. Allow yourself to reflect and learn, to see and hear what your imagination has to say.

Part IV

THE HEART
OF THE MATTER

18
Money

I HAD FIRST THOUGHT of calling the chapters in this
section, "The Unmentionables," not because they are
so little talked about but because the truth about these
topics is so seldom spoken. Psychological studies have
shown that money is the main cause of conflict be-
tween married couples. Even sex, that American obses-
sion, came eighth on the list, with children second.
Unfortunately, we are often inarticulate when it comes
to speaking about those things that are most meaning-
ful to us—love, freedom, our pasts, relationships, re-
sponsibilities, loneliness—or unwilling to express our
deepest longings and fears. Rarely do we value suffi-
ciently the problems they produce or the self-disci-
pline they require. A scarcity of love, money, or happi-
ness is for many still a forbidden subject. "Good
manners" dictate we not allude to these areas.

I think this silence prevails both because of personal
pride and because these are precisely the areas of life
most open to exploitation and manipulation.

I believe it is ideal for every woman to be able to be
self-supporting, at least to a certain degree. I under-
stand perfectly what Billie Holiday expressed in her
song: "Mamma may have and Poppa may have, But
God bless the child that's got his own." The money I
have earned myself has made all the difference in my
life. Nothing else has done so much to make me my
own person. We may tell ourselves that we would be
happier if we simply accepted our lot in life but the lie

Gertrude Vanderbilt Whitney in 1895.

Gloria's aunt Gertrude in one of the gowns designed for her by Leon Bakst, the Russian artist and stage designer. Photo by Baron de Meyer.

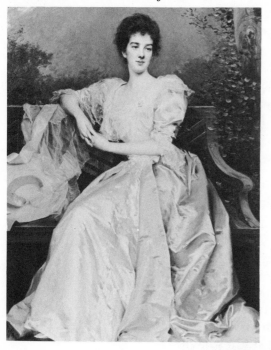

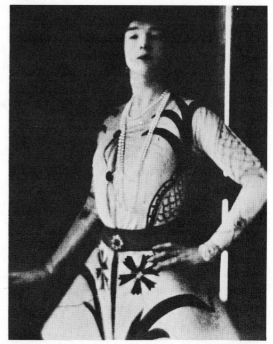

The Gertrude Vanderbilt Whitney House on Fifth Avenue. Courtesy Gertrude Vanderbilt Whitney Conner.

inherent in that statement is obvious. I think that for the sake of their own happiness and the happiness of their children, women must try to be more in charge of their own financial affairs.

A priority of education should be the goal of making one self-supporting, of developing to its optimum the special talent each of us has.

American women have often been short-changed because they don't know how much they are worth. An astonishing number of women work but they are willing to earn salaries that are well below those of their male counterparts. Learn what you're worth and ask for it! You may be turned down at times but you'll soon discover that such situations don't pay in every sense of the word. Stick to your price. You'll find that your confidence will change how people feel about you and increase what you can expect.

Many women work as volunteers and their contribution is a necessary and important one. However, I encourage my friends who work as volunteers to find similar jobs that pay.

I have strong opinions about this because I recognize what an extraordinary effect on my life earning my own living has had. What I do has a consequence. I'm able to put into effect many of the things I've been thinking and dreaming about for years.

Identity and worth are inextricably linked; both are absolute necessities for maturity. Men have understood this for years. Many women are just now finding it out. But it's an experience you have to be inside to appreciate. Work can make everything else—love, family, leisure—come alive.

I am in a strangely vulnerable position when I speak about money, because of my ancestors and because so much of my life has been lived in public. I learned very early on that the Vanderbilt name is associated by most people with money; they supposed that they knew how much money I had, and the amount was inevitably more—often fabulously more—than was the reality.

An ambivalent fascination for the rich has long been a popular sentiment. Both Mary Pickford and Shirley Temple made movies entitled *The Poor Little Rich Girl*. I felt trapped by the label, and by being referred

to as an heiress, but always some essential part of me was untouched and I'll tell you why.

To understand my feelings about money, you must realize that I came to live with my aunt Gertrude—at the age of nine—from a totally different environment. Until then, I had known happiness surrounded by the devotion of both Dody and my grandmother Morgan. Although I had not had a permanent home or family in the traditional sense, my sense of belonging was firmly rooted in their love. All of this changed when I went to live with my aunt Gertrude, who was really a comparative stranger to me. I saw much less of my grandmother Morgan and, shortly after, when Dody was taken away from me in the custody case and a strange governess put in her place, it was a shattering blow.

All these factors contributed to the alienation I experienced, for I always felt like an imposter who didn't belong and that it was only a question of time before I'd be exposed for being at Aunt Gertrude's estate in Old Westbury under false pretenses. Because of this feeling, labels such as "rich" and "Vanderbilt" didn't really reach me; I felt an outsider and remained untouched. And, in that sense, protected. Although I did not realize it at the time, this isolation was in many ways a blessing, because it freed me to struggle towards becoming my own person.

It is a source of joy—a great one in recent years—that I have come to know and love members of my family on my father's side. I was nine when I went to live with my aunt, and the circumstances were unnatural, to say the least. I am sure this put a strain on them, as well as on me. Now, the years have resolved themselves and we can meet and enjoy each other as friends, and through this I have the real sense of belonging to a family that I did not experience as a child.

My aunt Gertrude lived on an extraordinary scale, a scale that was unusual even in that more affluent day. Her estate at Old Westbury consisted, aside from her house, of three other houses, each like a self-contained estate, where her three children lived with their families. There were also stables and a building containing an indoor tennis court and swimming pool. Another of these outlying buildings housed my aunt's studio and still another the farm equipment and machinery. Her

own house in Old Westbury was maintained by three
butlers and a large staff. Since it was a perfectly run
house, everything seemed to happen with no effort
whatsoever.

There are few places where that sort of luxury exists
any longer. But then one imagined the atmosphere
going on forever. It was unshakable and positive—or so
it seemed. The pitcher of iced tea and the glasses
garnished with mint simply appeared as if no one had
put ice in the pitcher, brewed the tea, or picked the
mint. There was a solid sense of continuity, however
misleading.

The Harry Payne Whitney house at 871 Fifth Ave-
nue, my aunt Gertrude's Manhattan house at the corner
of East Sixty-eighth Street facing Central Park, had
been remodeled by Stanford White for William C.
Whitney in 1897; it was acquired by Harry Payne Whit-
ney in 1907. It was a superb brownstone building, a
self-contained French château, 55 by 200 feet in area,
consisting of four stories plus a basement. A wing on
the Sixty-eighth Street side housed the largest ball-
room in the city. It was 63 by 45 feet and more than 45
feet in height, with paneling in carved, gilded oak from
the chateau near Bordeaux of Phoebus d'Albert, Baron
of Pons and Foix, a chevalier and field marshal during
the reign of Louis XIV. The ballroom hangings were
Boucher tapestries and the "Monkey Gallery," set in
the wall above where the orchestra played, was of
intricately wrought iron.

Treasures were gathered from France, Italy, Greece
and other lands. Much of the interior walls were cov-
ered with massive antique carvings in wood and stone.
Sienese, Istrian, Carrarese and Levantine marbles had
gone into the construction; ornamental handiwork from
old Continental palaces had been acquired. The street
entrance consisted of two tremendous wrought-iron
and bronze gates from the Doria Palace in Genoa,
while the vestibule was an old stone gateway from a
Florentine house. And although the house was like a
Renaissance palace, the antique was blended with
modern facilities for comfort and ease. The grand en-
trance hall had a Renaissance floor made up of innu-
merable pieces of marble and brass in a magnificent
mosaic. The ceiling of carved Florentine wood, the

stained glass from southern France, the tapestries, marble wells and seats, and inlays throughout the other rooms, had been gathered from cathedrals and castles.

The walls were hung with rare paintings, including a portrait by Sir Joshua Reynolds, Millet's "*Sower*," Raphael's "*Angelo Doni*," Van Dyck's equestrian portrait of Charles I, Hoppner's "*Mademoiselle Hillsburg*," "*Dancer*," and a masterly Tintoretto. Perhaps the most impressive part of the house was the first-floor corridor leading to the ballroom. On one side were stained-glass windows displaying the skill of an unnamed Italian craftsman; flanking the windows opposite was a fantasy of antique inlaid wood, bearing the legend "Francisco Orlandi, Verona, 1547." Harry Payne Whitney died in 1930 and my aunt Gertrude lived in the house until her death in 1942, when, according to my uncle Harry's will, it was to be demolished.

Indeed this house was a museum beauty, and I remember with dismay when a young friend visited me there and commented that "it must be like living in Grand Central Station." Many of the parents of the children I went to school with at Greenvale lived on a similar scale. As a result, some of my classmates were totally unprepared to survive in the world.

After all, children who receive money as inheritances or trusts from their parents sometimes have no way of knowing how to value it. They can only learn if they have close communication with their parents. And as for talent, I do not believe it is inherited. It is a gift you are born with and if you have it, you owe it to yourself to fulfill it. And this takes character and discipline. It takes soul. If you are born talented, and also happen to be born rich you have to have all these same things—and perhaps quite a bit more drive and stamina—to succeed.

Because those are not values I received as a child, I have taken extra pains with my children to be as frank about money as I can. When they ask questions, I answer them. As a result, it's interesting to me to see the attitudes that they've developed. Both Carter and Anderson started savings accounts, and they think a long time before they spend their money. Is this or that purchase really worth it, they will ask one another. Last year, Carter asked what we planned to spend on his

Christmas presents because he was thinking that perhaps he could take that amount of money and spend it adding to his collection of toy soldiers. He was told what we had planned to spend and he considered his idea for some time. Then, he decided he preferred to be surprised.

Carter and Anderson recently appeared in a TV commercial I did for my jeans and blouses. They were very aware of their performance each moment they were on the set. Their behavior was 100 per cent professional. They knew they were being paid for their performance and behaved accordingly—which meant doing their *best* once they qualified for the job. And isn't that really the meaning of the word professional?

Not long ago, a friend of ours invited Anderson to come along for a day-long visit to Philadelphia where our friend was to make a television appearance, after which he planned to show Anderson Liberty Hall, the Liberty Bell, and the Philadelphia Museum of Art. Our friend was impressed because Anderson invited him and his assistant to have coffee and then insisted on buying treats for the return trip. Children relish the pride, pleasures, and responsibilities of money, as adults properly do.

A large part of the problem with money is that we cannot easily talk about it. Women in particular have to learn to say what they want. And they have to learn that men may feel threatened if they do. Letting someone else take care of the banking, insurance, and investment is simply not being fair to yourself. What we don't know can and does hurt us.

Women in the past have thought of money as part of masculine power, a male prerogative. Men were daddies or knights in shining armor, or Simon Legree. But often a woman's dependency on a man and his money was like living off someone else's smile. It took away a woman's responsibility for herself and it made it impossible for her to control her fate.

Until this past decade, the whole question for women of money has had a great air of unreality. That's perhaps where all the Maggie-and-Jiggs jokes about women buying lots of hats came from. Women were supposed to be—at least in cartoon strips—empty-headed spendthrifts. But the whole notion of conspicu-

ous consumption, spending money for the sake of spending it, always emerges when money doesn't mean anything. That era of buying houses, cars, jewels and furs just for the sake of spending has ended, and for this we can be thankful.

One of the examples of the unreality of money is the use of charge accounts. What could be more misleading than the idea of "fly now, pay later." Charging is a convenience but only up to a point. It is actually putting off the reality. I think it's much better to pay cash; it limits what you spend.

I've found for myself that I try to prolong the fantasy of spending for as long as possible and then I sometimes don't *actually* spend the money. One can have an extravagant spending life without spending a cent! I picture the Zandra Rhodes dress I would enjoy owning and I think of all the places I could wear it and what I would wear with it. After a week of fantasy about it, I find I don't want it so much after all. After two weeks, I've forgotten it! Visually seeing it and then absorbing it and dreaming about it can be like having it.

There has been an enormous change in how we think about money, but there has been an even greater change in how we spend it. A fur coat used to be considered a luxury but now, depending of course on the fur, a cloth coat can be more expensive. Much the same thing has happened with costume jewelry. Real jewels don't matter in the same way they once did.

One of the most remarkable alterations has been in the way people entertain. There seem to be fewer big parties. People now prefer to see one another in smaller groups where conversation and real contact are possible. And we often find, in these matters, that it is true that "less is more."

19
Parents and Children

I'M SO AWARE OF THE IMPORTANCE of the relationship between parents and children because it's something I didn't have myself. To survive and grow, a child has to have a frame of reference to build his emotional life on. As I've indicated, I was totally unaware that there were any possibilities other than the ones I grew up with. There was no male figure except for the men my mother saw and these I rarely came into contact with. My world was dominated by my grandmother and Dody. Because my grandmother had been separated for many years from my grandfather Morgan, I saw him rarely. She was bitterly hostile to him and often I would overhear her telling Dody stories of his cruel behavior. I now believe the stories were largely figments of her imagination. She also was obsessed with the belief that women had to use their wiles to manipulate men to get what they wanted.

And later too there was no male figure at my aunt Gertrude's.

So I've learned to be a parent because of the things I didn't have in my own life. Playing both mother and father to myself has given me insights that I wouldn't have had if I had grown up in a more conventional way. The ideas I'm sharing here, then, are not because I'm an expert or an ideal parent but rather because of the

importance and satisfaction this aspect of life has had for me.

I'm certain that the child's consciousness is not all that different from the consciousness of the adult. And for that reason we must be aware that that consciousness exists from the beginning—from birth and perhaps before. Men, in particular, often do not seem interested in children until the children have passed a certain age, not just because they are put off by diapers and bottles, but because they want the child to be able to respond either in conversation or through activity. That attitude has changed somewhat as more and more fathers are present at childbirth. With my own sons, I have seen the great difference it makes when both parents are deeply involved in their lives from their first day of birth.

That sort of attention has another important effect. It opens children up to the world of other people, and leads to consideration—the basis of the most real kind of manners—because they have grown out of an awareness of others. To have such manners, founded in openness not rules, is to have grace. I do find it jarring to meet a child *or* a parent who is oblivious to the wants and needs of others. But that again depends on one's frame of reference.

You are affected by what you have been exposed to. With my two younger sons, I have applied the lessons I learned with their older brothers. I don't overprotect them. I don't treat them as children. I'm delighted that the world is so much more available to them than it was to me or to their father. At ten and twelve, they had not only seen a baby born but seen actual filmed moments of an embryo's growth since the beginning of conception, on television! I was thirteen before I had any glimmerings of those most basic of all facts. They know so much because they have been exposed to so much and in a positive way.

I find it difficult to restrain the impulse to protect them from violence on television or in the movies. Yet, I don't allow myself to interfere in that way. Instead, I discover that they have a sense of how to regulate that for themselves and I believe they have the right to make that decision for themselves. The same is true, of course, for books.

Gloria with Carter and Wyatt Cooper. Photo by Toni Frissell. Courtesy of the Library of Congress, Washington, D.C.

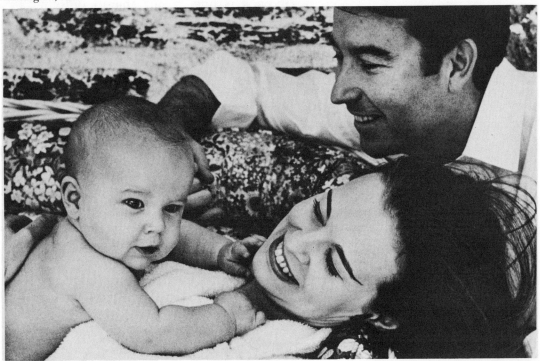

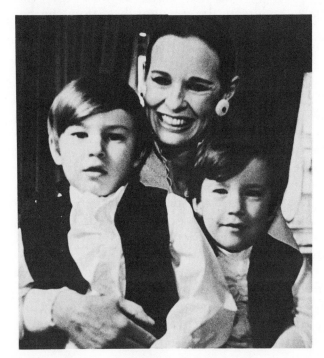

Gloria with her two younger sons, Carter and Anderson. Photo by Bill Cunningham.

Gloria with Carter at the circus. Photo by Wyatt Cooper.

Seeing movies is one of our shared delights as a family and we go to everything. We saw *Dog Day Afternoon* together, for example, because it was a real-life situation—about a man who staged a bank robbery to pay for his lover's sex-change operation. Of course, this was a complicated situation, with all sorts of feelings, life styles, and choices involved—and it had received a great deal of attention in the news media.

On television, they watch everything, and as a result, they have much more sense of the issues involved in the world in which they live than my generation had. Both Carter and Anderson form opinions that they express. They have been treated as individuals and persons from the start; their ideas were respected, so they have an added ability to absorb and reject information they receive.

More than their ideas even, I am delighted to see a strong difference in their responses. They are two very different people. Part of this comes from the fact that, although until this summer they have shared a room, they have always had desks, work space, and privacy of their own. They really get along because they are individuals. Anderson, the younger, has, from the beginning, been made to feel how important to us he is. I think there is a minimum of rivalry because they are respected for their uniqueness—not one superior to the other. Being older is purely chance, after all.

My life really does revolve around them, but that is also misleading; it is perhaps more accurate to say that our lives revolve around one another. We are a close family. We can't wait to get home to relate what the day has brought. The boys like their friends to come to our house; we treasure our weekends and trips to Southampton. The movies, plays, and the reading aloud we share together no matter where we are. Also, there is the nice sense that we are each working on projects and will share those together too.

I was forty when Carter was born and forty-four when Anderson was born, but it never occurred to me that that was unusual. Having two generations of children was a joy rather than a problem. The boys seem to like it, too. Carter and Anderson feel very close to Chris and Stan.

I've gained a great feeling of peace from being a

parent. I'm deeply fulfilled that Stan, for instance, is able to relate to women in a positive way. Because he is able, it's possible for me to let go. His ability to relate to women naturally gives me a sense of achievement, and it's something I want for all my sons. The ability to love is the heart of the matter. That is how we must measure our success or failure at being parents.

The actual experience of being a mother is one of the most fulfilling I've ever had. Pregnancy was the most continuous happiness I've known. Each time I've experienced birth there's been an overbearing feeling of loss, in the hospital right after the baby's birth, when the baby would be taken into the nursery. And then the greatest flooding of joy when the baby would be brought back to me.

My only regret is that I haven't had a daughter. That experience must be extraordinary—for a woman to have a daughter and really see another woman, part image of herself. I often look at my children and think I was once that height—exactly—or read that book, or perhaps dreamed that dream.

It's very hard for me to imagine that a woman would not want to have a child. However, personal feelings aside, I feel we have taken a giant step forward, in knowing that in today's society a woman can decide she does not want to have children and do so without censure. I believe there are women who should not have children because to do so is against the inner fiber of their beings. Their involvements and interests are concentrated elsewhere. Having a child will only distract and therefore the child will always feel a sense of not belonging and of alienation. A woman must extend herself a great deal to raise a child successfully. Every mother knows this, every woman senses it. I respect enormously a woman who knows herself well enough to come to the decision that she is not meant to be a mother. I know of many women who have been pressured by their parents or husbands into having a child because it was "unnatural" not to. It takes courage to stand fast by one's inner truth under these circumstances.

Speaking for myself, being a mother was a triumph for me. It meant that I had transformed much that was sad and painful in my own childhood into something

that worked. Having children meant my unlearning all that I had known as a child and putting in its place the happy experiences of my children. Children seem to me an expression of the hope that the world can be different, will be different, *is* different, with each new child.

Often my children have given me insights that have been of great help in my own problems. For instance, I still haven't conquered my intolerance of disorder. It upsets me terribly to come into a room and see disarray. But we forged a sort of truce on the subject. I have to remind myself that I couldn't work in my studio without disorder! So I've resigned myself to a point and have to keep reminding myself constantly to keep quiet.

I've already admitted to a tendency to be overprotective. But I know that that sort of protectiveness can limit growth in the long run. I've worked it out pretty well, but the response sometimes remains!

I also have to be alert to a tendency to understand and rationalize the other person's feelings as well as my own. The minute I start seeing it from their point of view, I'm done for. Then, I hold fast to the task at hand which is to get *my* point of view expressed.

Possibly the greatest shortcoming I have as a parent is one that extends to other areas of my life. I find it very hard to show anger. So, occasionally, anger remains bottled up. However, I'm working on this. Stored anger doesn't keep very well and often it will reappear over a more trivial but related subject. It's desperately important that children see and understand their parents' anger, and it's also important that the parent learn, in that anger, to explain its causes and the feelings involved. Children have to learn that they can both hurt and disappoint their parents. And they must learn to listen and answer back and forgive.

Often, I think, none of us is alert enough to the sort of pettiness, vanity, and inflation that goes with being human. Unless we can distinguish the part of our anger that is truly our own, belongs to us and no one else, from the part that belongs to someone else, we haven't advanced much beyond the tantrum. For anger to work it has to be fleeting, accurate and full of passion.

Too often anger is a result of expectations that have

not been clearly expressed. We have to tell our children what we expect for them to know it. I am always deeply moved when I see a child or an adult who can't say what he wants or needs. Having come full circle, that again is a question of the frame of reference we've been provided with. We all need to feel strong and free enough to say, I'm cold, I'm hungry, I'm angry, I need love.

That is something I'm still learning.

Gloria with her son, Chris, 1960. Photo by Sidney Lumet.

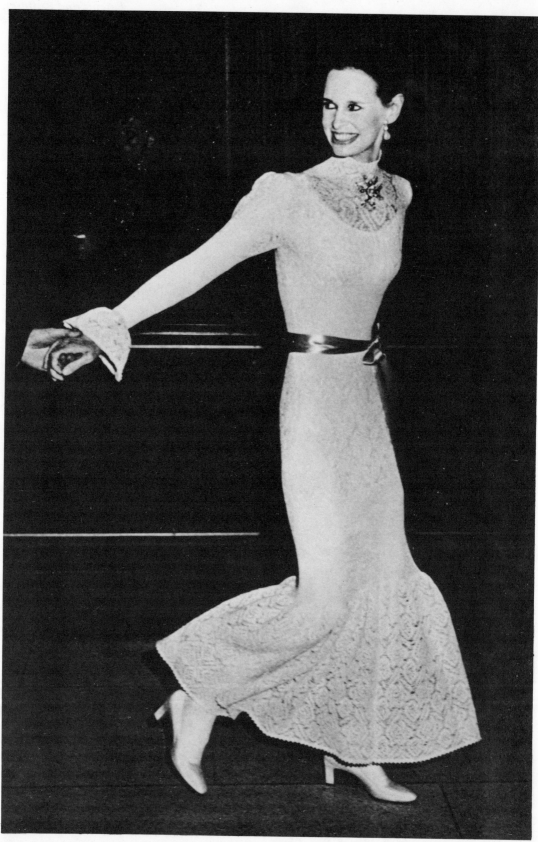

Gloria returns Wyatt Cooper's smile at a Broadway opening. Photo by Ron Gallela.

20
Men and Women

WHEN I LOOK BACK, I find that no area of my experience has been more transformed than the relations between men and women. I am not speaking of slight alterations or minor shifts in roles, but rather of major transformations in how we think about one another and how we live together. Women's liberation is only one manifestation of this. The change is profound, irrevocable, and, for me at least, exhilarating beyond belief.

Most of my early life, as I have mentioned before, was spent in a world virtually without men. Also, my grandmother Morgan, who dominated all of our lives, looked upon most men as powerful manipulators. So my personal experience is unusual. In any case, as a result, in direct opposition to my grandmother's hostility to men, I idealized and romanticized them, perhaps even more than my contemporaries did. I eagerly read every book and saw every movie hoping to learn more about these mysterious strangers. My grandmother would often say about herself, "If only I had been a man!" It was stated with such authority I never dared question it. But I thought about it alot and for a long time it shaped many of my feelings. It was no doubt why for a great part of my life, I felt a compelling longing to merge totally with a man; I hoped that would give me a sense of completion. Being a woman, I must somehow be inferior. After all, my grandmother had said so! I felt that perhaps a man would supply what I lacked. Now, I understand that the best relation-

ship is between two people who feel complete in themselves, who recognize and appreciate their uniqueness, their essential aloneness. What men and women need from one another is a celebration of fullness. Each gives to the other out of this. That's what makes life joyous.

For my generation, seduction and flirtation were the means of gaining a man's attention. From the cradle, women were taught they were inferior, and therefore second-class citizens. Now, men and women can meet in a totally free way without the deception and manipulation of flirtation. In most instances, I believe that women set the tone of their relationships with men. Some women are at ease with themselves and do not need the ploys of seduction and flirtation, while other women cling to them. For me, flirtation and seduction are icing on the cake. They come after the ground rules have been established. Even ten years ago, you were expected to begin with the game of flirtation. It was all for the man. The woman didn't seem to mean enough to herself.

Back then, relationships between very young men and women too often started out from point zero. The wedding vows were like saying, "I pledge you all of my nothing, nothing self." The woman fantasized the man into an impossible ideal; sometimes she thought, if that man wants to be with me, that makes me something special. And by the same token, out of our feelings of inferiority we sometimes wondered, what is wrong with him if he thinks I'm so special?

The whole idea of love was an exploitation of women's sense of inadequacy. Falling in love was a kind of obsession. It was so tremendously important because it meant salvation from the most narrow definition of life. I think love can be more real today because it is based in everyday reality.

Also, we need to be much clearer about the kind of devastating obsessions that love sometimes can bring. And, of course, we are often unrealistic in supposing that falling in love is all bells and fireworks and only that. There are all sorts of other involvements, some of which, when it's right, even last beyond the first electricity. When we feel that intensely, we want it to go on forever. We forget that there is a tomorrow. I'm all for

moonlight and roses, but what's really lovely is experiencing not only those feelings, but also a sense of the future, a future of experiencing a life together based on the individual truth of yourselves and respect for it.

It's impossible really, to talk about the subject of men and women with any sort of specificity because what each of us is looking for in relationships is so very different. But I do believe that there is a new openness possible in all sorts of relationships between men and women. I am certain from my own experience that women have to be willing to come more than halfway in reassuring men, because women have both the intuition and the sensitivity to recognize the problems before they become apparent. Women have to listen carefully to their own attitudes about men. Catch phrases such as, "All men are little boys," or "Men are like that," are full of disrespect and even contempt. Women and men have to avoid feelings of dependency and overlook the childlike need that often crops up between them. I like a certain component of femininity in the men I'm close to. It means that I accept my own vulnerability, and find a corresponding need in a man.

I've tried, as much as I'm able, to communicate some of these ideas to my sons. I hope they will wait a long time before they get married, and, by a long time, I mean until their middle or late thirties. I hope they will experience everything that they feel drawn to. I also hope they will have the confidence to be secure enough within themselves not to marry, necessarily, the first person they fall in love with.

I want them to marry if they have come to that decision deeply inside themselves, with no doubts. Then, they'll have marriages that are real because their hearts will be totally in it. I believe that often marriage at a young age leaves a feeling that there were unexplored possibilities that have now been closed off. I'm not speaking only of sexual experience—I see men and women who would have been much happier if in their formative years their work had taken precedence over romance. But, because of our spontaneous feelings (thank heaven) this is impossible, more so than not. The quest of one's twenties might prove more fulfilling if the quest was to discover one's talent, future work, and how to apply it to living in the world. Speaking for

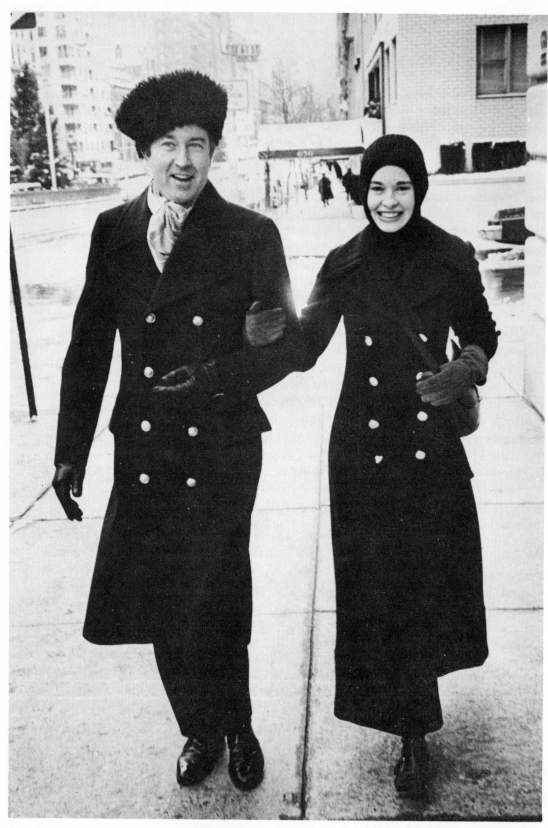

Wyatt and Gloria. <u>New York Post</u> *photograph by McCarten © 1968 by*
The New York Post Corporation.

myself, I wish I had had more opportunity to experience, in my early twenties, a less emotionally pressured life so that I would have had time to discover the center of myself sooner and the direction in which that center might grow.

I believe in taking marriage very seriously indeed. For that reason, I believe in total fidelity. Only when two people can totally trust one another can there be real openness. And sex, if it's wonderful, continues and grows. The quality increases.

I regret that we have sometimes poisoned the idea of marriage by not taking it seriously enough, and by making jokes about fidelity and trust. I think that the television situation comedy has done much to devalue the relationship between men and women. But I realize that the commitment to a marriage is only as strong as the man and woman who make it.

For that reason, when I think of my children and marriage, I have to consider what will make them more realized and whole as persons. I would like for them to be secure enough so that relationships do not become props. I would like for them to have a sense of belonging, so they may carry love with them wherever they go. I would like for them to have a sense of trust in themselves so that they may value themselves without seeking superficial approval and recognition. I want them to develop whatever talents they have for themselves so they become answerable to themselves.

I realize as I list these qualities that they are the same that I learned to value in my husband Wyatt Cooper.

There are men who still remain a total mystery to me, they seem so radically different from women. Time and again, I realize I simply don't understand them because my responses can be so different. Take color, for example. Men don't seem to me to have the same color sense as a woman. They gravitate toward shades that look to my eye like muddy colors. If I were to pick out a tie for a man, I would be certain to choose the right one by selecting the one I didn't like! To me most men don't have the same sense of form as women. When a man is trying on a suit, he isn't likely to look at the details or the texture of the fabric or even the intricacies of the tailoring. He looks at the silhouette.

Men seem to me to have a different sense of grada-
tion and intuition. Very often men will define "intui-
tion" as how a woman indulges her whims. It fascinates
me to hear a woman say that she would trust a man
before a woman. This is especially true in Europe,
where women seem much more competitive with each
other than they are here. There are, of course, excep-
tions, but as for me, generally speaking I would trust a
woman more than a man, for the simple reason that she
and I are related in a way not possible between a man
and a woman.

One of the greatest conflicts for me between femi-
nine and masculine values is the question of order. It is
rare to find a man who has the sense of order or detail
that usually comes naturally to a woman. If I weren't
careful I could find myself constantly reminding my
sons to pick up after themselves because I don't want
them to get the feeling that there will always be a
woman to pick up the towels from the bathroom floor.
I'm not speaking about tidiness or cleanliness but a
sense of order that fills a house with a feeling of seren-
ity. Men appreciate it when a woman creates this atmo-
sphere, but many don't seem in tune with the time,
thought and effort that go into achieving the tranquil-
lity that results from having the world put in order. If
you see an ordered desk in some executive's office,
more than likely there is a secretary who put it that
way.

The answer, then, for women is loyalty to self. The
more we value ourselves, the more we will be valued.
We all must learn that involvement is a mutual matter.
The more independent our lives are, the fuller our
relationships will be.

I do believe that premarital sex can be constructive if
it is part of a supportive relationship. Sex is a vital link
to reality, to other people and to one's sense of oneself.
People should be open to whatever experiences are
necessary to gain a sense of themselves and a maturity
of feeling.

21
Alone

WHAT OTHER SUBJECT IS AS FORBIDDEN, as misunderstood, as loneliness? Even the word can open an abyss of terror in conversation. Many subjects once taboo can now be spoken of, but loneliness is still too much at the core of our experience to be acceptable. Nothing seems to change it—money, success, love. It is the one unalterable fact of existence. Only now have I begun to accept it and to respect the freedom it brings with it. I have found loneliness everywhere. It is one of the unshared secrets of our lives. We seek love and accept security instead. For recognition and friendship, we relinquish our dreams and our souls. When I finally faced loneliness, I began to be my own woman.

I found that loneliness doesn't have to tear and gnaw. It can give strength and bring vitality. It can be the bracing wind from a window opened in a stuffy room.

What each of us makes of our loneliness is the individual stamp of our destiny. There each of us is most individual. Some people wear loneliness as if it were a noose. Others seize it and make of it a great happiness.

But loneliness does not remain the same. We develop our own defenses against it, to pretend it isn't really there. We may feel desperate, but we learn to cover it up. And when loneliness suddenly reappears, we are astonished, thinking we had buried it. That self-deception, whether it works or doesn't, is always with us. It is a mark that just barely conceals our need.

I remember when Dody was taken away from me by

Gloria with Dody in 1927.

the New York courts. I felt as if the loss and pain would never end. As I got older I discovered that I lived those feelings again and again. Then, I understood that opening yourself to love always meant the possibility of opening yourself to pain. But it doesn't necessarily have to turn out that way, so it's worth the risk.

I sometimes think we are too often trapped in those absolute feelings of childhood. Love, then, is the merger with something stronger, more secure than ourselves. We feel that love is either all or nothing. If we get angry, we feel so guilty that we turn it on ourselves. Love is so wonderful and all-giving that it doesn't allow for anger. But I have come to see that anger is often a way to show love; those who can express anger can love more profoundly because they aren't content to keep up appearances. They understand that hate and anger are not the same thing. They are no longer children.

I think that strength of belief comes from knowing and understanding yourself and your uniqueness. I always felt incomplete because I sensed my mother felt incomplete. She felt incomplete because her mother felt incomplete, and so on. That chain of dissatisfaction is endless. If only we had learned to look within ourselves for satisfaction, how different the courses of our lives might have been! That is the greatest legacy a mother can give her child: a sense of trusting herself.

Romantic love is so much caught up in the idea of incompleteness. We are always looking for someone else to fill in what we lack, to deliver us from loneliness. Much of loneliness is the longing for something or someone more powerful to surrender oneself to. But that, of course, is the wish of the masochist. The moment we begin to recognize that we are not separate, we have begun to solve the struggle between our helplessness and our desire for independence. We don't need anyone. We need to master ourselves.

Falling in love is often a substitute for love itself. The battle of the sexes is a diversion. We're more interested in the violins and champagne than in the feelings they evoke. Romantics seem to adore the excitement of the pursuit more than the emotions that result from the pursuit. Love takes real effort.

But romance is taking love lightly. If we face our

loneliness, we suddenly recognize that we don't need to be diverted and that a few words of truth are worth more than a record album's worth of love songs. Romance has its own format. Love means following a relationship along its unique course. There are no rules. Loving means learning the special language and emotions of a unique relationship that has never existed for you before and may never exist again. It means being able to be selfish or foolish or honest in ways which embarrassed you before. And it means being willing to make mistakes, lots of mistakes.

But most important, it means coming to know that all of our needs arise from childhood—memory again, the touchstone of this book. We have to be patient with ourselves to sort out what *was* and what *is* meaningful to us. In that way, romance keeps pulling us back into the old ways of feeling when it was "Big You" and "Little Me." Only when we break our need for parents and security in love do we begin to live and love on our own—and not to be lonely.

The test of this freedom is how we change our attitudes toward sex. Sex can obliterate who we are or it can be an affirmation of our uniqueness. Sex without a realization of self-worth is inevitably a form of rape. Men value us because we value ourselves. Men recognize our uniqueness because we recognize it. Men love us because we first love ourselves.

That sense of self makes a great many issues much clearer. It makes sex a part of love and not the only form of intimacy one can allow. It makes it possible to find one's way out of solitude without going to bed. It makes it possible to be free to stay or free to go. No one is trapped.

I feel that many of us don't take enough advantage of being alone. Solitude is treated as if it were something to be gotten through as quickly as possible. I've learned to prize the moments when I am free, alone. I'm always storing up treats—a bubble bath or a special record. I make a point when I'm alone not to rush through meals or take shortcuts. I reward myself with special presents when I've stuck to my diet or gotten through a difficult job more quickly than I had planned. I try to put as much interest and enthusiasm into my room as the rest of the apartment because I spend so

much time there. I find my time alone a luxury. We fear being alone because it's one of the rare moments when we confront ourselves.

Women have told me they feel helpless without their husband or children. They can't eat unless they're with their family. They will fix special dishes only if they can share them. Or they'll sacrifice the decor of their bedroom because they feel it's selfish to indulge themselves. All of these attitudes are danger signals I feel we should be alert to. What will these women do when their children are grown? What are they to do if they are widowed or if their life changes and the husband travels? And what of divorce? We must all learn to live with and appreciate solitude.

I am most disturbed by people who turn themselves off because they cannot face loneliness and the freedom that can result from it. Enthusiasm and curiosity are absolutely necessary to stay alive. What is interesting and important is the world out there. For that reason, staying alive in the best sense of the word is staying alive to the world. When I see a face that is deadened and eyes that have been deadened, I know that this is a person who is afraid to face being alive and being alone. Joy has to be the one most important goal we have.

All of us have the capacity for joy. But it means that we must be open not just to pain or pleasure but to both. We begin to limit ourselves when we don't find ways to express all of our emotions. We make a mistake when we try to live only by good manners and not with our hearts.

When we begin to live by the rules, we may often feel that our life is living us. That is why I'm so firmly convinced that a major part of maturity is to find more and more ways to invest ourselves in the world. We can only truly exist when we have found some objective means of expression. That, of course, has little to do with behaving ourselves or obeying the rules or even keeping a stiff upper lip.

I know from my own life that these changes are hard to make. Women have to learn to listen to even the

faintest stirrings of our inner lives. We have to take the time and the patience to let ourselves develop at every point in our lives. And we have to understand that at no point are we finished. We are never complete.

We make a big mistake as young mothers when we don't arrange for more time for ourselves. Of course, we are learning to be mothers and each experience is a new and special one. But I am also certain that we are also avoiding being alone in our business. We don't want to encounter the torrent of questions that might come flooding in. In escaping that important encounter, we cheat ourselves and our children. Then, even that glimpse of loneliness is quickly lost, forgotten, to be revived later.

How do we begin to accept ourselves as we are? That is a question of patience, time, work. No one else has the answer to our loneliness. I cannot lose myself no matter how much I may want to. What we must do is avail ourselves of the fulfillment that is already waiting within us. We must stop living in the future and start living with the past, and in the present. We must find in our work, our dreams, our homes, our memories, the deeper and fuller realization of our selves.

Through my work, I have learned the extraordinary power of doing nothing—of sitting still, listening, and communicating with the truth of myself. It is in these moments that we stretch and grow. I now know more about the difference between emptiness and imagination.

I am no longer frightened by the word loneliness. I think of Katherine Mansfield's first husband, who scratched out the word "lonely" in one of her early poems and substituted the word "solitary."

I *am* alone. I have learned to welcome change and the unexpected. I invite the contradictory, challenge the suffering and self-pity that are part of loneliness. I want to survive. I want to beat the pain. I want to know others who can face loneliness. I want the silence of being alone with another.

How right was the poet who said that anyone who is original is also experimental. That is the task that loneliness imposes on us.

Part V

SHARING PEOPLE, PARTIES, AND PLEASURES

The contented cat who appears in many of Gloria's drawings and designs.

22
Parties and People

A PARTY IS A SPECIAL OCCASION FOR ME. Whether it's lunch for two or dinner for twelve, I hope to express as much of myself as I can. A party is really a gift you present to your friends. Each time I am with someone I want them to share that feeling as well. I hope to give them something—something special, pretty, and a part of me.

A party says, "Here I am and I want you to be here with me." A party is suddenly rising to embrace the moment. It is a joyous exposure of your life, thoughts, food, house, and decor. It's opening yourself up in the most expansive and loving of gestures. As Carol Matthau said to me when I asked her how she gives her special and unique parties, "It's as though you stopped hiding for a few minutes."

The main ingredient of a party is, of course, people. And I don't mean people in general but friends with whom you've learned to share. A party for me is sensual—the scent, the feel, the look, the sound. Flowers and candles are as important to a party as food and liquor, but it takes special friends to make it all work.

I don't give business parties. The people I invite to my house are people I want to see. Nothing destroys the spirit of a party more than a guest who is not truly welcome. Also, nothing is more deadly than someone who comes only to watch and see things critically. They seem to say, "*Make* me have a good time." People who are not socially generous don't belong at a party.

Carol Matthau told me she would never ask anyone to a party to repay an obligation or "give a party to pay back everyone I know." Her solution, she said, was "to send a lot of flowers." The most important parties are the ones I share with my family.

A recent one took place last March when Anderson, Carter, and I were walking on the beach. We were playing tag with the waves along the shoreline. Anderson suddenly reached down and started writing in the sand. "Mom is—" Unexpectedly a wave crashed over erasing the words. We all got our feet wet and ran on laughing. "What were you going to write after, 'Mom is—?'" I asked Anderson. "Great," he said, giving me a hug. I'll remember and cherish that beach party forever.

And parties at Christmas continue to be special. It is a lovely feeling to have everyone gathered around the apartment filled with Christmas smells, and the laughter and enjoyment that only come when things have been shared comfortably and intimately for years. I want the rooms and the table to sparkle and glisten. I try to put something on the menu that each of us likes and bring out the Christmas treasures to hang on our tree, tying past memories and present, all the years together. And although it may not be spoken, I love the surge of pride and reflection that comes at such a moment. Look, we're here together—loved and warm and close to one another.

That is the best party for me. Any other party can only approximate it. And every other occasion radiates out from those family parties. That is why I prefer a lunch with a friend to a roomful of people. I want to be able to talk and think, react and communicate. I want the food to be delicious and the conversation full of thought. I want there to be wine, and a table that is a magical land that transports us far, far away.

There are certain parties that live on in my mind. They seem few but they linger because of the people whose memories they include. And, not surprisingly, they are not all parties we've given.

Ten Gracie Square was a terrific place for parties, as I mentioned before. The large living room with a piano in front of one window, candles inside and out, the

reflected lights of river and city. There were small parties at 10 Gracie when Harold Arlen would play and sing his haunting music—"Stormy Weather," "Come Rain or Come Shine," or later, as the evening became quiet, "Over the Rainbow."

There were large parties, a special one when Marilyn Monroe stood on the terrace looking out over the river, talking to Dick Avedon. Artist John Groth had arrived at the party and, hearing Marilyn was there, he casually wandered out to catch a glimpse of her. He returned shaking his head. "That's not Marilyn," he said· with conviction. What he had seen was a girl wearing a baggy army sweater and plaid skirt, leaning against the railing, devoid of make-up except for a touch of Vaseline on her eyelids. "Why, she doesn't even look like her!"

Later, when she came into the room filled with people, John realized it was indeed Marilyn. From across the room she sensed, without a word spoken, his admiration. She reached out her hand and gravitated towards him as though pulled toward the sun. When she reached him she touched his shoulder as though warmed by it.

Jule Styne was settled at the piano sharing his *joie de vivre*, energy, and spirit. If there is a piano in a room Jule immediately goes to it, bringing it alive with his fabulous hits. Now Sammy Davis had joined him and was singing, and a circle had formed around them. As the applause followed the song I found Marilyn looking at me hesitantly. "Do you think I could, I mean, would it be all right, do you think Jule would mind if I sang "Diamonds Are a Girl's Best Friend"?

We went up to Jule together, and, after a few whispered moments between them, she started singing. She never seemed more touching than when midway through the song she forgot the lyrics and looked beseechingly at Jule to prompt her. Marilyn was capable of a luminous beauty, and I think it is tragic that her inner demons prevented her from finding fulfillment in her life.

One party we gave at 10 Gracie Square was called a "Mystery Lunch." Invited were Carol Matthau, Babe Paley, Slim Keith, and Cecil Beaton. Each one was asked to invite a "mystery guest" whose identity no

one except the person who had invited him would know until the guests arrived. The party day dawned, and it must have been February, as I remember taking great care arranging the ranunculas—one of my favorite flowers—usually only available during that month.

Carol was the first to arrive and her mystery guest was Kenneth Tynan. Soon after came Babe and Ben Hecht and Cecil with Phil Silvers. My mystery guest: Bill Paley. And last Slim, with Elizabeth Taylor. Shorter than I had imagined her, violet eyes more beautiful than any photograph, outgoing and friendly, she introduced herself: "Hello, I'm Elizabeth Fisher."

A mystery lunch or dinner is a wonderful way of capturing the spirit of surprise which adds so much to any party. One could give mystery parties for friends who are unexpectedly in town or ones who haven't seen each other in a long time.

I have mixed feelings about going back to places where I've lived, never having succeeded in doing it except to my Aunt Gertrude's house at Westbury. Perhaps a certain amount of time has to go by for the filtering of memories. We were recently invited to a party at 10 Gracie Square by its present owner. Somehow I couldn't bring myself to go, for somewhere in memory the laughter, gaiety, and magic of other parties held there were still too strong. It would have been rather like shattering a kaleidoscope.

Gloria's remembrance in fabric of the festive days of Faraway.

There were evenings with Carl and Fania Van Vechten. Carlo, as all his friends called him, successful in many of the arts, was a close friend of the people who made up the modern movement in theatre, art, and letters, spanning decades. He and his wife, actress, Fania Marinoff, lived mostly in New York but he was always involved in and part of the world at large.

The Van Vechtens' apartment, in the West Side's San Remo building, had an extraordinary view of Central Park and was filled with mementos of their full and varied lives. Carlo and Fania loved giving little dinners for not more than eight, for which they transformed the library (with its walls of books, including first editions of his prolific career as a writer), by means of an expanding table, into a dining room. Both took great care in planning the menu and often, when calling Fania

the next day to thank her for the evening, I would beg a recipe from her, which she was most generous in sharing.

Paintings from friends graced the walls. The Florine Stettheimer portrait of Carlo was a portrait of a life, really, as it showed him sitting in his crimson-walled studio, transformed by her imagination but identified with his true preoccupations: writing, cats, cooking (he wears the Cordon Bleu) a shrine to his wife Fania Marinoff, whose name is seen in Broadway lights out the window, and a piano suggesting his role as a music critic. (Florine Stettheimer signed the painting with her full name on the keys of the typewriter.) Van Vechten's name is woven into the floral rug. In the room where he took his photographs (which included an impressive collection of photographs of practically every important talent of his time taken over the years, and which now belongs, as does his voluminous correspondence, to the Yale Library), hung his recent portrait painted by Richard Banks. Fania and Carlo were masters in the art of living. They both had the capacity to be loyal and devoted friends.

Gloria's fabric design "Mosaic."

I miss Carlo's often daily letters, sometimes only a jotting down of a spontaneous moment of thought or feeling, always arriving with large stamps which he took great care in selecting and which often related to the contents of his letters. For example, on the envelope of a letter about Willa Cather would be a Cather stamp, on another, Eugene O'Neill. And postcards would arrive. Perhaps a photograph of a room in Venice, Fortuny fabric spilling over a round table, Venetian glass carafes, and spun-glass griffins holding goblets of wondrous delicacy, light filtering through checked panes of glass, and outside a city of dreams. "The room," Carlo would write on the back, "where we would sip Strega with Mabel Dodge of an evening after dinner."

I particularly remember an evening when the Van Vechtens welcomed Baroness Blixen to America. As Isak Dinesen, she was the author of books fabulous in their fairy tale quality, not only about her life in Africa, but others, including *Winter's Tales.* For years, the baroness and Carlo had corresponded but had never met. There were many parties given for her during her

first visit to America, including one at my house, but none was as memorable as Fania and Carlo's. Red roses, squashy and full-blown as in a Fantan Latour painting, were gathered into a bouquet as though just picked in a garden, circled with white velvet ribbon, and placed on the front door. Under this, a poem of greeting, written by Carlo on a parchment scroll. Inside, a much larger group than usual, as befitted the occasion, gathered to give homage to this most special guest.

The baroness was ensconced in a low emerald-green slipper chair, centered between the two windows looking out onto the park. Folds and folds of black chiffon cascaded over her unbelievably fragile, ancient frame. Her huge eyes were luminous and ringed with kohl. One was fearful of approaching her. Ceremoniously, each guest was presented to her. She talked animatedly, and once one was actually conversing with her, any apprehension one may have felt dropped away completely. Placed beside her was a low Chinese black lacquer table, enameled with gold dragons; it held a Bristol blue plate piled with black grapes, a tulip-shaped goblet of champagne, and a bowl filled with cracked ice holding oysters, the staples of her diet.

Years later, just before Fania Van Vechten died she asked me to come and see her. She wanted to give me a Spanish cross made of tiny trembling shells, strung together by almost unseen wires, and the pair of tables with their painted Italian scenes, romantic and fanciful. I had always admired them because they were an essence of the Van Vechtens' taste and style and, of course, now I appreciate having them as part of my everyday life, because they belonged to such dear friends.

The party we gave in our house on Sixty-seventh Street for Oona and Charles Chaplin was memorable for all of us. The Chaplins were returning to America after an absence of many years, as Sir Charles was to receive not only a special Academy Award in Hollywood but to attend another gala at Lincoln Center in New York, planned to honor him.

Everybody wanted to come, and we ended up with sixty-six guests. We tried to have as many friends of

Anderson Cooper welcomes Sir Charles Chaplin at the reception given for him and Lady Chaplin at 45 East 67th Street, April 4, 1972. Photo by Larry Morris, The New York Times.

Oona and Charlie's as possible, and there was a tender moment when a very fragile Charlie touched Lillian Gish's cheek with affectionate fingers and said, "Lillian, I'd know that face anywhere."

We invited the guests for seven o'clock. To welcome them, we put pots of blue and lavender hydrangeas on either side of the marble steps in the front hall. Around the fountain were massed smaller pots of hyacinths and narcissus. The house looked its best, with an air of something lovely about to happen. Carter and Anderson, dressed in their party-best black velvet suits with white ruffled blouses, were the first to greet our honored guests. In the dining room round tables seating eight were covered with ruby red cloths, crystal and silver candelabra set around flowered centerpieces of white, pink, and red carnations. Upstairs in the library was another large table seating ten.

Wyatt claimed to have no interest in party menus or decor, but his interest was in working on the seating, which he saw as like writing a novel. He also liked making speeches when the occasion was right, and in his toast to Oona and Charlie he said: "I don't suppose anybody's wondering why we've asked you all here tonight."

"Charlie has given the world more laughter than any man who ever lived. Not only has he made us laugh and cry but he has shown us something of what we are. He speaks a universal language and anywhere in the world is his home. . . ."

23
And More Parties

IMAGINE A HOUSE OF CERULEAN BLUE set on a road high above the sea. Secret and special, because from its exterior you have no idea that behind the house there's a sweep of lawn extending to a rose garden which seems to circle the Pacific far beyond. Imagine the interior of this house filled with flowers, covering chairs, sofas, and sometimes the carpets as well. All in delicious colors such as apricot, lavender, apple green, and geranium. Bowls of cinnamon-scented potpourri, and, sometimes, vanilla candles burning. Each table filled with objects and photographs to surprise and delight the eye. Music coming from somewhere. And overall prevails the spirit of love, home, and fires burning on chilly nights. This is only a small part of the magic of the house created by Carol and Walter Matthau. And this is the house that celebrated the arrival of the Chaplins on the West Coast.

It was a lunch party, and because there were so many people Oona and Charlie wanted to see, there were ninety or so guests in all; everyone arrived promptly on the dot of twelve. Not only on time but dressed up—most unusual for casual daytime California. The round lawn tables, many umbrellaed, were covered with scalloped Porthault cloths and sprinkled with peach- and lemon-colored blossoms. On each table were pots of white hyacinths. As Walter looked out over the scene in their garden where so many recognizable Hollywood legends mingled, he said it was like looking "at a very old tintype." Just then, a flotilla of sailboats came into

view and someone jokingly asked Carol how much she had paid to have them arrive at this perfect moment.

That same day there was a rehearsal for the awards ceremony at the Academy of Motion Picture Arts and Sciences, and people left after lunch and then came back. The Chaplins left at six, but everyone else was having such a good time, they stayed on. The Matthaus had asked a wide range of people, and since so many stayed on, Carol served another meal at twelve, and the party went on until 3 or 4 A.M.! (Carol feels that the little touches made the party. Theodore, the caterer, rented flowered English china, rather than the usual white china with gold rims, to set off the Porthault tablecloths. Because Oona and Charlie love wine, Carol served only California wines to show off American vineyards, to the Chaplins' great approval.)

Security for the lunch was very important and Carol had hired Pinkerton guards to look after it. One very odd character seemed quite suspect and the guards asked Carol who he was. She couldn't place the face either so the Pinkerton men went up to him. The man, it turned out, was Charlie's own security guard.

I'll never outgrow the magic of being with the people I most admire. One Sunday, just as Lynn Fontanne and Alfred Lunt were selling their house in New York to live permanently in Genesee Depot, Wisconsin, Paula Lawrence and Charles Bowden brought them to dinner to our house on Sixty-seventh Street. Wyatt's toast gives you a feeling of the occasion: "When we sat watching you, we knew that we were in the presence of the truly exalted. We were in the presence of beauty and brilliance, of grace and genius; you showed us something of the best that a mere man or woman could aspire to. No one will ever do that again. No one will ever dare even to try."

In retrospect, the memories of the food and wine and candles seem to melt away and only the glow of the faces and wonderful talk remains. Wyatt wrote about a party we gave for Dorothy Parker:

"After a snowstorm prevented Dorothy Parker from coming to our house for dinner, my wife suggested we give a party for her and ask people she'd like to see— some she knew, some she'd like to meet, some she'd

enjoy looking at, and some she'd enjoy talking to. . . . Dottie followed all developments joyfully, but about a week before, she suddenly said, 'You know I can't go there with Mrs. Paley and all those people. What in God's name would I wear?' It is true she had no clothes. "Gloria had always wanted to see Dottie in some kind of Chinese robe, delicately embroidered and elegant, and when, a few months before this, Gloria started wearing kaftans as maternity dresses, she often expressed the desire to have one made for Dottie. Having no measurements to go by, she had it made in size three, of yellow brocade with gold trim encrusted with little pearls. I took it over to Dottie, and she sat looking at it and touching it. . . . She went into the bedroom to try it on, and emerged after a long time to say that she didn't know how to get into it. I put it on the floor, and, as one would in dressing a child, I lifted her feet to place them inside the dress, pulled it up, and fastened it around her. The stand-up collar, the soft color, and the rich material emphasized the essential femininity of her face. She stood looking at herself in the mirror and she was transformed. It was as if for a long time she had been unaware of her beauty, and suddenly she could see what she had forgotten. The dress was too long by at least six inches. I offered to have someone come in to shorten it. 'No,' she said immediately, 'I want it long. Then I have to lift it, like this. . . .' She pulled herself tall, and with one hand raised her skirt like an Edwardian lady about to step into her carriage. 'I want to have that haughty look,' she said, which she had."

"Gloria Steinem and Herb Sargent brought her to the party, and she entered the room trembling but looking magnificent, like the last dowager empress of China, a creature frail and exquisite but a power not to be tampered with, a lady of grace and modesty but well aware of her own value. She was not unlike a great actress who may have been away for a while, but who knows her audience is still waiting for this appearance, and she's going to make it a triumphant one.

"I saw Mrs. Paley catch her husband's arm. 'Bill,' she said quietly, but with some awe in her voice, 'do you know who that is?' and Mr. Paley went over to sit beside Dottie and talk of previous meetings. Others

came to her, and she was unfailingly gracious and charming and impressive. The evening had a certain amount of glitter; everybody looked just right, and Dottie's eyes took in every detail of the women's clothes, jewelry, and hairdos; each item was tucked away in her mind to be produced at will later on."

Dinner at Dolly and Albert Hirschfeld's house is always looked forward to. They plan their parties well ahead. Dolly opens the door and one feels the warmth of hospitality from that moment on. Climbing upstairs to the second-floor living room, one is welcomed by the sound of relaxed talk among friends. The lighting throughout the house is subdued and seems to come indirectly from unseen sources. Around a low round coffee table holding a platter of canapés, there are cozy chairs to sink into. No guest has to stand if he doesn't want to, since there is no such thing as an uncomfortable chair or sofa to sit on at the Hirschfelds'. Al mixes the drinks, and in spring and summer he might present Pimm's in frosty pewter mugs with stirrers made of icy cucumber sticks.

The dining room is on the first floor. In winter, there is only a pane of glass between the inside warmth and the fantasy of a New York winter's snow covering trees and garden. In summer, doors are open wide and drinks are enjoyed in the garden before dinner.

The expanding dining table with its candles and decorations imaginatively arranged by Dolly varies with each occasion. Candles and flowers are placed low so that they never block conversation. This makes communication possible among a table of twelve or fourteen. Usually with this number, groups of two talk to one another throughout dinner. Each dining room chair encourages comfort and often guests linger for hours at the table after dinner is over, held by the atmosphere of shared friendship.

To spend an evening at the Hirschfelds' is to be included in the aura of warmth and love they have extended both towards one another and towards their friends. To be with Dolly Haas Hirschfeld and Albert Hirschfeld always gives me a sense of continuity and stability. The years seem not to touch them. They look and are to me as beautiful and enduring as when I first

Al Hirschfeld's caricature of Gloria.

Bruce Cabot, Gloria Vanderbilt, Rita Hayworth, El Morocco, Autumn 1941. Gloria and Rita are wearing Howard Greer "tabletop dresses." Photo by Jerome Zerbe.

met them so many years ago. Surely two of the most civilized human beings that walk this earth.

One of the most glamorous occasions was a dance given by Isabel and Frederick Eberstadt. All their furniture and rugs were removed and stored in a van several days before the party. Then the entire apartment was draped, each room like a tent, with a bright print of varied flowers and leaves. It was totally unexpected to enter first the hall and hear a band playing and to see each room canopied as though it was a bower.

Round tables with printed cloths reaching to the floor were in each corner of the room. On top were terra cotta pots of geraniums with matching saucers used for ash trays. Two bands alternated so that the music never ceased and dancing continued until dawn. Each guest entering expressed delight and surprise at the magical atmosphere the Eberstadts had created. It was like a masquerade party with the interiors for costumes. One felt for a brief moment part of a wondrous and newly discovered country.

But other moments come to mind that are what Carol describes as "the realest parties." I recall the tea parties Carol and I had at my rented apartment in the River House long ago. We'd sit watching the fog and gloom roll in over the East River, listen to the Warsaw Concerto, and cry. And I remember walking down Lexington Avenue with Carol, eating candy apples and then coming home and having tea and laughing.

Also, I remember the lunches of soup and salad we had in my first studio on Fifty-third Street—a small room, but with a skylight and fireplace. The kitchen was in a closet. The floor was bare but one chair was covered in a white cotton print with strawberries on it. It added a touch of gaiety and that made the studio a perfect place for a party—even just for two.

Carol Matthau also reminded me of something that is absolutely essential to entertaining: always serve something that your guests won't get at home. Carol often asks people in at the last minute because Ray, her marvelous housekeeper, is doing something special such as bouillabaisse, fish stew with ingredients fresh from the fisherman's pier near her house. She ladles

the bouillabaisse out on oversize thin white china plates that are almost bowls. For dessert, there will be perhaps pineapple or lemon ice.

I also like her idea of serving a very simple meal and following it with four of five desserts. Carol loves to prepare desserts more than anything else and her crème chocolat, crème brûlée, and Devonshire cream are worth every calorie.

Living in New York one can get locked into a much more organized schedule than prevails in other parts of the country. Often spontaneously put-together evenings are the most fun. Some of our most successful evenings have been the most informal ones, such as serving meals on trays when we're watching something special on television.

I recall annual picnics we had on the roof at 10 Gracie Square with South African lobster tails grilled on the barbecue and September corn cobs roasted in foil.

The Matthaus give a television party on New Year's Day so Walter and his friends—without their wives—can watch the Super Bowls. Carol serves soup at noon and then more substantial food as the day wears on. "By the time the games are over," she once laughingly told me, "we've lost the house." For Walter's famous poker parties, Carol puts the food out on the table—hot dogs, pizzas, chili, and so on—in heated serving dishes so people can eat any time.

Of course, any party with a buffet seems to run almost on its own. Carol reminded me of a party we gave years ago for thirty or so people. Carol did the cooking and I said I'd do the drinks. The party was a great success and the buffet was going all night. All the people were laughing and dining and Carol was delighted. It could have gone on for days. When we were cleaning up, Carol said, "What a wonderful party. Everyone loved your martinis but there's not a drop of vermouth used. What's your secret?" "Straight gin with a drop of pernod," I had to answer.

24 Pleasures

THE REAL PLEASURES, FOR ME, are the minor ones, the everyday pleasures that make moments memorable—a fresh cake of soap when you first unwrap it, the sound of the ocean, anything that has been freshly laundered, then dried in the sun.

And then there are the rarer pleasures: a Frozen Hot Chocolate from Serendipity 3 restaurant in New York, swimming in a heated pool, a feather bed at the Vierjahreszeiten Hotel in Munich.

If I could, I'd have champagne and caviar often, not because they are luxuries but because they are two of my greatest pleasures. Except, of course, for making love, which is the greatest pleasure of all.

I also think of my beautiful friend Carol Matthau's house, created from her feelings of beauty and serenity, with every pleasure you can imagine, of sight and scent and touch. The gardens, with their view of the Pacific, seem to come into the house: potpourri, scented candles, and flowered fabrics surrounding you. And it's as if Carol had done it all just for you. On your bedside, a bowl of roses beside a wicker-covered carafe of iced spring water. Every place the eye rests there is something to delight and enchant. And throughout the house and gardens, a sense of permanence and continuity.

One of Gloria's pleasures in fabric—"Summer."

There are other pleasures in life that are purely personal—for some, sleeping as late as you like. An Elizabeth Arden pink paraffin bath to float in for twenty minutes—like a petal on some warm, embracing sea—

before the wax is peeled off. Having a pedicure. Your back rubbed when you're tired. Your favorite body lotion after a bubble bath. Drying your hair in the sun. The linen closet scented with lavender and in your drawers sachets of gardenia.

Then there is the pleasure of giving. Often, too little thought is given to this special grace. The last-minute Christmas panic of what to give has, at one time or another, possessed us all. It is especially true when seeking the perfect gift for the special person. If we don't find it, we panic and get pressured into buying either something too expensive or too conventional or perhaps both. The only way to avoid this is to rethink your pattern of giving. Consider it a year-round activity instead of just a seasonal event.

Start by making a list of all the people you love for whom you want to find the unique present. Beside each name list the occasions: birthday, Christmas, whatever. Mull it over and add below the person's name a description of your friend. It need not even be in sentences—just a word here and there that evokes the image you have in your mind of what your friend enjoys or reminds you of. Keep adding to it whenever the spirit moves you. As time goes buy, you will surely come across exactly what you have been looking for. You may find that out-of-print book your friend mentioned unexpectedly while traveling. Buy it in August and give it to her for her birthday in January. Collect special wrapping papers and cards as you find them. The wrapping is part of the gift and I have often received a present so beautifully wrapped that I wait days before opening it just to enjoy looking at it.

I will never forget, while appearing at a store in Sarasota, Florida, the gift which was brought to me by Mrs. Lucille Youngs, who until that moment was unknown to me. It was a ring carved from a single "turban" shell. Mrs. Youngs had all my fabrics in her home and from them knew my delight in shells and said that the ring reminded her of me. It is one of my favorite pieces of jewelry and I wear it almost everyday.

My cousin Esmé Hammond is a genius in the art and the pleasure of giving. She will give the serendipity gift. Perhaps a box of stationery that reminds her of me waiting at the table in the restaurant where we meet for

lunch. Or, waiting under the Christmas tree, a terrific belt with a buckle paved with colored rhinestones in the form of the American flag to wear with my jeans.

The perfect gift doesn't necessarily have to cost a lot of money. And, of course, the gift you make yourself always shows the love that went into it, and is perhaps the most special gift of all.

I connect European spas with those most personal luxuries. The bed turned down at night; the towel racks' heated pipes, so bath towels are warm. A single rose on the breakfast tray. The architecture vast, baroque, and splendid. Food unsurpassed, chairs soft, and, floating above, the shimmering of crystal chandeliers. At teatime, musicians appear playing Viennese music. Guests seeming to spring from the imagination of a Fellini fantasy. And over all a sense of unending time and leisure stretching before you.

One joyful aspect of all pleasure is the sensation of being transported. That is what travel is about for me—whether it's packing a small bag for a week or a fleet of suitcases for a month in Europe. All my senses are sharpened—every sight has new interest and each person seems a character from a novel. I relish trips that pull me back into the past—my past or the past of someone I love. Then, travel is the unraveling of some internal thread; perhaps the heart is where the maps of pleasure are stored, rolled up, waiting to be unfurled and followed.

But what is ever more wicked or sensual or mysterious than a hotel? A hotel can be a concentration of all the world's pleasures and luxuries into one place, so intense and alive that one's sense of expectancy is heightened. Only one hotel still seems to retain that intensity for me and that's the Ritz Hotel on the Place Vendôme in Paris. Nowhere else in the world can you find the gray-violet light of Paris, the twitter of the sparrows that begins even before dawn, or the look of Paris after snow—as if it had been dusted with sugar.

The Ritz seems unique because it has changed so little. There are still five hundred employees for only two hundred guests. I appreciate the feeling of serenity that pervades this place and the deep quiet on the Rue Cambon side of the hotel. Also the little touches that are scattered through the hotel—suite "F" for one per-

son only with its Louis XVI paneling. The interior garden is one of my favorite spots in the world and I love to see it sifted with snow in the winter with the filtered gray light reflected into the Louis XV lobby. And the bar just to the left of the entrance is a delightful place to meet people.

A hotel is special in that it has for me an atmosphere like that on an ocean liner. It's the same glamour and excitement we seek in restaurants and the theatre. It's also the sort of mystery and complexity that huge old houses have for me as well. That was certainly the feeling at William Randolph Hearst's San Simeon; at my Aunt Gertrude's house at 871 Fifth Avenue, certainly the most extravagant house I've ever experienced. I remember the feeling of suspense and mystery, playing games of hide and seek with my cousin Gerta among sheet-covered furnitured rooms on the unused upper floors. And later we might slide down the marble stairs that seemed to us like ski slopes, on tea trays filched from the butler's pantry.

Every house should have as many pleasures as possible, pleasures of color, light, view, scent, comfort, and touch. In fact, there are pleasures that every room can have in some profusion. Only a few touches can give a room real luxury and comfort. And I'm not thinking of major flourishes but of simple, thoughtful necessities that make it possible to settle down in a room and feel at home. As much care should be taken on bedrooms as on living rooms, since it is likely that more time will be spent there, and pleasure and comfort count for more in rooms that are constantly in use. It might give more pleasure to place a favorite treasure or work of art in a private room, for private enjoyment.

I feel the same way about china and silver. Why hide it away? I use my mother and father's silver and my grandmother Morgan's silver every day. I even found a use for my father's big silver trophy cups, as wine and champagne coolers for parties, or filled with tall branches of quince or dogwood. Even if you are watching your budget closely you can save to buy two place settings of the silver and china patterns you respond to the most. Or you can pick up odd pieces of silver at junk and antique stores—not at all expensive, as I learned when I put together a group of spoons that included two Apostle spoons.

Because of the hurried lives we lead, convenience is an indispensable part of pleasure. Careful attention to making the various levels in a room work brings rewarding results. And, for me, it is a luxury to have a wardrobe of stationery in various shapes, sizes and colors, including postcards, so that I can dash off a note or letter and have it convey some sense of my mood and feelings.

I'm so convinced of the importance of pleasures and the destructiveness of delaying joy that I'm not certain there are many luxuries that should be saved up for. I've discovered that if I really can't afford something, I shouldn't save up for it either! But there are certain pleasures that I make an exception for. One is perfume, since a really large bottle can do more to lift my spirts than almost anything else I can imagine. I think it's more than worthwhile to save up to give yourself a secret present, whatever your special pleasure might be. Everyone needs a reward and what better than an extravagance that is also a secret?

Some pleasures are almost irresistible—at least to dream about. In furs and jewels, sable to me is the most luxurious fur, with lynx second on my list. And what could be more luxurious than a sable-lined raincoat? You can buy these by my favorite form of osmosis, by fantasizing. You can own many things in this way without actually possessing them.

When I first became interested in jewelry I used to relate to the object itself as a thing of beauty in its color and design, isolating it from my own personality. I thought that if I liked it as an object it would necessarily follow that it would be becoming to wear. It was only years later, after visiting Cartier in Paris that my entire perspective changed. I had asked the salesman to show me some earrings from the cases to try on. He brought them out, but as he did so he said, "I don't think these are right for you, but let's try them on and see." He was absolutely right. They were as wrong for me as a particular dress might have been, even though I admired it as an object for its intrinsic beauty. He suggested another pair and they were absolutely right. From then on I looked at jewelry in a completely new way. It must relate to the person wearing it in the same way that a dress or other personal possession does.

One's sense of luxury has changed enormously in the

last ten years. Finally, we seem to have understood that the world is changing so rapidly and unalterably that we must do all we can to preserve the quality of life, the pleasures we value. We are much more aware of the pervasive importance and influence of ecology in our daily lives and the lives of our children and grandchildren.

But I am concerned that we also preserve an equally precious heritage that has been endangered by the effects of worldwide industrialization: and that is the heritage of hands.

The work of hands is the most extraordinary luxury we have left. Whether it produces a loaf of bread or a piece of pottery, the heritage of hands should be fostered and protected—otherwise it may die out. I feel that it is crucial that each of us do all we can to support the continuance of the oldest legacy of mankind's adventure on this planet—the ripe fruit of mankind's labors. Part of this is a question of the goods we buy and the craftsmen we celebrate. But deeper, I believe, it is the affirmation in our daily lives of the power and beauty of all that the hand touches.

Because of air travel, television, world business, we experience the world as a totality. Because the world shaped by hands is now on the wane, it seems to me that the old distinctions that once separated art from craft no longer apply. For the first time, in the past decade, patchwork quilts were shown in museums with the most advanced paintings. This revolution in our understanding of what art is was not just in terms of taste, or even what we considered beautiful. Rather, it was a re-evaluation of our experience.

No longer is the pleasure of art confined to museums or galleries or the moneyed few who can afford to be its patrons. Art belongs to all of us. Our eyes have been opened. I may not be able to afford a Bonnard painting but I may buy a Navajo basket or a Moroccan rug or a Vallauris pot. I share in the joy of all mankind in the shaping and making and doing—the joy we must sustain and affirm if it is to remain alive and strong.

25
Sharing People, Parties, and Pleasures

TO BE REMEMBERED AND LOVED, what else matters? That is the profound hope of art, the joy in living, and the promise of intimacy.

We are never alone if we are alive to ourselves. But we are never more vibrantly alive than when we are sharing, especially the riches of self. A conversation can be more rich, more varied, more exhilarating than a ten-course meal. A walk can have more excitement and energy than a party. A movie, a matinee, a concert, a gallery can open new windows on the world.

I am for cozy dinners, small parties, easy gatherings—tea in eggshell-thin cups, hand-kneaded bread, wine from carafes.

Entertaining, whether it is a tea-party or a dinner or something even more festive, is sharing. Thus, any moment you share with someone else, with ten or one hundred people, will sing if you approach it in the spirit of sharing. This is another reason why I believe strongly in steering clear of having people in to repay obligations. To make life expressive, particularly one's intimate life, I think one needs to dig a deep and wide moat of serenity around oneself, one's home and fam-

"Forget Me Not"—Gloria's motto for a fabric design.

ily; then concentrate on the moments and events you want to share with others. Your unique and individual style of entertaining will emerge. At times it is easy to lose sight of what entertaining is all about. We take the juice out of it. The essential ingredient of any gathering is the occasion. Occasion will have its own built-in theme, appropriate food and drink and guest list. Occasion will provide the reason for giving a party whether it's a picnic lunch or a wedding breakfast. Let the occasion give your entertaining its structure.

I say occasion because I've learned that the best parties are built around people. A guest of honor is someone you know and what he or she likes to eat and whom they like to see are the ready makings of something wonderful. That's why birthdays and anniversaries, especially the anniversaries of friendships, are terrific pretexts for getting together. Focus your party on someone.

The occasion will decide what sort of party you are giving. The guest of honor will help decide the guest list. If the guest of honor is five or fifty, be certain that the guests are people that she or he would choose. Don't impose a guest list or try to transform a family party into something else. Rely on the occasion.

Then make everything as easy for yourself as you can. Prepare food that you know that you do well and, even more important, food that you like and have had success with in the past. (At the back of the book, you'll find many of my favorite recipes that have evolved in response to the places I've lived.) Unless you've studied at Cordon Bleu, I'd stick to American cooking.

I'm always surprised at the amount of nostalgia people feel for the foods of their childhood. The power of memory, again. If you're transplanted—and most of us are these days—you may want to specialize in the cooking of the region you come from. Most cities have their cookbooks, and then there are good Junior League cookbooks that have done so much to conserve local specialities. To each meal, I try to add something special and unexpected such as Nora's Chili Cornbread (see page 298).

If you plan carefully, you won't be spending most of your time in the kitchen. I try to serve the first course with drinks—perhaps a shrimp cocktail with my own

Nora Marley who has been working with Gloria and her family for almost thirty years.

222

sauce presented on thin, flat seashells. This works particularly well if you skip the usual drinks and start out by serving a dry white wine, perhaps a California chablis or blanc-de-blanc.

Serving the main course can be simplified as well. If you're having a few people for lunch or dinner, you might arrange the food on a sideboard and let the guests help themselves. Or for a larger dinner party, you could serve the meat course on the guests' plates and pass the side dishes of vegetables. I like to toss the salad at the table as a second course or serve it along with the meal on salad plates.

I like to make something of the dessert. Clearing the table gives everyone a chance to relax, so don't be concerned with the time it takes to make coffee. Dessert, for me, is the fantasy element in every meal. Even if I'm on a diet, I serve dessert, although I may sample it only with my eyes. I love extravagant, abandoned confections crammed with calories and buried in whipped cream.

One custom, however, I have preserved from my past. I like to linger over brandies, cordials, and liqueurs after dinner. I find their colors and scents add to the atmospheres of a meal, making an evening complete. For me, they are as necessary to a splendid occasion as the candles and the flowers. And champagne.

I have spoken elsewhere about how the ideas of collage can be applied to table settings. But I want to emphasize again the remarkable possibilities of sharing that our houses and apartments offer. One object can pull a room together but there should be pleasures for the eye everywhere. Bring particular treasures to the table, share new acquisitions or something old that you have seen in a new way. Sometimes, I will prop a book open to share an idea or a poem; place a seashell in the fold of a napkin; or hide a flower just inside a bowl.

All our moments with others are privileged, moments that can never be regained. What we discover with one another is what we are willing to share. People and parties are abundance for me. Sharing pleasures is our common richness. We give what has already been given to us.

223

Part VI

SHARING YOURSELF - AND YOUR WORLD

Gloria's drawing of her son Christopher Stokowski, 1968.

Discovering
Yourself

NO ONE IS IN A BETTER POSITION to know you or your potential than you are. Often, however, we waste a tremendous amount of time waiting to be discovered. We hope and believe that someone else will recognize who and what we are, or perhaps fill in the gap, or that we will become stars overnight. Women make this mistake especially, as I mentioned before. But men too often feel they are on the sidelines, waiting. This encourages one to waste precious time. No one is ever going to recognize that heightened version of yourself unless you believe you can realize it without them— that you can do it by yourself.

This involves assuming what by now you know I believe in above all—an inner and an outer self—that are in touch, and joined. The outer me is made up of all the things I've been told that I am by my mother, my grandmother, my friends, my husband, and my children. The inner me is related to this, but on another level is somewhat bewildered by what all those outsiders have had to say! What they see doesn't seem to have much in common with how the inner me sees itself. The outer me is answerable to the world, but the inner me answers to a rather different call.

When I speak of discovering yourself, I'm referring to that inner self, the "me" that may be the most

elusive and hidden part of your identity. At first, it may seem difficult even to establish real contact with that inner self, but I promise you that when you do the rewards will be well worth the efforts. When it happens, you have reached the center of yourself. And that is when you can start living fully.

I've tried to describe in these pages some of the techniques I've learned to get more in contact with my self. To a large extent, these are means I had to invent or discover for myself. You surely will too, to a large extent. We each find our own way.

But the steppingstones are everywhere, in the elements in everyday life. The clues of one's inner self are in everything you touch—your dreams, your fantasies, the colors you select for home or dress, the art work you choose, or make. The key is memory—the transformation memory, I think, makes of the world you are constantly creating for yourself and those you love. That self is always present in all you do, what you wear, how you look. That is the grace that is only a smile away.

It's present, too, in gifts you select—and in the gifts people select for you. At times, I take an almost childish delight in the gifts my family and friends give me. I cherish them because they are the most flattering of compliments, but they also often point the way to parts of myself that I haven't yet recognized or understood. A friend has seen it, and gives me a clue, through the gift. Nicknames and special words are clues, too. I think the dolls I've been given over the years fall into this category, and some silly and unexpected gifts. The gifts we are given communicate some larger sense of ourselves as seen from the outside—your outer self mostly, but also an inner image; they define in a concrete object your image—how other people see you. And, the gifts you give reflect yourself too—and your inner self of another person.

Raymond Davidson's drawing of the 45 East 67th Street House.

Trust spontaneous reactions to things outside yourself; those reactions give you some clue as to how your inner self sees the world. It may be no more than an object or color, or a painting or photograph that you go back to again and again. Sometimes, I know for sure why I am drawn to something, and other times the reason for my reaction remains quite obscure to me.

Sometimes it may be years before I am quite certain why I like something. But it usually has something to do with my inner self.

In my painting, I have learned to trust these reactions because they often lead me on to discoveries about myself, and about the direction in which my work is going. Often, something that bothers me about one of my paintings may occur only as a minor nagging worry. But if I listen to that worry it may lead me to see the painting in quite a different way. That one tiny fissure of doubt may lead to a real breakthrough. For that reason, I seldom see my work as finished. I may come back again and again to rework part of a painting as I study it over a period of time. Or unexpectedly, when I'm not thinking about it, I may understand, in an entirely new way, something I've done.

This is one of the most important means of self-exploration for me. I'm not so much involved with what this process means as with the results it brings in my visual world.

I believe something very similar is possible for you in your life. You may of course have realized this long ago.

Anyway, to understand and keep in tune with my inner reality, it helps me enormously to hold onto illustrations from magazines, scraps of fabric, newspaper clippings that remind me of things I've reacted to strongly. Slowly, over the months, certain affinities and patterns of things that one notices, picks out, will begin to emerge from this grab-bag of ideas. Again, a bulletin board may be a way to display what has caught your eye, or a scrapbook—tools to keep your display, and thereby sort out, your attractions, and what they say about you.

I think the purely visual may be a stronger clue to the totality of our being than any other single aspect.

All this has to do with the importance of the idea of integrity in all we do—integrity in the sense of being integrated, authentic, and true. It is the inward principle that integrates how we live, think and feel. If we trust it, we can't go wrong. Integration for me means pulling all the disparate elements of the self into a whole—helping, and letting the self make its own sense of itself.

This is another reason why I do not believe in rules about how to live. Manners and customs come and go. A sense of beauty, a consideration toward others— these are eternal. They are the basis upon which each of us builds her individuality.

Self-discovery cuts more deeply into the core of being than any simple motives for success or winning friends and influencing people. I know it's popular now to have ideas that revolve around a kind of enlightened selfishness. I don't think selfishness works. I believe the greatest motive of life is to share. There should be an uninterrupted wave always from the inner to the outer. Art plugs into that extraordinary energy and seeks always to share and communicate it. By art I mean anything you create.

Women on the whole seem to me often more conscious of this kind of expression than are men. And I think it is this expression that is behind all happiness. It is the spirit we share in our homes and at our tables. It is the bond with our husbands, our children, and our friends. The strength of that bond depends on how much we understand and express about ourselves, the degree of our honesty and the passion of our openness.

What matters most are the results of self-discovery; it leads to making all of your life a work of art, an expression of your inner and outer self.

Thus, how you dress, how you decorate your home, how you live is part of the ongoing romance of self-discovery. Always there will be new discoveries, new manifestations. We must be certain that the world we create is as charged with our secret identity as we can make it. "Taste" is no more and no less than what you find in yourself.

Everything you do is part of this ongoing self-discovery. We change, and grow, all the time. Following the rules or someone else's advice is to escape the excitement and gratification that can come from doing and seeing it your unique way. There are no shortcuts. Your mistakes are your mistakes. Your failures are your failures. But they come from you, and help you grow.

I often hear it said that the era of great individuals is finished. Nothing, it seems to me, could be farther from the truth. Rather, what I think has eroded is our ability to value individuality when we see it. American

women are better educated and better informed than women anywhere in the world. They are healthier, better dressed, and more beautiful. Because of travel, education, and awareness, they have more sense of the profusion and richness of the world's beauty than women have had anywhere at any other time. Also, they have more money to spend on their families and themselves than they have ever had before. Many of them work for this freedom.

As I travel to stores, and lectures, around the country, I meet extraordinary women who are keenly aware of the benefits they have won for themselves and their children. I find a remarkable and intensely independent attitude about what they wear and how they live and what they want for their children. And also, how they want to spend their time—one of my favorite subjects, and one I'll talk about next. In the past decade women have discovered—as we all have—that the world isn't going to change unless we change it. Talking with these women, I am impressed by the great importance they put on the personal and inner aspect of their lives. They are responsible for a new awareness of the self that is changing how people live and think in this country.

I cannot speak for them but I believe they are a force to be reckoned with. Traditionally, women have been left with the so-called refinements of life—education and the arts. I think many women are beginning to feel that these important areas of our national life should be given greater influence. They want some of the ideas they have encountered in their discovery of self to be brought into greater play. I think there is already great evidence that their call for greater emotional truth has already begun to bear fruit. I look for more and more emphasis on personal values because of the growing importance of women and their thinking on every level.

There is another important sign I have encountered in these conversations. I believe women are deeply committed to changing the quality of life for themselves, their husbands and their children. Women have taken the lead in improving the environment and beautifying their surroundings. They have begun to fight for better nutrition and greater sensitivity to diet. They

have spoken out for truth-in-advertising and greater responsibility on the part of manufacturers. They have asked the government to protect their rights and insure their working conditions. They have moved to help the lot of working mothers, to enable more women to get jobs. These are not just the results of one movement but the sum total of some very serious thinking, on the part of a lot of us. These accomplishments are directly related to our growing self-discovery.

I hope that the next generation of women will have even more fully discovered themselves. Each of us longs for more of the experience and glory of the world to come.

Time

I WONDER WHY WE HEAR SO MUCH about the tyrannies of sex and money and so little about the tyranny of time! Psychology has helped us to gain greater freedom in so many ways that it's strange that the subject of time so seldom comes up. I'm sure you'll agree that it is one of the major pressure points in life, and it's one of the hardest factors to control—balancing time—in dealing with life, work and family.

For myself, I find that budgeting time is just as important as budgeting money. I'm not certain that my solution for this problem will help you but perhaps it will give you some perspective about how you spend *your* time.

First, take a long and careful look at your appointments book. How much of what you do is truly necessary and how much is done only out of a sense of guilt or obligation? Don't make a list, but keep those dates in mind.

Now, calculate how much time it takes each week to get the necessities done. In this category, include your hours at work, shopping, school meetings, etc., and the time you spend cooking, taking care of laundry, your house cleaning, and so on. If you do a quick estimate, I think you'll see that two thirds or more of your time is devoted to necessities, to obligations partly for other people and the responsibilities you feel toward them.

Such an accounting can come as a shock. Suddenly, you have to face the fact that you don't have much time in your life for yourself.

"Gerta's Garden," Gloria's flowers and gingham.

Now estimate the time you spend on day-to-day beauty maintenance, exercise, time for make-up however minimal, hair care, and whatever time you may make for self-improvement. I'm sure you'll find there is little time indeed for any of these activities because your schedule just doesn't allow for it. No wonder you haven't time to take up needlepoint or pursue something you've been drawn to or read a book. You are exhausted from the tasks you already have, and so you don't have time for yourself. When was the last time you did something for yourself? Well, the point is, of course, that we have to *make* time for things.

As you begin to make your time your own, a marvelous expansiveness will take over. The time-hungry details will assume their real and secondary proportion. They'll become like delicious hors d'oeuvres before the entrée—or dessert after a nourishing meal.

As you grow, your time will grow. You'll find that as your sense of yourself increases, the wherewithal to do *all* you have to do will grow apace. You'll enjoy what you do more because you're more in command, of time.

I know how hard it is to break a pattern of spending time, because each of us has learned to put other people, obligations, our families first—with work and other responsibilities simply being added on top. We get into a routine—which can quickly become a rut. I believe that a rigid schedule ultimately defeats your purpose; what you need, rather than a schedule, is an attitude about time. Time is not love. The commitment of hours and days does not necessarily provide us or our families with what they need of your care and comfort. Rather, I'm certain that all of us can learn to make much more effective use of time.

To do this you have to eliminate anything that is not absolutely necessary. But the real change has to take place in your thinking. Why do you feel that others have such a priority in your scheduling of time? I know from my own experience that time itself is not a substitute either for real effort or for real feelings. Too often we spend time out of a sense of guilt over not having done other things for those we love. Also, I recognize that this misuse of time is often part of a larger sense of self-sacrifice that women only now have begun to see through.

Your time is indeed your time. How you spend it is an essential part of how you see yourself. Don't confuse filling up your schedule with sharing. Your husband and children may not be alert to the number of commitments and responsibilities you have but you owe it to yourself and to them to make them understand your work, your life, and their part in it. I think you'll be surprised how quickly they will begin to adapt their lives to yours, as you have to theirs, and they'll take pride in what you are doing and accomplishing. You'll probably find they'll become even more helpful and more considerate because they are participating in your priorities. And, when you are there, you are really *there*, in tune with them—not distracted.

What are your priorities? My greatest satisfaction is in being with my family as much as I can. To accomplish this, and still have time for my other goals, and myself, as mentioned before, I get up early (five o'clock); in the early morning hours I spend some time by myself, and then with the boys as they have breakfast and go off to school. I try always to be able to have dinner with the boys. We talk about what has happened during the day, and afterward the boys do their homework or we may watch television together, read out loud, or just talk. I do everything I can to protect this routine, the parentheses around each day. Slowly, I've eliminated most of the things we used to do in the evenings because of my work and my usual nine-thirty bedtime. This carefully protected schedule has made it possible for me to concentrate my energies on my work and my family.

Since I have almost entirely eliminated business lunches, I have water-packed tuna and catsup in the office, or a special-occasion lunch with a friend. I've found it a tremendous relief to handle lunch in this way. When I do have lunch, it is a pleasure and not an empty obligation. I try to apply the same rule for any dinners or parties I may go to.

To be fair, these choices were comparatively easy for me to make now because they came after much sifting and sorting out of alternatives. It takes time to know how to spend one's time! Your priorities for your time will be different. But I've found, at least since I've been grown up, that I prefer to live as intensely as

possible in relation to my family and my work. Working as both a painter and a designer, I've had to pare down even more carefully what I do. Because I'm always concentrating on a new project, I want my energy to go there; I don't want to dissipate it in other directions. I find that heightened concentration is absolutely necessary if I'm to work at the level I want. As a result, the time I spend with my family is the reward.

I've also discovered that I have to keep at least one day a week free for myself. I find that I need time regularly to think and sort out the experiences of the week. Part of this, I'm sure, is purely a need for rest, but my mind races ahead and recharges itself when my routine opens up. Unfortunately, other people sometimes feel free to break in when they see such a chunk of open time. I've learned to guard these days jealously because they are a necessary complement to my work. Because they understand how helpful these days are, my family protects them also. I have established this principle as well when we go out to Southampton on weekends. Then, the whole family takes part in the peaceful life we've made for ourselves there, sleeping and reading and walking on the beach.

I don't think anyone emphasizes enough the benefits of truly free time. We have a tendency when we have a day off or a vacation to organize every minute, to fill the time up. Rather, what we seem to need in our crowded lives is time in which to do nothing. The renewed interest in meditation seems to take this into account because meditation breaks into the ordinary routine and provides a psychological distance. We require peace, quiet, and serenity, to hear what our inner selves may be saying. When you make the effort to control your own schedule, you have made a major step toward creatively controlling the whole of your life and freeing yourself for all that is truly important in life. To learn the art of stretching time, savoring each moment and experiencing it with all our senses.

Another question regarding time seems crucial to personal development. We seem to have lost the old idea of life as continuity and have substituted in its place instant change and instant gratification. Unfortunately, very few insights hold true forever. Life evolves, changes, and expresses itself. Nothing of last-

ing worth happens instantly. If we know and trust the larger structure of our lives, we can give ourselves time to evolve over the long run. But often that willingness to wait involves great stores of patience.

When I speak of patience, I don't mean closing yourself off from experience or limiting access to new ideas and feelings. On the contrary, because change is slow and unpredictable, the more open you are to what the world brings, the better. Your curiosity, aliveness, and enthusiasm will make the difference not only within yourself but in what you share with those around you. If the time you spend—or most of it—is spent the way you decide it should be spent, you can experience things more deeply by not being so harried.

One of the most extraordinary developments of this century has been the willingness of the American woman to make herself over. The American woman has set the pace for the whole world in this way. I'm not speaking solely of surface changes or the regard American women have for health and vitality, but rather of the interest in education, the new, enlarged involvement with business and finance, and the tremendous results of women's involvement in improving the quality of American life. None of these accomplishments have come quickly, and to a certain extent, they have been the outcome of the cooperation of generations.

The tradition of the self-made woman in this country is available to all women. Mass-produced clothing and cosmetics have made it possible for every woman to look her best without spending a fortune. A new awareness in business and education has made it more and more possible for women to have exciting and profitable careers. A rapport with men has developed that has put a new lease on marriage and the family.

The next step in this development would seem to me to be an inner one. Because women are leading more exciting, valuable lives, there now comes the opportunity to instill the same vitality and enthusiasm into the inner life, and on into the middle and late years of our lives. No longer is a woman the sum total of her duties as wife and mother. We all have lifelong contributions to make, but it requires enormous imagination and inventiveness to make those contributions possible.

Part of that realization involves understanding the

real complexity of being a woman at this moment in history. Work, marriage, and children are all possibilities. But perhaps none are an end in themselves, nor does work any longer exclude the possibility of children or vice versa. Rather, every woman owes it to herself to claim as much of experience as she wants. For the first time the American woman is beginning to be in control of her destiny. Her choices have been broadened enormously. When she begins to think of her life, she can plan a lifetime that is expressive of her wants and goals. She no longer has to put her children, husband, and work into separate compartments. She can work and is admired for doing so. Her worth is no longer measured by what she has given up to be a wife and mother but by what she has been able to include.

Thus, an enlarged sense of time becomes a necessity in personal development. On the one hand, we have to give ourselves the leeway to evolve at our own speed. On the other, we should welcome the whole lifetime of change and evolution that lies ahead. None of us are any longer wife or mother alone but a glorious complexity of roles and possibilities. Don't limit yourself to one role. Time will tell. Let it be your whole story in all its richness and intricacy, and evolved over time spent according to your own plan.

The basis of a time plan that works, of course, is trusting your own instincts, the impulses that come from your inner self. Trusting yourself is the next thing I'd like to talk about.

28

Trusting Yourself

YOU CAN MAKE THE MOST of your world if you see and understand *your* potential in it. No one else can fill it with your grace and laughter. No one else will understand how to make it run and purr the way you do. Only you know the major formula, the open sesame of the particular world you live in—because your world really is you. Don't trust any advice or judgments but your own. Trust yourself.

I found this very hard to do, especially at first. All of us have trouble learning to listen to our own minds, to understand the messages from our hearts. When you're blocked, close your eyes and see how the responses tumble in—they are your most important resources. The secret of living and thinking is spontaneity. Do what your eyes and heart tell you to do. Stop to listen, alone. The first steps you take in your own special and unique direction may be stumbling ones, but each step will give you greater and greater assurance. You know you like that color, that fabric, that piece of furniture. Or you know that somehow, you don't really like it— something is off. You may not be able to articulate why, now, but the more you think about it the more words you'll be able to find to explain it. One explanation is probably in memory.

"Tulip Garden," Gloria's homage to one of her favorite flowers.

Don't be intimidated by words. Trust your intuition to guide you. Remember, the salesman or your best friend won't be living with your choices. If you love it, it's good taste. No further questions. Don't back down.

Even though someone else may see something you've chosen and think it's appalling, don't give an inch. The world may follow in your footsteps.

So many of us edit everything we do. What will my husband think? What will my mother think? What will *his* mother think? What will people think? And then we suppose because someone else's name is on it that *our* choice has been sanctioned. If Louis XVI did it—it must be good. Whose life are we living?

Unfortunately, you and your taste evolve only in reaction—your responses. Choosing the accepted is not a short cut, but a detour around one of the most exciting and gratifying experiences you can have—expressing yourself in your own terms. The poet Paul Valéry said that taste is made up of a thousand distastes. I say, rather, that each of us is made up of a thousand good tastes and bad tastes. You can't know who you are until you've had a little of the sweet *and* the sour.

Children are extraordinary in this way because they are so spontaneous. They don't edit themselves. They adore the sunshine and the puddles. They live in a world that has not been fragmented into good and bad, right and wrong. They see the beauty in an icicle or the prism of a chandelier. Dandelions are as thrilling for bouquets as jonquils. A gulp of cold air is as bracing as a shot of Napoleon brandy. That is why so many artists and poets have wanted once more to see things as children see them.

Nothing gives me more delight than to visit someone who has something or is wearing something absolutely beyond the pale to my eye but that they mightily enjoy. I feel real complicity in such freedom. I feel I share in the smile.

Recently, an enormous wall-hanging was tried out in the lobby of our Manhattan apartment building. Because it is a co-operative building we all were concerned about what it would cost but few would speak frankly about how they *felt* about it. One man in the elevator was concerned that the artist wasn't well enough known. "Ah yes," one of his companions agreed, "I would like to see more of his works." "Is it a ——?" a woman asked, ready to like the wall-hanging; she was obviously crestfallen when it turned out to be by someone she had never heard of.

We are so used to being told who and what to like that without a point of reference we simply get confused, don't know what we think. That of course is always a shortcoming of any canon of "good taste." It works only as long as it is applied to the known. But another attitude seems even more prevalent: we seem neither to like *or* dislike. We're not concerned here with taste, but with the refusal really to *care* about what one chooses. You are your world. Your world is what you have chosen it to be. Even the magazine out of place or the wrong drapes or the tired toast or the down-at-the-heels conversation *are* choices.

Here are some of the symptoms of the sort of dullness I dislike but that is easy to fall into:

1. *Price Tags:* Prices are a fascinating subject but putting a price tag on everything can be a bore. Bargains and extravagances are dead-end topics—shockers that quickly lose their electricity. How does price justify taste?

2. *Names in Fashion:* The only time to buy names is before they're known. I'm afraid this mania has made the label more valuable than the goods. I still believe that you only sign your name to something you're willing to stand behind. Buying names only works when you're buying what you like as well.

3. *Status Objects:* I'm always worried by toys for adults. Nothing looks older or more tired than a fad that has had its day. You're better off on your own.

4. *The Clothes Horse:* In the good old days of the slick magazines, there was always someone who followed their advice to a "T." No one looks more ill-at-ease than someone who has been pre-packaged.

5. *The Right Thing:* Some people read the gossip columns as if they were delivered from on high. Keeping up is the refuge of small imaginations!

6. *Gourmet Cooking:* Many feel that pyrotechnics are more important at table than food. What isn't fresh or French is excluded. I'm certain purism in food has produced more anxiety than good dinners. Let your refinements be your own.

7. *Red Wine, White Wine:* Perhaps this should be a subdivision of *Gourmet Cooking* but it is one of the rules that seems to have a power of its own. Serve the wine that suits you. But serve it generously. Generous amounts of wine in carafes is far more hospitable than a

1927 Lafite Rothschild with an inch-deep sediment.

8. *In and Out:* The sixties were enormously preoccupied with what was In and what was Out. The instant crazes no longer apply. Don't be tortured by what everyone is doing. They're waiting to see what you're up to.

9. *Language:* Words are one way of sounding young or in the swim. The air is full of words that are signals of incipient idiocy or sagging vocabularies. See if you catch yourself saying, "Hopefully," "at this point in time," "I'm very into," "business-wise, fashion-wise or whatever-wise." If you're guilty of just one, wash your mind out with Jane Austen or Fanny Burney!

10. *The Dance-card Syndrome:* Some people are terrified unless every minute is filled, booking their days months in advance. If you catch yourself filling up your date book and leaving no free time for yourself, break the pattern by keeping at least one afternoon a week open. Make a date with yourself, and write it in your engagement book. Build your social life with the care you bake a cake. You know which ingredients work for you.

11. *Playing Possum:* Often, I meet people who feel overwhelmed by their lives. They don't exercise their judgment because they're convinced they have none. Or they may be living out the wishes of their mothers or fathers. For these people, any expression of their own uniqueness may well transform their lives.

Once again, let me say that you alone can make the difference in your world. Your sensitivity, intuition, and care are greater resources than the skills that a decorator or a fashion consultant can offer you. What you know and feel are essential to making your world more beautiful, joyful, and comfortable for yourself and those closest to you. But don't be afraid to seek the help of experts in making your decisions. They will benefit from hearing your special way of looking at things. In fact, you will gain immeasurably if you get into the habit of learning to describe specifically what you want, whether it's to a wall painter, a florist, a hairdresser, or a dermatologist.

To trust yourself, you have to love yourself enough always to level with yourself. If you do react, hang onto

that reaction and explore it. Where did it come from? What does it tell you about the rest of your experience? How can you use the reaction to strengthen your spontaneity? How can you learn from reaction and how can you expand it? The most important thing is to see things for yourself—without considering what other people are going to think.

A couple of years ago, a good friend in the Midwest asked who should do the apartment she was thinking of setting up in New York. I suggested a decorator and told her something about her work. My friend hesitated and then said, "I'd have to find out who the other clients are." I understand that hesitation but I also know that it prevents us from becoming the fullest versions of ourselves.

Allow yourself to be attracted. Follow the gleam. Your life is never finished. I am not ready to write my autobiography because I know I have a whole life out there I haven't lived yet.

29
Growing

THE PROCESS OF DISCOVERY AND CHANGE, of self-realization and creation is never-ending. Each break-through brings another breakthrough, each completion another beginning. Each painting another painting. The road from being numb to being alive and aware has no signposts. We only know we have traveled the road *after* we have traveled it. Growing is the necessary process if we are to undo the mistakes unwittingly imposed on our minds, bodies and feelings by the past.

Growing is learning to be one's own support. We move away from the support that others give us—our mothers and fathers, our teachers and friends, our bosses and peers—to some valid self-definition that provides us with the approval we need from within ourselves.

An effective step one can take in growing can be to choose someone out there as a model, not to copy but as a source of inspiration—what you would like to be in the outer ways. But, in making this choice, it's important to realize that the model should not embody just one or two characteristics you want to emulate but a totality of experiences. In making your choice look for a wide range of qualities so you will feel unrestricted in the direction you take yourself. This person may be a friend, a teacher, a therapist. It should be someone you know personally so you won't idealize or wish your model out of reality.

The most important function a model can serve is to

One of Gloria's Valentines for Hallmark.

allow you to profit from another's mistakes and short-comings. But remember that this model represents only a short cut. What you become is entirely of your making. And a model.is useful to help you get started.

There are certain traits, qualities of character that I think one does well to try to cultivate. They are goals, bridges that will serve us well all the days of our lives. They provide balance as the inner journey continues.

Each of these seven qualities seems to imply the next and each is present in the others. They seem to me a sort of ladder to reach high in the tree of experience.

One quality is simplicity or the willingness to be yourself, to be real, to live in the world with acceptance. Simplicity is the most endearing human trait because it comprehends that to be alive is not to be perfect. Simplicity is the understanding that all that is needed is already in the heart, the source of all beauty, all wisdom, all riches.

A second quality is identification, the ability to transform yourself into someone or something else, empty. That is our bond with others, with the visual world. It is being open to people, to new experiences, and to ourselves and our impulses. And a third quality is value, the willingness to see others as they want to be seen, to nurture their dreams and wishes, to care deeply—to be able to value those who are closest.

Another quality is enjoyment, the ability to find in things that which is new and interesting, to affirm rather than deny whatever life brings.

A fifth quality is belief, the faith that grows out of the first four qualities and cements and shapes experience. And with belief, patience. The knowledge that all development has its own time, its own priorities, its inner structure. Also recognition, the acceptance of another's experience of life, the understanding that we are both more like and more unlike others than we can possibly imagine.

Recognition and also participation, are perhaps cumulative traits that come only with experience and age. By participation I mean the willingness to suspend ego, drop masks, to dance to another's time. Participation comes from our need to merge with others, to participate in their ideas, their lives, their creativity. And it seems to me the hardest of the qualities to achieve.

This book is the rough record of my growing: more than likely, your growth will take a quite different form.

I have already indicated the overriding importance of the independence of time, but I want to assert it again once more here. A day without an hour spent alone—at least one hour—is not a human day. We give up so much of our lives to others that we must learn to rescue one part of it for ourselves, if we are to flourish.

This book is of course about the return to self, about how my experiences led me to believe that each one of us must reach into ourselves as a means of experiencing the world with greater power.

The most valuable "secret" you can learn from this book is to understand that the root of pleasure, beauty, growth, always comes from within.

If you want to pursue this idea with greater intensity, take a new object to experience with pleasure, each day. Start out with the objects at hand. The contents of your desk top or your dresser drawer. After you've recognized the pleasure these objects bring you, begin to plug in the associations and chains of memory that go with it. You will know that this exercise is working when you're able to establish contact with your first rose, your first orange, your first handkerchief.

I see life as an ongoing program of self-exploration. The further you go, the more paths will open themselves to you. Keep that box or bulletin board of pictures, postcards, snatches of poetry that catch your eye, as a sort of haphazard, collage-journal of your development. Certain patterns, certain themes, certain ideas will begin to isolate themselves from your experience. These will lead to the major themes of your life, and to the pleasures that mean the most to you, that reveal the structures of your inner self. With these ideas, you may want to make something. Choose the form that comes easiest to you. A painting, a quilt. Worry less about what you're doing than what you're saying—really, what you're embodying is yourself, or aspects of it. You may want to make a scrapbook of that collage-journal you've been keeping in a box, or you may be putting together a poem of the words and images that have come to you.

This is all a part of the continuing search of self that will again and again unearth your wishes and dreams

and help you make them real. You may want to reconstruct a shelf of the books you most loved as a child, or the favorite objects. Or return to the spot you found most beautiful as a child. Or re-establish a friendship that has long since lapsed.

I find for myself that every link I forge anew with what was is a powerful force in my dreams and fantasy. Giving memory its credence closes the circle of completion.

I'd like to suggest here a sort of loose calendar that may aid your self-development as it did mine.

The year I'm describing doesn't follow the actual calendar but an inner calendar that seems to me much closer to the one we truly follow. Its beginning is in September when vacations are over and we go back to our inner school. As a result the preparation beings even earlier.

May–June: Hit on some area of special inner interest that you have not yet explored. It may be an idea or a craft or even a historical period. Put together a reading list and be sure to note experiences from your own life that have caused you to have this particular interest.

July–August: Take whatever leisure time you have during these months to read, think about, and explore your interest. You may want to meet someone who is an expert, visit a craft museum, or even plan your vacation around this interest.

September–November: Begin a project in earnest that focuses your interest. You may need to get special instruction or acquire special tools or materials but set yourself a deadline. You may not feel you are skilled with your hands but you will find that it is worthwhile to attempt something you've never tried before. Perhaps, you'll want to make something to give for Christmas.

December: Allow yourself a fallow period to think over what you've been doing and to reflect on its significance for your own fantasy and dream life.

January–February: Find a way to make your new project entirely your own. How can you transform your interest into something which is directly expressive of you? How can you share the experience with those

closest to you? How can you give the project its widest importance?

March–April: Reflect on what you've accomplished and try to expand your chosen project to involve more aspects of your life. Another year's cycle has passed and you are nearing the beginning of a new cycle. Where will your eye take you next?

I've found that an inventory of self can be enormously useful. Perhaps, you'd like to try it for yourself. Put the book aside and make an inventory. Perhaps you'll want to keep it in a notebook. You'll find that making out an inventory might be a particularly good thing to do on your birthday or at the first of the year—whatever date has special importance for you. Or, on the first of September.

Here's how the "inventory" can work: write down as many numbers as the years you are old in the left-hand margin of your notebook. Next think of as many things that give you pleasure as there are numbers on the list. Don't worry about writing sentences, or the order the ideas come in. Jot down phrases that will quickly call to mind the things you most enjoy: "Love making, baking fresh bread, sharing a meal with a friend, the first robin, seeing an old movie, running on the beach, and so on."

Put a dollar sign after any items that have to be purchased or paid for. You'll be astonished how few of these experiences cost anything at all! The best things in life *are* free.

Put a check mark beside each thing you do on your own. A plus mark if you prefer to do it with others; two plus marks if there is a particular person you like to share it with. The check marks and pluses will give a much clearer idea of how much you like to do things on your own and how much you like to do them with others. If you're married, you may find out that you need to spend more time on your own. Or you may need to find a new special person with whom to share.

Circle the numbers of all the items that would not have been on the list five years ago. Underline all the items you want to be on the list ten years from now.

Do you see a pattern emerging? Are you surprised at yourself?

Ask the person closest to you to do a similar list and

then compare lists. The correspondences and discrepancies will tell you much.

Be sure to date your list and put it away until next year. Compare this year's inventory with next year's.

This inventory can be a good measure of growth, how well you are in touch with yourself. It may be the most revealing record you can keep.

Part VII
THE SPIRIT OF THE ARTIST

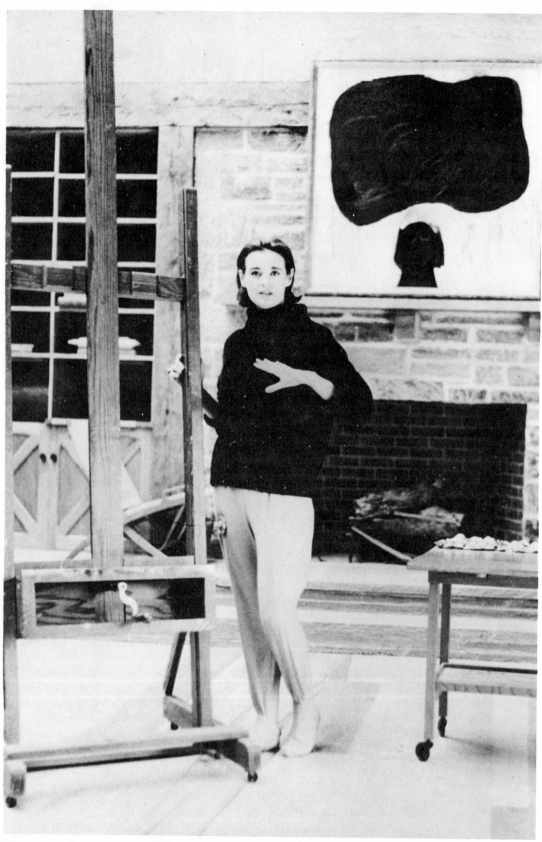

Gloria at work in her studio at Faraway. Photo by Frances McLaughlin Gill.

30
Finding the Art in Living

THERE IS AN IMPULSE in each of us somehow to make our own personal and individual mark on the world around us. As you know by now, that is the story of this book. The little child coming upon a stretch of clean white snow gleefully rushes forward to imprint the shape of his feet upon it. A woman passing through a strange room pauses briefly to move an object on a table—making a slight rearrangement that may go unnoticed by others but that her eye finds more pleasing. A boy carves his initials on a tree. A girl places a daisy secretly against the grass. We all write our names upon the sand.

All of us hope that our choices, our actions, our influences will in some manner make this life a little sweeter for our having been there, those rooms we enter, those worlds we move through, those lives we touch, those people and those places we leave behind us.

It is, in a way, our small gesture toward immortality, our little message to the universe. It says, "I was here," to the ages.

That urge may very well be the essence of what it is to be human—a refinement of the spirit, some admirable impulse toward beauty, a part of a persistent and persisting drive toward self-improvement. It is surely a gesture, at least, in the direction of grace.

*Gloria's drawing of "Brothers,"
1968.*

To transform our surroundings into something more compatible with our better feelings about ourselves, trying to create an ambiance that reflects our enthusiasm about life and beauty and grace and harmony. It is the same impulse that has led us to invent song and dance and pictures; it is the part of us that dreams and invents, that is reckless and fanciful.

Each of us in some way participates in the spirit of the artist. We share the artist's hunger and passion and something of his vision, which is also *her* hunger and *her* passion and *her* vision, for art has no gender. We share the artist's compulsion to give form and permanence to what is formless, impermanent—and eternally elusive—his and her compulsion to define the indefinable, translate the untranslatable and express the inexpressible. All of us know something of the artist's lust and fire and anger and soul and sensation. It is the artist in us that makes beauty and meaning out of what seems like chaos and confusion; the artist in us that from bits and pieces, the flotsom and jetsam around us, creates something new that has balance and order and coherence.

People sometimes ask me if my children show signs of artistic talent. I answer that all children are artists, are talented. Every child is unique and individual and has his own way of seeing—as every woman does. The child's world is one of expectation and discovery and wonder. What he *is* goes into his drawings, into his play. It is precisely the child's freedom of curiosity, his unceasing inquiry, that eagerness to express, that we should cherish and encourage and nourish both in our children and in ourselves, for it is somewhere in that region of our minds and imaginations that our most valuable self resides. At the center is that divine, god-like and creative part of ourselves that we are forever in danger of losing touch with.

Too often, as part of the price we pay in growing up, we lose or we have smothered out of us, or frightened out of us, that blessed innocence, that sense of wonder, that trust; we cease to see with the clear, clean eyes of youth. We stop growing and start mistrusting ourselves, our tastes, our impulses, our appetites, our instincts, our judgments. We let other people tell us what we think, what we like, what we feel. We don't make time

Gloria's fabric design, "The Family."

to listen to ourselves—we don't value our time enough.

Wherever I go, whomever I'm asked to speak to, what I have to say is the same: don't be afraid to listen to yourself. Don't be afraid to leave yourself open to experience, open to looking and seeing and responding. Life is a long process of seeking. We seek for meaning in the world around us and we seek for the truth of ourselves.

Just as every child has genius—he has to have, if you consider the astonishing sum of skills he has to master, the incredible amount of information he has to learn, the endless lessons in living that he has to absorb—just as he has genius, so have you.

We must dare to do. We must give of that better part of ourselves, and draw upon that well of creativity there is inside us, and when we reach out to make our mark on the world around us, it will truly be *our* mark—for better or worse. It will be ours alone, not a copy, not an echo, no imitation, but ours, the real thing, something *we* felt, what *we* found, what *we* made.

It has taken me a great deal of time to learn about this freedom. Hours that I might have used for other pleasures, for walks, for travel, for roaming the wide world, perhaps even for a more "feminine" leisure. How did Katherine Mansfield manage her extraordinary industry? Her pen never rested. No matter how ill she became, she kept spinning out the words. I am awestruck by her determination, and admiring of her self-discovery.

What I have learned, I have learned from my painting. I respect and admire Katherine Mansfield's voyage on paper and ink but I am content with my less orderly vocation. With my brush, from the center of myself I pour the color onto the canvas. When I'm painting my friends say that I am too full of joy to call it work; but I have found my peace in the concentration of my work. I have discovered my purpose in the painting of sunlight, flowers, and mothers twined with their children on memory beaches.

My calling, as I've said, is not a new one. I began painting within myself long before I actually started painting. The canvas, my canvas, was a threshold that no one else dared to cross. It was the door to all my

Table setting at 45 East 67th Street. Beadle Photo © 1969 by The Condé Nast Publications, Inc.

possibilities. And, although the history and tradition of painting was long and deep and wide behind me, painting was new to me. I made it mine. It belonged to me. I belonged to it.

There are the nestled circles made of pink and red strokes that give the illusion of the rose. And more circles and there is a bouquet. Add swoops of blue and purple and a ribbon dances round it. What garden has ever been so alive with beauty, shaded over with such trees? What room has ever been so filled with sun or so charmed with faces? And where, on which beach, can I still find my beloved Dody? But each of these canvases is filled with its reluctant beginnings, the terror of the leaps from sun to shade, the ardent greens, the audacious reds, purples, blues. It is in surveying these secret gardens and private castles and memory faces that I have found my place.

I put the key in the lock and turn it to the right and left, then once again and again. My key—my paintbrush—glows, leaving its trail, opening and closing simultaneously the canvas door. My autobiography is traced in trees that merge with sky and roses that never die, eyes that smile and lips that bloom. My hand moves in time with music that I no longer hear. My canvas sings the song Dody first taught me: "You and I together, Love . . . Never mind the weather, Love."

Soon, I hope to say: "I'm not at home to anyone, just now, except for this anemone. I want to be left alone with this shell. I have gone for a stroll down the paths and lanes of this patchwork. I have a date for tea with my dolly with the sad, brown eyes."

But I haven't reached that goal as yet. I am still rehearsing. I want more and more to paint, to live my imagination.

All my life I have reached out for the smile of others. When strangers saw my work, they suddenly found they loved me and, to my great pleasure, sometimes told me so. That is my delight and, because of that bond of recognition, I have tried.

That is how I became, and am becoming, Gloria Vanderbilt. I hope this is part of my story that will have meaning for yours.

A Few Biographical Facts

My Family

Laura Kilpatrick Morgan, my maternal grandmother. Born Santiago, Chile, the daughter of Louisa Valdivieso and Judson Kilpatrick, Union general and American minister serving in Chile.

Harry Hays Morgan, my maternal grandfather. Born on the family plantation, the Aurora, Baton Rouge, Louisiana. Son of Philip Hickey Morgan, judge of the Supreme Court of the State of Louisiana. Later, appointed first judge of the International Court of Alexandria, Egypt.

Their children:

Harry Hays Morgan, Jr.
Consuelo Morgan
Gloria and Thelma Morgan, identical twins, my mother and aunt.

Reginald Claypoole Vanderbilt, my father. Son of Cornelius Vanderbilt, who was the grandson of Alice Claypoole Gwynne Vanderbilt and Commodore Cornelius Vanderbilt, whose family came to America in 1640. The Vanderbilts were Staten Island farmers, and later the Commodore made one of the first great American fortunes in shipping and railroading. His great-grandson Reginald C. Vanderbilt devoted his life to raising champion coach horses and was the founder and president of the American Horse Show Association.

Gertrude Vanderbilt Whitney (Mrs. Harry Payne Whitney), my aunt, the sister of Reginald: sculptor and founder of the Whitney Museum of American Art.

Biography

1923: My mother, Gloria Morgan, age seventeen, married Reginald C. Vanderbilt, then forty-two. They

259

divided their time traveling in Europe, living in their
New York house at 12 East Seventy-seventh Street,
and at Sandy Point Farm, their estate at Newport,
Rhode Island; in Newport, Reginald C. Vanderbilt
raised his horses.

February 20, 1924: I arrived at 9:55 A.M. in the Manhat-
tan Lying-In Hospital and was named Gloria Laura
Morgan Vanderbilt. I was born under the sign of
Pisces, ruled by Neptune, the planet of the poet. The
emblem of the sign is two fishes, one going upstream
and one going downstream. The nature of Pisces is
dual; also filled with empathy for others. It is the sign
of compassion. I was brought home from the hospital
by nurse Emma Sullivan Keislich, the beloved
Dody. Also Laura Kilpatrick Morgan moved in per-
manently with my parents, leaving her husband,
Harry Hays Morgan, at his diplomatic post in Buenos
Aires, Argentina.

September 1925: My father, Reginald C. Vanderbilt,
dies in Newport. Almost immediately, my mother
takes me, my grandmother Laura Morgan, and Dody
to live in Paris. She leads a very active social life and
I rarely see her. Grandmother Morgan and Dody are
my constant companions.

1933: At my grandmother Morgan's insistence my
mother takes me, Dody and my grandmother to
America where I have not been since my birth. My
mother leaves me and Dody with my father's sister,
Aunt Gertrude Vanderbilt Whitney, at her home on
her estate in Old Westbury, Long Island, and returns
to Europe. My grandmother settles at the Hotel
Fourteen in Manhattan but spends weekends in Old
Westbury. At this time, I meet my cousin, Gertrude
Vanderbilt Whitney Henry, the granddaughter of
Aunt Gertrude, who lives with her parents in another
house on the Long Island estate. We become lifelong
friends. I begin school for the first time at the Green-
vale School, Glen Head, Long Island.

1934: My mother returns to New York intending to take
me with her to Europe. Manipulated by my grand-
mother Morgan, my aunt refuses and she starts pro-
ceedings to gain custody of me. An account from one
of the newspapers of the time reads:

"Society is still rocking with the sensation of the week—the revelation that 10-year-old Gloria Vanderbilt, pawn in a desperate custody battle, stated in court she preferred living with her aunt, Mrs. Harry Payne Whitney. It was a tremendous blow to the mother, Mrs. Gloria Morgan Vanderbilt, whose income is largely derived from the child's millions.

"The words fell naively and without rancor from the 10-year-old girl's lips as she rocked in a big swivel chair in the chambers of Supreme Court Justice John F. Carew, who had previously announced that his decision would be largely determined by Gloria.

"During a three-hour examination which was disguised as a chat, Gloria dangled her long, spindly legs from the chair and talked of many things with the jurist, who has five children of his own. . . .

"Little Gloria wanted it understood that she did not dislike her mother. It was simply, she explained, that she hadn't seen much of her. And when she was in her mother's care, they travelled so much, all over Europe. She couldn't remember much about it, but she was sure they jumped around a great deal, so much so that she never had any steady playmates."

As a part of the court order, Dody is dismissed and is not permitted to see me. A stranger, Mademoiselle Ruel, replaces her.

1936: "A Dancing Girl," my first oil painting at Greenvale School.

1937: I enter Miss Porter's School, Farmington, Connecticut, but leave during the spring term for an emergency appendectomy.

1938: I enroll in the Mary Wheeler School in Providence, Rhode Island, where I have art classes with Miss Brown and Miss Emerson.

1939: I meet and become friends with Carol Marcus, now Matthau, who introduces me to Oona O'Neill, now Chaplin—both of whom become lifelong friends.

1941: I visit my mother in California and decide not to return to Aunt Gertrude Whitney's.

1943: I study briefly at the Art Students League.

April 1945: I marry Leopold Stokowski.

1945: I discover a volume of Katherine Mansfield's

correspondence in the Hollywood branch of the Pickwick Book Stores.

1947: I become a working painter while living in Greenwich, Connecticut.

August 22, 1950: My son Stan—Leopold Stanislas Stokowski—is born at 8:50 P.M. in New York Hospital, Manhattan.

January 31, 1952: My son Christopher Crysostom Stokowski is born at 8 A.M. in New York Hospital, Manhattan.

1952: My first one-woman exhibition at the Bertha Shaeffer Gallery in Manhattan.

1953: I begin my professional acting career, playing the lead in Ferenc Molnar's *The Swan*. Among my other roles are appearances in William Saroyan's *The Time of Your Life;* William Inge's *Picnic;* Edward Chodorov's *The Spa;* an adaptation of Molnar's *Olympia;* Robert Thom's *Minotaur;* Ugo Betti's *The Burnt Flower-Bed;* and James M. Barrie's *Peter Pan*. My television appearances include roles on the "United States Steel Hour," "Studio One," and "Kraft Television Theatre." This is now referred to as the Golden Age of Television, although none of us were aware of it at the time.

1954: *Love Poems* is published by World Publishing Company.

1955: One-woman show at the Juster Gallery, New York.

1958: I write two plays, *Cinemee* and *Three By Two*, taken under option by Michael Myerberg and subsequently Oliver Smith, but never produced. I contribute to *Cosmopolitan* and *Show*, as well as review for *Saturday Review*, the New York *Times*, and *Cosmopolitan*.

1959: Sylvania Television Awards Citation for Distinguished Achievement in Creative Television Technique.

December 1964: Wyatt Emory Cooper and I are married.

January 27, 1965: My son Carter Vanderbilt Cooper is born at 6:07 P.M. in Doctors Hospital, Manhattan.

1966: A one-woman exhibition of paintings in acrylic at the Hammer Galleries, Manhattan.

June 3, 1967: My son Anderson Hays Cooper is born at

3:46 P.M. in Doctors Hospital, Manhattan.

1969: Collages using line drawing, painting, fabric and paper, are shown at the Hammer Galleries, including "Elizabeth" and "Cavalier." Johnny Carson turns the "Tonight Show" over to my Hammer Galleries collage show. Don Hall in Kansas City sees this video, and as a result

1969: I begin work as a designer for Hallmark Cards. Subsequently, my career as a designer begins—in home furnishings: textiles, decorative pillows, sheets, towels, comforters, table linens, china, stemware, flatware, kitchen and bath accessories, stationery and paper goods.

1969: One-woman shows at the Neiman-Marcus stores in Dallas and Houston.

1969: Neiman-Marcus Fashion Award.

1970: Fashion Hall of Fame.

1970: *The Gloria Vanderbilt Book of Collage* is published by Van Nostrand Reinhold Co. and by Galahad Books.

1971: Retrospective at The Reading Public Museum and Art Gallery, Reading, Pennsylvania.

1971: One-woman exhibition at the Hoover Gallery, San Francisco, California.

1971: Retrospective at The Monterey Peninsula Museum of Art, Monterey, California.

1972: Retrospective at The Tennessee Museum of Fine Arts at Cheekwood, Nashville, Tennessee.

1973: American Home Sewing Council Fashion Home Sewing Award.

1973: One-woman exhibition at the Circle Gallery, New Orleans, Louisiana.

1973: One-woman exhibition at the Hammer Galleries, New York.

1974: Frederick Atkins, Inc., Certificate of Recognition.

1975: The McCall Corporation publishes three issues of *Gloria Vanderbilt Designs for Your Home*.

1975: San Francisco Beautiful Citation.

1976: An edition of lithographs for Felicie, Manhattan.

1976: The American Mart Pacemaker Award. First ready-to-wear collection for Gloria Vanderbilt, Ltd., is shown. Subsequently, I go on to designing watches, scarves,

eye wear, lounge wear, lingerie, sleepware, foundation garments, blouses, jeans, wallpaper, needlepoint and latch-hook rug kits, and a shopping bag.

1976: National Society of Arts and Letters—Gold Medal of Merit.

1977: Limited edition of "Flowers of the Seasons" baskets for The Franklin Mint.

1977: Retrospective at Amarillo Art Center, Amarillo, Texas.

1977: *Gloria Vanderbilt Designs for Your Home* is published by Simon & Schuster/The McCall Pattern Company.

1977: Euster Merchandise Mart Award.

1977: Talbot Perkins Children's Services Mother of the Year Award.

1978: Westchester County Federation of Women's Clubs Woman of the Year Award.

1978: Commencement address at the Moore College of Art. Awarded the Moore College of Art Honorary Doctorate of Fine Arts, Philadelphia, Pennsylvania.

1978: Southampton College Designer Showcase Award.

1978: Abraham & Straus Woman of the Year Award in Art and Design.

1978: I contracted with Murjani, U.S.A., a multi-faceted international business complex, to handle all my fashion-related licensing arrangements.

Answers
to Some Questions
Putting Oneself
Together

TODAY I AM INTERESTED in spending as little time as possible putting myself together. I take as many short cuts as I can. I get made up for an occasion—lunch with a friend or a meeting with people from one of the department stores I'm working with—but I try to save as much time as possible for the really important things—my family and my work. Depending on what my schedule is I usually get up early, five o'clock or so. I make instant coffee in the kitchen. Outside it's still dark night. I take the cup into the living room where I sit looking out, watching as imperceptibly, the moon seen from one corner window descends and the first sun rays rise over the river. These are moments I have to myself. The rest of the house sleeps. I have time to dream, to make plans, or to think of nothing except the joy of being alive. At seven, the children are up and off to school before my outside day begins. Seeing the boys for breakfast and for dinner is a lucky privilege.

I couldn't get started without a shower as hot as I can stand. I try to double up the steps in my beauty routine as much as possible. I'm now using mainly products by Janet Sartin, who worked with Dr. Erno Laszlo for years. I find her diagnosis of my skin seems correct, so I try to follow the steps she recommends. I cover my face with her skin oil and I wash it off in the shower with her soap. This should be done in the basin, filling it with hot water, and with your hands rubbing the cake of soap onto the face, before splashing it for thirty times with the same water. However, in the morning, I take a short cut by washing my face under the shower instead.

After I'm out of the shower and dried, I put Janet Sartin's skin lotion on my face. Interestingly enough, it is *not* a moisturizer. I've found that for me, moisturizers are one of the hypes of the beauty industry. If you have a correct balance of skin oils, you simply don't need a moisturizer. It's no more than a stopgap.

Over the lotion, I put on Janet Sartin's liquid base on my nose and forehead, which tend to be oily. As you can see, this is peculiar to my face, so my routine is really suitable only for someone with similar problems. On the rest of my face, I spread a paste base from Janet Sartin that gives my skin a certain creaminess. Let me say here that I don't believe in facials. I think the skin is very delicate and facials can often do more harm than good.

For day, I use Janet Sartin's cream rouge and I apply it as a highlight. I don't necessarily follow the same format each day. For example, I may use slightly more or less on my forehead and temples—always some on my forehead, high near the hairline. For my eyes, I use a shade of eye shadow of a blue-green or green shade. I find my hazel eyes can go pale or brown depending on the eye shadow. Again, I apply it on the basis of what seems to look right in the mirror.

I brush a waterproof black mascara lightly on my eyebrows and always use an eyelash curler before putting the same waterproof black mascara on my lashes. Most often, I don't take the time to do this except for a full make-up. This is the procedure when I do. With a flat rubber circle sponge I dust Johnson's Baby Powder onto the lashes before using the eyelash curler. When they are heavily coated with the powder, I use the curler—holding it clamped tightly—to the count of 100. After this I apply the mascara. I invented this idea inspired by a make-up trick I heard of which consisted of flecking off lint from black velvet with a razor, collecting it onto the mascara brush and brushing it on the lashes before applying mascara. My version works just as well, if not better, and is certainly a lot less trouble.

For my lips, I use a lip pencil to create an outline and then fill it in with lip gloss. I use a Sienna shade pencil for browner shades of lip gloss and a red pencil for redder shades. I use a lip gloss in chestnut or polished coral tints according to the color I am wearing. I find

that Janet Sartin lipsticks do not cake on my lips after a few hours. When I'm not made up, I use Janet Sartin's Sartinizer, which is not a lip gloss but is a great protection, very soothing for chapped lips. My whole family in fact uses it during the cold months.

Before putting on evening make-up I use Janet Sartin's oil to take off whatever make-up I have worn during the day. This time around, I do take the time to wash my face in the basin using very hot water. I go through the same routine with the lotion on my nose and forehead and the paste for the remainder of my face. I do much more shading at night, and it varies from time to time.

Most important, I use a flat shading cake. Shading 54, which Way Bandy, the superb make-up artist, told me about, is available only through the mail. (The address is: RCMA Cosmetics, 352 New Spaulding Street, Lowell, Massachusetts.) In general, I use it under the chin and around the jawline. On the sides of my cheeks, I use a cake blush-on. For highlights, also very necessary in the modeling of the face, I take a white Temperella pencil and use it under the eyes and under the eyebrows. This same white pencil is also effective drawn along the inner lower eyelid to whiten the eyes. I may even use a lavender pencil to go with a particular dress.

I draw a line under my lower eyelashes with a Temperella Bistro black pencil where the eyelashes join the lid.

My daytime make-up takes only twenty minutes or so but at night I may take as much as forty-five minutes to an hour depending on how festive the occasion is. When my evening make-up is set, I often use a Lancôme sky-blue crayon to set it off. I place a large dot in the center of each eyelid and blend it in. It sparkles the eyes and makes them look much bigger.

For special occasions, such as a photography sitting for a magazine, I always try to book the great make-up artist, John Richardson, who is so much in demand he has to be booked far in advance.

John in extraordinarily sensitive to not only the outer personality of his subject but also to the inner beauty of the person. He never swamps a woman with a too-stylized make-up unless, of course, she asks for one. Instead, he will make you look your best self—accen-

tuating rather than submerging the real you.

My hair is one of the least complicated parts of my regimen. I have it cut once every six weeks by Mr. Hideo of Suga at Bergdorf Goodman; it gets shampooed, brushed, and blown dry three or so times a week, depending on how crowded my schedule for store appearances and so forth is. (I shampoo my own hair and the blow-drying takes about twenty minutes.) Mr. Don, at Clive Summers salon, does my hair coloring every two weeks.

There are certain beauty staples that I've stuck by. I've found that Neutrogena is the best hand cream. It is used in the Arctic by fishermen whose hands are exposed to severe cold. I find it works when my hands have been covered with paint and I wash them with turpentine. I use Conte castile soap as a body soap, and the best shampoo for me is Caswell-Massey's Ultra Shampoo. I never wear nail polish on my fingernails but I do use Dior's nail oil, Huile Fortifiante. For my toenails, I find Lancôme's nail lacquer to be the best. Miss Elba at Suga does my pedicure every two weeks.

I'm often asked what my perfume is, and all I can say is—experiment. Each metabolism is different. I happen to wear Miss Chess Tuberose toilet water which even taxi drivers often ask me about. I sometimes also use Nuit Blanche by Signe Arys, and for summer, Lemony Lime, Verbena, and White Rose colognes, all from Caswell-Massey. Unfortunately—perfume is merchandisable as a fantasy. I am all for fantasy, but in this case, it can be misleading. You may respond to a fantasy, but your metabolism may negate the scent the second it touches your skin. You will only know by trying. The best way is to sample—take advantage of sample sprays on department store counters. If someone says to you four hours later, "What perfume are you wearing?"—you've got it. Make it your own. As often as not the cologne or toilet water, always less expensive, serves as well. Once you have found it, invest in the purse spray size. It does wonders during the day, sprayed at the elbow (one of the most absorbent areas) and, of course, at the top of the neck under the hair and behind the earlobes.

To freshen up, I use witch hazel on cotton pads over the eyes, or put my heels under the cold water tap.

Wow! For winter, after a bath, I rub Vaseline on the soles of my feet and then wipe it off, to avoid dry skin.

Before bed, I put the Janet Sartin oil on my face and then wash my face in the basin, rinsing thirty times. The oil and soap soften the skin remarkably. On my nose and forehead, I use Janet Sartin's controlling lotion. On my neck and the rest of my face, I apply the Sartin cold cream and blot it off after ten minutes. After the bedtime bath I use Janet Sartin's body lotion.

I never take sun baths on my face, only on my legs—once I have a tan I never wear stockings during the summer. At the beach in summer I use the Sartin sun screen on my face.

Luckily, I have no trouble falling asleep. I usually read before I doze off. Sleep is terribly important to staying healthy, and I think that's why some people seem to need more than others. I believe we all have a sleep clock inside and once we are in tune with this we can discover what hastens sleep, whether it is reading or perhaps a bowl of hot soup.

The hours to myself in the morning are essential. I get up, shower, do a minimum of make-up. My breakfast menu doesn't vary. I have a four-minute boiled egg, Kava instant, Lahvosh Armenian Cracker Bread, which I order from The Valley Bakery in Fresno, California, and Willwood spread—marmalade, strawberry, or blackberry. This spread I use has only thirteen calories per teaspoon and is made by Williams and Woods Ltd., Dublin, and sold in this country by Country Cheese Store, Main Street, Southampton, and at Alexander's in New York City. A fresh whole orange called Honey-bell from Florida is lovely when available, according to season, from Tropical Fruit Shop, 261 Royal Poinciana Way, P.O. Box 605, Palm Beach, Florida 33480.) I never drink coffee. Instead, Kava instant—a no-caffein, no-acid mixture, with a half teaspoon of Coffeemate powdered cream. The breakfast tray with china and linens from my designs has been laid out the night before.

I carry the tray back to my room and read the New York *Times* and the *Daily News* while I'm having breakfast. While dressing, I listen to the radio. While I'm dressing in the evening, I listen to current favorites or long-enjoyed cassettes of Bobby Short, Mabel Mer-

cer, and Beverly Sills. And a treasured Harold Arlen one of Harold singing his own songs.

The phone will not ring, as it's too early in the morning. I find the phone's ring jarring and usually switch it off in my bedroom. I focus on what concerns me the most at the moment.

An essential part of tranquility is planning ahead. Each evening, I do a brief dress rehearsal for the day that follows. I have a long hook on the inside of my closet door and I hang there whatever I need for the next day—both for the day and the evening. I select not only the dress or dresses but also the accessories and so on. The lingerie and stockings I put in a green and white flower-patterned sachet-filled lingerie case which always remains on an open shelf in the closet. Thus, if I'm going out in the evening, I don't waste time. I do up my purses for day and evening ahead of time also, thereby gaining time to relax and do my make-up.

When I'm traveling, I put everything out on the bed the day before the trip. I'll have a rehearsal with the accessories and the books I'm taking so I can eliminate as much as possible beforehand. On my personal appearance tours, I usually wear the same wardrobe. Because these clothes get so much wear, whenever possible I get a duplicate of a particularly favorite dress to prolong its wearing span.

I've always had a tendency to try to develop a uniform for myself. It saves so much time. When I'm working in the Seventh Avenue office, I wear black jeans and sweaters. I'm only interested in comfort and ease. I don't want to think about what I'm wearing. I always think of Daisy Fellowes who, if something worked, would have it copied again and again. There's a great deal of sense in that fashion concept. I find I wear things that I like until they no longer work.

I must say that I don't believe in seasonal colors. I often wear the same colors all year-round. I try when I'm shopping to buy staple things that will last the whole year. I buy in depth. Shoes are perhaps my one costly investment. If I get the best, they last, and sending them to the cobbler increases their time span.

I find this the least interesting part of my life, but I've gone on at this length because these are questions that I'm so often asked.

I feel very strongly that one of the most revolutionary aspects of this century has been making beauty and health available to everyone. American women are constantly involved in self-improvement. That is all to the good. For this reason, we each need to do as much as we can to dispel the mystique that has been built up about how women look. I am proud of my age and the experience that has come with it. I'm not interested in looking younger than I am or pretending to be someone I am not. But I also feel that if it were necessary I would have cosmetic surgery or do any number of other things to remain vital and alive. All women need to extend to one another the comfort and support to be able to change and grow.

Often, my friends are curious about the care with which I watch my diet. More curious because I seem to be able to eat whatever I want to eat. I'm afraid I have no secret. I watch my weight every day. If I gain more than three pounds, I immediately cut back or diet strictly. I do not think of this as vanity but as part of the disciplined maintenance that will keep me alive and well.

I bring this up because again I think we need to help one another in our life plans. In our society, the superstition is often expressed that women are foolishly involved with their appearance. Pride goes much deeper, I am sure. I believe that we must wish one another well. Age, change, and wisdom do not come easily in our society for women or men. But women in particular are made to suffer.

As I see it, ripeness is all.

Traveling

I'VE TRAVELED SO MUCH in the past few years that I've had to master a routine that almost makes it *easy* to walk out the door with my bag and get on a plane.

Certain necessities I always pack: from Wyatt, enclosed in a tiny wood box, a small carved statue of a Chinese goddess that soothes me with its serenity, a little pillow covered in a print I designed, a folding triptych with photographs of my family, an electric coffee pot because I usually get up before room service, and a box of Bent's Biscuits.

I've found that the key to packing without wrinkles is using the plastic bags from the cleaners. They are much more effective than tissue paper and you can see everything at a glance.

As I've said, I always have a rehearsal of what I'm going to take, along with the accessories. I've learned never to take anything new that I haven't worn and therefore don't know how it will look, feel, and fit. The rehearsal also keeps me from taking too much. In this rehearsal I also include whatever books I intend to carry along.

I always take a pair of blue jeans, sneakers, and a T-shirt because I want to be able to relax when I'm not making appearances or doing interviews. I cut corners by taking along a terry-cloth robe that doubles as a towel since hotel towels are seldom adequate. And, of course, I carry along my own Conte castile soap, washcloth, and make-up preparations.

I carry a separate make-up bag so that all of these articles are together and can be found easily. The minute I enter a hotel room I take the shades off two lamps and replace their bulbs with the 100-watt bulbs I carry with me. Then I move a table in front of the window, put a terry towel over it to protect it from any spillage and use it as a dressing table. The two lamps go on it. This gives me a flat, direct light to apply make-up in the evening as well as a flat, direct window light in daytime. I have never been in any hotel anywhere in the world where the lighting in bathroom or bedroom was suitable to use when putting on make-up. It takes

about forty-five minutes for me to do my make-up for television.

In my handbag, I carry my engagement calendar, sketchbook, crayons, daytime make-up, Miss Chess Tuberose toilet water, Frenchette Italian dressing—only two calories a tablespoon—Lipton's packets of Instant Tomato Soup, and other last-minute things. Remember when we used to carry nothing more than a compact, handkerchief, lipstick, and comb in our purses?

I do find it hard to sleep when I'm away from home, so I take along my Norell bubble bath to help me relax.

Relaxing

I find that this exercise is a great help with a backache:

Lie flat on the back.

Take a knotted Turkish towel and place at the base of the spine.

Relax.

Breathe.

Think of lovely things.

Only remove the towel when it feels like an intrusion.

When it does, its work has been done.

I *never* sleep on a foam rubber pillow. Rather, I find that an ideal pillow can be made from two regular-size pillows placed together in a regular-size pillow case. I do this in a hotel room when I'm traveling. This can be done because in almost all hotels, pillows are not as fluffy as the ones we use in our homes.

Whether I'm at home or on the road, I relax in my white terry-cloth robe and sandals. The freedom they give me is always a lift.

Nora's Miscellany of Household Tips

Odds and Ends

Floor Boards

A little talcum powder, or soap worked into cracks between floor boards, will help to lessen a squeaky noise.

Address Books

When listing names and addresses in an address book, use ink for the names and pencil for addresses. The names will stand out clearly and when it is necessary to change the address, the old one can be erased and the new one entered.

Stamps

When you buy a sheet of postage stamps, sprinkle a little face powder or talcum powder on a puff and rub it lightly over the glue. The stamps will not stick together even in humid weather.

Ink

If you work with ink of different colors, keep a small bottle of ammonia handy. A dip of the pen into the ammonia cleans it like new.

Bills

To store receipts, etc. at home, use letter-size envelopes (9½ × 4). Mark each envelope with the contents such as light or gas, telephone, insurance, automobile, cleaners, etc., and file them alphabetically in a drawer. The envelope takes up little space and the papers will be handy when needed.

Shower Curtains

To prevent shower curtains from slipping off the hooks, try alternating them in opposite directions.

Travel

This tip will save a pressing job. Wring out a wet turkish towel and hang it in the closet with your suits

and dresses after unpacking. Close the door to keep in the moisture, and wrinkles will come out of the articles in a few hours.

When traveling, wind a strip of colored adhesive-backed tape, or tie a colored ribbon around the handle of luggage in order to distinguish it quickly.

Kitchen Hints and Nutritional Hints

1. To remove garlic easily from cooked food, insert a toothpick in the garlic so you can spot it more readily.

2. Unused celery tops may be frozen or dried. Add to soups, stews, or recipes calling for celery flakes.

Wax

A strong solution of boiled tea makes a good cleansing agent for mahogany furniture. It will help to remove old wax and camouflage any scratches.

Cleaning

When cleaning dresses and cabinet drawers, use strips of Scotch tape to pick up the dust and lint which gather in corners.

Stains

To remove yellow stains from a porcelain sink or bathtub, go over the spot with a brush that has been dipped into a paste made of hydrogen peroxide and cream of tartar. Rub hard and repeat if necessary.

Kitchen Cues

Dry mustard mixed with water and put into a cup in the refrigerator will remove food odors and keep the refrigerator fresh and clean-smelling.

Iced Tea

To give lemonade, punch, or iced tea added zest, freeze mint leaves in with the ice cubes. The cubes will be decorative as well as flavorful and nice to look at.

Celery

To keep celery fresh and crisp for a long time, wrap it in four sheets of paper toweling. Place it in a plastic bag and store in the refrigerator. The paper towel absorbs excess moisture.

Eggs

A cracked egg will last as long as an unbroken one if

a piece of cellophane tape is placed over the opening. Always keep in the refrigerator until a few hours before using.

Ice Cubes

When you empty ice cubes out of a tray, put them in a plastic bag. Put them back in the freezer, they will stay frozen indefinitely and not stick together. Also you can fill the trays right away and return them to the freezer.

Mint

When chopping mint, sprinkle vinegar on the board to prevent the leaves from turning brown.

Baking, etc.

Place all ingredients at the left side of your mixing bowl before you start to use your recipe. As you use each item move it to the other side of the bowl. You will not have to worry about what you put in or left out of the batter when interrupted by doorbells or telephone calls.

Pudding

After you make a pudding, cover it with wax paper or Saran Wrap while it is still hot. This will help prevent skin from forming on the top.

Stockings

Before hanging nylon stockings to dry, wrap them in a turkish towel for a few minutes. They will be easier to handle, will not drip, and will dry in a short period of time.

Blouses and Lingerie

Before washing nylon lingerie and blouses, soak them in warm water with a little baking soda added. They will look fresh and new again.

Dacron and Fiberglas Curtains

When washing Dacron, nylon, or Fiberglas curtains add about half a cup of powdered milk to the last rinse water. This will give body and a fresh look to the curtains.

Curtains

To retain the stiffness in the ruffle of a Dacron curtain add one quarter cup of sugar to the last rinse water and dip the ruffle into it.

Penny Wise

Sew the buttons on the children's play clothes, coats, overalls etc., with elastic thread. They won't pull off but stretch instead.

Bath Towels

Don't dispose of worn or faded bath towels. They make good padding for the ironing board. Place one on top of another for desired thickness and then put on the cover.

Vinegar

Here are some of the ways in which white vinegar comes in handy.

Not only is vinegar a time-honored remedy for insect bites and sunburn, it also soothes bruises, chapped hands, and hives.

A vinegar bath will help loosen a rusted or corroded bolt.

For a shiny top on homemade bread, brush with vinegar just before baking is finished, and return the bread to the oven for the final few minutes.

Stopped-up sink drains can be opened by pouring a handful of baking soda down the drainpipe, adding a half glass of vinegar, and covering tightly for about a minute.

A solution of two tablespoons of vinegar and three tablespoons of sugar in a quart of water will help cut flowers last longer.

A half cup of ammonia and an eighth of a cup of vinegar added to each quart of warm water forms a solution that is excellent for washing windows without leaving films or streaks.

Boiling a little vinegar will eliminate unpleasant cooking odors.

Dark stains caused by minerals in food and water inside aluminum utensils can be removed by boiling water spiked with vinegar.

A soft cloth moistened with vinegar will clean and shine patent leather.

And wine vinegar:

A marinade made in the proportion of a half cup of *wine* vinegar to a cup of heated liquid, such as bouillon, makes an excellent tenderizer for tough meats and game.

Asparagus

For storing asparagus, cut ¼ inch off the stem. Place in a suitable container filled with one inch of water and refrigerate. The asparagus will be crisp and tender for several weeks.

Tulips

Put a penny in a vase of tulips. The copper will keep them perky and fresh longer.

STAINS AND SPOTS

Stain	*Nonwashable Fabric*	*Washable Fabric*
Fruit	Take it to a dry cleaner and tell him it's a fruit stain.	Stretch the stained part over the top of a bowl or saucepan. Pour boiling water through stain from height 2 or 3 feet. Never use soap.
Grease	Put blotter under wool or silk. Cover spot with Fuller's earth starch, or talcum, then layer of porous paper. Iron with paper over spot. On linen, rayon, cotton, use carbon tetrachloride.	Use hot, soapy water first; carbon tetrachloride if stain persists.
Lipstick and rouge	Take to dry cleaner; you could try carbon tetrachloride.	Rub in glycerine or Vaseline to loosen stain. Wash in warm, soapy water.
Ice cream	Sponge with a little warm water. Dry. Sponge with carbon tetrachloride.	Soak in cold water or lukewarm water. Launder in hot soapy water.
Coffee and tea	Better to take to dry cleaner as soon as possible.	Sponge immediately with warm water. Then pour boiling water through stain from height. Wash. If cream left greasy spot, use carbon tetrachloride.
Perspiration	Sponge with clear water, if stain persists send to dry cleaners.	Launder. Use chlorine bleach solution for bad, persistent stains on white cotton or linen.
Gum	Take to the dry cleaners. You could try to remove by using an ice cube to harden gum, scrape off. Then sponge alternately with water and carbon tetrachloride.	"Freeze" with an ice cube until gum hardens. Scrape off. Soften remaining gum with egg white and then wash.

Ink	Best to take to the cleaners.	Treat right away. Rub in glycerine. Rinse and apply glycerine again as long as ink comes out. Rinse. Wash with warm soapy water.
Scorch	Dampen and lay in sun.	A deep scorch in any fabric spoils fibers. For light scorch, dampen fabric and lay in sun. Launder.
Grass and flower stains	Sponge with wood or denatured alcohol. Test on unexposed portion first.	Use chlorine bleach on white fabrics, otherwise plenty of soap and water.
Paint	Sponge with carbon tetrachloride. If stain persists, take to dry cleaners.	Treat while fresh. Scrape off. Wash with soap and water. If paint has dried, soften with oil, lard, or Vaseline, then wash, or sponge with turpentine.
Stains	When removing a stain from material with cleaning fluid, place a piece of paper toweling under the material. This will help to absorb the stain.	

Menus and Recipes

I've included here menus and recipes from three of my favorite places—Faraway, our Manhattan apartment, and Southampton. Each of these homes represents a different world to me. Faraway— only yesterday in my memory—was much more expansive and leisurely in its style, a greater freedom of time reflected in the recipes. I have included recipes and menus from Faraway because I am so often asked for the recipes by people who remember our shared days there together.

The apartment in Manhattan and the house in Southampton have evolved on a far more intimate scale. Entertaining is now inextricably linked with the family and our circle.

Recipes are given for items marked with an asterisk (*).

Faraway

You'd think from these recipes we lived on caviar, but we didn't.

Brunch for Two
on the Upstairs Terrace

Scrambled eggs
made with butter in double boiler
A large scoop of caviar
on each plate
Dark pumpernickel bread
Unhulled strawberries
Krug champagne
Café filtre

Lunch for Four
Under the Apple Tree

Baked potatoes stuffed with caviar
Sour cream with garden chives
Slices of rare roast beef
Homemade raw spinach salad from
the garden, with crumbled bacon
Grapefruit ice with fresh blueberries
Macaroons
Krug champagne

To stuff the baked potatoes, scoop out about ⅓ of each potato, pop in butter, and fill with a good dollop of caviar. I mix the salads at the table—vinegar, oil, salt, and pepper. Lemon ice sprinkled with instant espresso coffee alternates with the homemade grapefruit ice and berries.

Sunday Lunch for Sixteen
by the Pool

Guacamole* and Fritos
Large whole salmon
served cold
garnished with watercress,
lemon, and radishes
Cheeses on a wooden tray
Tunbridge Wells biscuits
Garden tomatoes
stuffed with succotash
Round loaf of Italian bread
Hot brandied peaches
mixed with crystallized ginger
Whipped cream
Cheese cake Faraway*
Soave wine

The guacamole, served with drinks, disappears in seconds; the recipe is for four to six people and had to be doubled (or more) for sixteen. The hot brandied peaches and the cheese cake are optional, but—for a splurge—are served together. Alternate for red or white Spanish wine in covered carafes.

Guacamole

4 strips bacon
2 avocados
1 clove garlic
1/8-inch slice of lemon, minced
1/4 teaspoon salt
2 dashes Tabasco
1/4 teaspoon chili powder
Pepper
Mayonnaise

Fry 4 strips bacon until crisp, crumble and set aside. Mash 2 ripe avocados, then add 1 finely minced garlic clove. Stir all ingredients together well, except for mayonnaise and bacon, put into a small bowl, and cover top completely with mayonnaise so that no air reaches avocado. Just before serving, stir mayonnaise and crumbled bacon bits into the avocado mixture. I always add more chili

powder and Tabasco—so taste as you go along and add accordingly. This can be made way ahead of time. The mayonnaise top seals the mixture. Serve with Fritos. Serves 4–6.

Cheese Cake Faraway

This is a wonderful dessert and very easy to make.

Crust:
Mix together 22 single graham crackers rolled fine and a bar of melted butter. Sprinkle on the graham crackers Spreckels sugar and cinnamon—it comes in a shaker jar. After this is blended together, press mixture down in a pan with a plastic spatula. Make it a hard crust. Have oven preheated to 350°. Bake crust in an 8-inch springform pan for 6 minutes. Cool it while filling is prepared.

Filling:
In electric mixer beat together 2 packages Philadelphia Cream Cheese (8-ounce size) and 2 eggs, add 1 cup of sugar, and 1 tablespoon vanilla. When blended smooth, pour on crust and bake 18 minutes. Cool 1 hour.

Topping:
Mix a 16-ounce size carton sour cream with 2 tablespoons sugar and 2 tablespoons vanilla. Pour over the cake, sprinkle on some of the Spreckels sugar/cinnamon, and bake 6 minutes. Place in refrigerator 10 hours or more before cutting. Cut around the cake tin, then slide the knife under it so it comes out nicely. Each of the three bakings is at 350°.

Dinner for Six
in the Studio

Raw mushrooms
peeled and filled with caviar,
a dash of lemon juice on each
Faraway casserole*
Romaine salad
Scallions from the garden
Nora's bread*
Johannisberger du Valais
With dessert: Château d'Yquem

The mushrooms are served with drinks before dinner—with grated onion and hard-boiled egg yolk for those who like it.

Faraway Casserole

Take 3 cups boned cooked chicken and arrange in the bottom of casserole. Distribute 1 cup cooked carrots, 12 small white onions (cooked), 12 cooked potato balls (made by scooping from cooked potatoes with a melon-ball cutter), 1 cup cooked peas, 1 cup mushrooms (sliced), in the casserole on top of chicken. Make a white sauce of 6 tablespoons chicken fat or butter, 6 tablespoons flour; season to taste with salt and pepper; add 2 cups of chicken stock and about 1¼ cups heavy cream, and pour over chicken.

Optional: 1 can cream of mushroom soup. Add to casserole mixture.

Crush 4 cups cornflakes, toss in 4 tablespoons melted butter. Sprinkle over the casserole. Bake in hot oven (400°–425°) for about 15 to 20 minutes. I bake this at 500° but watch it very carefully.

Nora's Bread

1¾ cups 100 per cent whole wheat flour
1 cup self-rising cake flour
6 tablespoons wheat germ
¼ teaspoon salt
1 tablespoon sugar
3 teaspoons baking powder
2 tablespoons butter
1 egg
1 cup milk

Mix dry ingredients together, then cut in 2 tablespoons of butter or margarine; add 1 egg and a little milk to make a stiff dough. Turn onto a floured board and knead lightly until the side next to the board is smooth. Bake in whole rounded loaf on cookie sheet for about ½ hour (350° oven); the dough holds exactly the shape it's given, and a slashed crisscross on top will keep the crust intact. This recipe must be followed exactly.

Family Dinner
After the Guests Leave for Home

Marinated Carrot Salad*
Spaghetti with Faraway sauce*
Bread sticks
Eskimo pies from the freezer
or
Dundee fluff *

Marinated Carrot Salad

1 cup cider vinegar
¾ cup sugar
¼ cup oil
3 bunches carrots
8-ounce jar of sliced pimentos
1½ cups chopped green onion
1½ cups sliced green pepper

Boil the first three ingredients until sugar dissolves and let cool.

Slice and cook the three bunches of carrots (not too soft) and let cool. Add pimentos, green onion, and green pepper. Place in a casserole dish and toss lightly.

Pour the sauce over the vegetables; mix together. Cover and store in refrigerator until ready for use; stir often.

Before serving, drain the sauce and store, as it may be used again.

This recipe keeps very well when stored and may be made 1 or 2 weeks in advance. Serves 4.

Faraway Spaghetti Sauce

1 onion, finely chopped
1 clove garlic, minced
2 tablespoons olive or salad oil
½ pound ground chuck
½ pound sweet Italian sausage
¼ pound hot Italian sausage
2½ cups (one pound, three ounces) canned tomatoes
2 7-ounce cans tomato paste
3½ teaspoons salt
1½ teaspoons sugar
¼ teaspoon crushed red pepper
Monosodium glutamate to taste
½ teaspoon oregano leaves
½ teaspoon basil
Fresh-ground black pepper to taste

Cook onion and garlic slowly in the oil until the onion is transparent. Add the beef and cook until no longer pink. Stir in the sausage, tomatoes, tomato paste, salt, sugar, and red pepper. Cover and simmer one hour. Add the herbs.

Serve on spaghetti cooked not more than 8 minutes!—and sprinkle generously with grated Parmesan cheese.

Seasoning listed is very conservative. I always add lots more of everything—especially oregano and basil. Make sure herbs are very fresh and that the sausage comes from a good Italian market. You can start this sauce at any time and simmer it practically all day on an asbestos pad. But if you want to do it quickly, it can be cooked in an hour over a higher flame.

Dundee Fluff

This recipe must be followed exactly. Beat 3 egg whites stiff. Add slowly 3 tablespoons granulated sugar and 3 tablespoons Dundee orange marmalade. Put in well-buttered top of double boiler, cover tightly, and cook for 1 hour. Never let the water stop boiling. Turn out on a warm plate and serve with the following sauce, passed separately.

Sauce:
3 egg yolks beaten with ½ cup powdered sugar; ½ teaspoon vanilla, ¼ teaspoon salt, 1 cup whipped cream, and the juice of 1 lemon. Chill well, and before serving, sprinkle with ½ cup not too finely chopped Macadamia nuts.

Manhattan

No matter how small or large the meal, the secret ingredient is always Nora's splendid dessert.

Lunch for Two
Looking Out at the United Nations

Gazpacho*
Slices of cold boiled beef
with carrot spears and
onion rosettes from the broth,
served with horseradish sauce
and English mustard
Endive and watercress salad
Ritz cracker pie*
Pouilly fumé

Gazpacho

1½ cups Mr. & Mrs. T Bloody Mary Mix
1 beef bouillon cube
2 tablespoons of wine vinegar
1 tablespoon salad oil
½ teaspoon of salt
1 teaspoon of Worcestershire sauce
Red pepper sauce to taste
¼ cup chopped unpeeled cucumbers
¼ cup chopped green peppers
¼ cup chopped onions
1 cup chopped tomatoes

Heat juice to boiling, add bouillon cube, stir until dissolved. Stir in remaining ingredients. Chill several hours; overnight is even better. Last 4 ingredients to be added when cold. Also serve with herbed croutons. About 4 servings.

Ritz Cracker Pie

3 egg whites
1 cup sugar
1 cup chopped nuts (pecans)
½ teaspoon baking powder
16 Ritz crackers, crushed

Pre-heat oven to 325°. Beat egg whites until stiff; add sugar, one tablespoon at a time. Continue beating; add baking powder. Fold in cracker crumbs and nuts. Turn into a greased pie plate and bake for 30 minutes. Cool. Decorate with whipped cream.

Lunch for Four
with the Tulip Glasses
and Rosy Plates

Fresh asparagus
Sliced gourmet shrimp*
Beet and spinach salad
Nora's ice cream pie*
with rum sauce*
Montrachet

I enjoy filling the table with the patterns I've designed, spread out over one of my cloths. It reminds me of a tea party long ago to which only friends and dollies were invited.

Gourmet Shrimp

2 tablespoons powdered flour
8 tablespoons fresh chopped dill
Dash paprika
1 teaspoon salt
1½ pound cooked, cleaned shrimp
1 tablespoon margarine
2 cups sliced, fresh mushrooms
2 tablespoons fresh shallots
1 cup skimmed, evaporated milk
3 tablespoons grated Cheddar cheese

Mix the flour, dill, paprika, and salt together. Spread onto a large board or platter. Drain and dry the shrimp thoroughly. Spread them out on the flour mixture and turn them several times until they are evenly coated.

Melt the margarine in a pre-heated skillet and toss in the shrimp. Turn them frequently until they are coated with margarine and appear glossy.

At this point, add the mushrooms, shallots, and milk. Warm them thoroughly. Sprinkle the cheese on top. Cover and simmer for about 1 minute. Serves 4–5.

Nora's Ice Cream Pie

1 quart praline ice cream
1 quart vanilla ice cream
1 quart coffee ice cream
Macaroons
Butterscotch sauce
English toffee
Crushed pralines

Crush enough macaroons to cover bottom of spring-form cake tin (about 9-inch size). Then cover the crumbs with praline ice cream. Then drizzle with butterscotch sauce. Then layer of small, whole macaroons. Next put in vanilla ice cream, butterscotch sauce, and whole macaroons. Then coffee ice cream, butterscotch sauce, and whole macaroons. Put in freezer for at least 8 hours. After you remove spring-form tin from pie put crushed macaroons and crushed English toffee or crushed pralines around sides. Serve with rum sauce.

Rum sauce:

1 cup of sugar
1 tablespoon grated lemon rind
1 cup boiling water
1 tablespoon butter
1 tablespoon cornstarch
3 tablespoons lemon juice
½–¾ cup rum
Dash of salt

Combine sugar, lemon rind and, water. Add butter and heat to boiling point. Mix cornstarch with lemon juice and add to sugar mixture. Cook about 8 minutes, stirring. Remove from heat. Strain. Add rum and dash of salt. Serve hot or cold with ice cream pie.

Dinner for Six
Before the Theatre

Mercedes Eugenio Antipasto*
Broccoli soufflé
Nora's baked chicken*
Arugala and watercress salad
Cold chocolate soufflé*
Saint-Véran
(from the vineyards near
those that produce the much
more expensive Pouilly Fuissé)

I've found that it simplifies things enormously to serve the first course *with* the drinks. This antipasto works beautifully, or, for a less rushed meal, I put shrimp on seashells or serve the mushrooms I mentioned in the Faraway section.

Mercedes Eugenio Antipasto

1 cup olive oil
3 medium onions, chopped
½ clove garlic
Oregano
Italian spices

Sauté the above.

Add:
1 large can of tomato paste
1 large jar of Red Hot sauce (Pace's Picante Sauce, 16 ounces)

Add any combination of the following: chopped green peppers, celery, carrots, zucchini squash, green onions, cucumber, parsley; any marinated vegetable—hearts of palm, artichokes, or salad olives. To marinate your own vegetables, place in Italian salad dressing.

Make at least 24 hours before serving.

This mixture will freeze; then "freshen up" with fresh vegetables.

Nora's Baked Chicken

1 cup lemon juice
1 teaspoon salt
1 teaspoon freshly ground pepper
1 teaspoon basil leaves
8 cloves garlic crushed
1½ cups dry white wine
3 chickens, quartered
1 cup melted butter
3 cups crumbled potato chips

Pre-heat oven to 400°. In a large bowl, combine lemon juice, salt, pepper, basil leaves, garlic, and wine.

Add chicken, cover, and marinate in the refrigerator for 4 hours, turning occasionally. Remove chicken pieces and pat dry.

Dip each piece into melted butter then in crumbled chips. Arrange pieces in a large, flat, buttered baking dish and bake uncovered for 1 hour. Serves 6–8.

Cold Chocolate Soufflé

½ cup sugar
1 envelope unflavored gelatin
Dash of salt
3 eggs, separated
1 cup milk
1 cup semisweet chocolate chips or 1 8-ounce bar
½ teaspoon vanilla
2 cups whipped cream

Stir ¼ cup of sugar, gelatin, salt, egg yolks, and milk in a saucepan. Add chocolate, stir over low heat until chocolate is melted. Beat with a beater to blend. Add vanilla, cool until thick. Meantime, tie a standing 2- to 3-inch collar of foil around the top of a straight-sided 1-quart soufflé dish. Beat egg whites with remaining sugar until stiff. Fold into cooled chocolate mixture. Fold in whipped cream. Fill collared soufflé dish; chill until firm. Remove collar. Serves 6.

Dinner for Four
on Trays in the Library

Fresh peas on snow pea pods
Herb-crusted lamb pie* or
Chicken pie with cream puff crust*
Fresh mushroom and Bibb lettuce salad
Fresh fruit
Banfi red wine

This is one of those family meals that friends like to join at the last minute. Perfect for big television nights.

Herb-crusted Lamb Pie

Crust:
1¼ cups flour
½ teaspoon salt
1 teaspoon chopped chives
1 teaspoon fresh parsley, minced
1 teaspoon dill, chopped
1 3-ounce package cream cheese
½ cup butter

Mix together the flour, salt, and herbs.
Cut in the cream cheese and butter and mix together until they form a ball, adding a little ice water if necessary.

Filling:
3 pounds boneless lamb shoulder, trimmed and cut in 1½-inch cubes
Salt and pepper
1 garlic clove, chopped
3 tablespoons olive oil
1 cup or more dry white wine
1½ teaspoons dried rosemary
12 small white onions, peeled
1 tablespoon lemon juice
2 eggs
1 tablespoon grated lemon rind
1 egg yolk with 1 tablespoon milk for glaze

Sprinkle the lamb with salt and pepper.
Sauté the garlic in hot olive oil and then add the lamb, browning it over medium heat. Add the wine, rosemary, onions, and lemon

juice. Cover and simmer until the lamb is tender, stirring occasionally and adding more wine if necessary.

When lamb is tender, beat eggs in a bowl, and, stirring, add hot lamb broth and grated lemon rind. Spoon the lamb, onions, and sauce into a buttered casserole dish.

Pre-heat oven to 400°. Roll the herb crust to a thickness of ¼ inch. Cut into 1-inch strips and arrange a lattice on the casserole, trimming the floppy ends. Glaze the top with the egg yolk and milk mixture and bake until browned. Serves 6.

Chicken Pie with Cream Puff Crust

Filling:
3 whole chicken breasts, split, skinned, and boned
½ teaspoon salt
2 tablespoons butter
1¼ cups chicken broth
1 can artichoke hearts
¼ cup heavy cream
2 tablespoons cornstarch
½ teaspoon dried tarragon
¼ pound sliced, cooked tongue cut in strips
1 cup grated Swiss cheese
Salt and pepper
½ cup sherry

Sprinkle chicken breasts with salt, and sauté in one tablespoon butter for a minute on each side. Add the chicken broth. Cover and simmer for 15 minutes.

Remove the chicken from the broth and cut into strips. Save the broth for the sauce.

Cut the artichoke hearts into quarters and sauté briefly in the remaining tablespoon of butter.

In a small saucepan, bring the reserved broth to a boil and add the sherry. Stir together the cream and cornstarch and whisk into the boiling broth mixture. Add the tarragon; salt and pepper to taste.

Arrange the chicken and tongue strips and the artichoke bottoms in a 1½-quart rectangular baking dish and pour on the sauce. Sprinkle with grated Swiss cheese.

Cream Puff Crust:

¾ cup water
6 tablespoons butter
¼ teaspoon salt
¾ cup flour
3 eggs

Bring water, butter, and salt to a rolling boil in a saucepan. Lower the heat and add flour all at once. Beat until the dough forms a ball and no longer sticks to the side of the pan.

Remove from the heat and beat in the eggs, one by one, until the mixture is smooth and glossy.

Pre-heat oven to 425°. Cover the ingredients of the baking dish with the cream puff paste by placing mounds of the pastry on the top of the chicken mixture by the spoonful. Bake at 425° for 20 minutes. Lower the heat to 350° and bake for another 15–20 minutes. Serves 4.

Christmas Luncheon
for Twelve

Gazpacho
Pumpkin soufflé
Spinach purée
Cranberries in orange shells
Chili corn bread*
Baked ham with Madeira sauce
Nora's plum pudding with hard sauce
Irish coffee ice cream*
Taittinger champagne

Holiday meals work their own magic. However, I find that bringing someone to help makes everything move with much greater ease.

Everyone may be in pants and blue jeans, but the meal sets the occasion.

The chili corn bread, surprisingly enough, goes with almost every meal. It adds a bright, unexpected taste that everyone seems to relish. Because it is so delicious, both hot and cold, it disappears quickly.

Chili Corn Bread

1 cup yellow corn meal
1 cup flour
¼ cup sugar (optional)
4 teaspoons baking powder
½ teaspoon salt
1 egg
½ cup milk
¼ cup soft shortening
1 cup cream-style corn
1 cup shredded sharp cheese
⅓ cup drained chilies (a little more if you like)

Rinse and seed chilies. Cut in strips and drain on paper towel. Sift together corn meal, flour, sugar, baking powder, and salt into bowl. Add egg, milk, and shortening. Beat until smooth, about one minute. Add corn and mix. Spoon half the batter into greased pan (8 inches in size). Lay chilies over batter. Sprinkle with half of the cheese. Top with the remaining batter and cheese. Bake in 350° oven for about ½ hour.

Irish Coffee Ice Cream

(Serves two—increase proportionately.)
1 pint coffee ice cream
3 tablespoons instant espresso coffee or any strong instant coffee
3 tablespoons Irish whiskey or Bourbon
1 cup whipped cream
Chocolate bits, optional

Soften ice cream. Dissolve coffee in Irish whiskey or Bourbon and stir into ice cream.

Refreeze. Serve with scoops of whipped cream on top and sprinkle with chocolate chips.

Southampton

A casserole can be the makings of a feast.

Eating at Southampton is much more informal. We're concentrating on rest, work and relaxation so we want meals that come together easily. I'm including here a series of one-dish meals that both Nora and I have come to depend upon. Add a salad, dessert, and a ripe American or non-vintage French or Italian wine and you have the makings of a feast. The chili recipe, by the way, has almost as many fans as my Faraway spaghetti recipe. By now, you've noticed that we like spices. You may want to temper my heavy hand somewhat. Nora suggests an old Spanish trick to bring out the full aroma of herbs—marinate them in olive oil for thirty minutes or longer before adding them to sauce or stew.

Country Casserole

½ pound wide noodles
Salt to taste
1 tablespoon butter
1¼ pounds ground beef
Freshly ground pepper to taste
2 cups tomato sauce
1 cup cottage cheese
½ pound jack or Cheddar cheese (grated)
¼ cup sour cream
⅓ cup minced scallions (use more if desired)
3 tablespoons minced green pepper
2 tablespoons of melted butter

This dish is best if made several hours in advance of baking. Cook the noodles in salted water for about 5 minutes. Do not overcook. Remember that they will be baked later.

Heat 1 tablespoon butter in a skillet and cook the meat, stirring and breaking up lumps. Add the tomato sauce, salt and pepper to taste, remove from heat. Combine the cottage cheese, jack cheese, sour cream, scallions, and green peppers. In a 2-quart casserole, make layers of noodles and the cheese mixture. Pour the meat sauce over all. Pour melted butter on top and chill. One hour before serving pre-heat oven to 375°. Bake the casserole for 45 minutes. Serves 4–6.

English Cottage Pie

1 large onion, coarsely chopped
1 clove garlic, minced
2 tablespoons butter
2 pounds ground beef
3 large carrots, finely chopped
1 to 2 tablespoons tomato paste
1 teaspoon finely chopped fresh parsley
½ teaspoon chervil
½ teaspoon dried thyme
1 bay leaf, crumbled
½ teaspoon dried sage, crumbled
⅔ cups dry red wine or beef broth
Salt and pepper to taste
3 cups or so mashed potatoes
½ cup grated Cheddar cheese

Pre-heat oven to 375°. Sauté the onion and garlic in the butter until limp. Add the beef and cook, breaking up with a fork until it is brown. Stir in the carrots, tomato paste, and all the herbs. Add the wine or the beef broth and salt and pepper to taste. Simmer gently for about 30 minutes. Spoon the mixture into a well-buttered, deep, oval baking dish. Spread the mashed potatoes on top. Sprinkle the cheese on top of the potatoes. Bake for 8 to 10 minutes or until the cheese is melted and golden. If you like, you can slip it under the broiler to brown it nicely. Serves 6–8.

Mary Ann's Chili

1¾ cups pinto beans
3 cups cold water
Salt to taste
5 cups canned tomatoes, preferably imported Italian tomatoes
2 tablespoons peanut vegetable, or corn oil
4 cups chopped green peppers
4 cups chopped onions
2 tablespoons chopped garlic, more or less to taste
½ cup finely chopped parsley
8 tablespoons butter
2½ pounds ground beef chuck, preferably a coarse grind
1 pound ground pork, preferably a coarse grind
¾ cup chili powder
3 teaspoons ground pepper
2 teaspoons crushed cumin seed
1 teaspoon monosodium glutamate

Place the beans in a bowl and add the water. Let soak overnight. Pour the beans and soaking water into a saucepan and bring to the boil. Cover and simmer until tender, about one hour. Stir occasionally to prevent scorching or burning. About ten minutes before the beans are done, add salt to taste.

Drain the beans, but reserve both the beans and the liquid. Pour the liquid into a saucepan and add the tomatoes. Set the beans aside. Bring the tomato mixture to a boil.

Heat the oil in a skillet and add the green peppers. Cook, stirring, about five minutes. Add the onions and continue cooking, stirring, until the onions are translucent. Stir in the garlic and parsley.

Meanwhile, heat the butter in a casserole large enough to hold all the ingredients. Add the beef and pork, and cook, stirring to break up any lumps, about 15 minutes. Sprinkle with the chili powder, and cook, stirring occasionally, about ten minutes longer.

Add the green pepper mixture and the tomato mixture to the meat. Add salt to taste, ground pepper, cumin seed, and monosodium glutamate. Cover and simmer about one hour. Stir often to prevent scorching or burning. A great deal of fat will rise to the top, but this will be skimmed off later.

Uncover and simmer 30 minutes longer, stirring occasionally. Add the beans.

Tilt the casserole so that the fat runs downward. Skim off and discard as much of the fat as possible. Serve piping hot with garlic bread. *Yield:* about three quarts.

Optional: Serve with dollop of whipped sour cream seasoned with lime juice and salt to taste. Sprinkle with chopped raw onions.

Moussaka

4 medium eggplants, about one pound each
2 pounds lean lamb, ground
3 onions, chopped
¼ pound butter
2 tablespoons tomato paste
¼ cup dry red wine
¼ cup extra strong coffee
¼ cup finely chopped parsley
2 teaspoons salt
¼ teaspoon freshly ground black pepper
⅛ teaspoon cinnamon
2 eggs lightly beaten
1 cup freshly grated Parmesan cheese
1 cup bread crumbs
Vegetable oil
4 medium tomatoes, sliced
6 tablespoons flour
3 cups hot milk
⅛ teaspoon nutmeg
4 egg yolks, lightly beaten
2 cups ricotta cheese

Pre-heat oven to 350°. Peel the eggplants and cut into ¼-inch-thick slices. Sprinkle with salt and let stand about 15 minutes.

Brown the lamb and cook the onions in two tablespoons of the butter. Add tomato paste, wine, coffee, parsley, salt, pepper, and cinnamon. Simmer until the liquid is absorbed.

Stir in the eggs, ⅓ cup of the Parmesan cheese and ¼ cup of the bread crumbs.

Wipe off excess salt from eggplants and brown on all sides in the oil. Alternate layers of remaining bread crumbs and Parmesan cheese, the eggplant, lamb mixture and tomato slices, ending with eggplant in a greased 4-quart casserole or baking dish.

Melt the remaining butter and blend in the flour. Gradually stir in the milk and bring to a boil, stirring. Add the nutmeg. Pour a little of the hot mixture onto the egg yolks. Mix. Return all to the pan and cook two minutes.

Cool slightly. Stir in the ricotta and pour over the top of the casserole. Bake one hour, or until bubbling hot and browned on top. Cool 20 or 30 minutes before serving.

(This recipe serves 12 and can be made a day ahead and frozen.)

Torta Rustica

Crust:
2 cups flour
½ teaspoon salt
⅔ cup shortening
½ cup grated sharp Cheddar cheese
4–6 tablespoons ice water
1 egg yolk mixed with 1 tablespoon milk for the glaze

Mix flour and salt in a bowl. Cut in the shortening and cheese. Add just enough ice water to soften the dough. Mix lightly with a fork until well blended and forms into a ball. Chill.

Filling:
3 tablespoons butter
1 onion, chopped
1 pound boneless pork
1 pound boneless beef
1 pound boneless veal
½ teaspoon salt
¼ cup chopped parsley
¼ teaspoon ground nutmeg
1 4-ounce can pimentos, drained
2 10-ounce packages chopped spinach, cooked and drained
¼ cup butter
1 teaspoon minced garlic
4 eggs
1 cup grated Parmesan cheese
¼ pound ham cut in julienne strips
Salt and pepper
4 hard-boiled eggs

Melt 3 tablespoons butter in a large skillet and sauté the onion until tender. Coarsely grind the pork and beef and veal together. Add the

ground meats to the onion and sauté until the meat is no longer pink, breaking up with a fork. Add salt, parsley, ground nutmeg and chopped pimentos.

In another skillet, sauté the cooked spinach and garlic in ¼ cup butter for 5 minutes. Cool both the spinach and meat mixtures. Add salt and pepper to taste.

Beat together the 4 eggs and add the Parmesan cheese. Blend half the egg mixture into the meat and the other half into the spinach. Grease a 10 × 5 × 4-inch loaf pan.

Roll out the dough on a floured board and line the bottom and sides of pan with it, reserving ¼ of the dough for the top.

Pre-heat oven to 350°. Spoon half of the meat into the pastry-lined pan and cover the center of the meat mixture with half of the spinach. Lay the peeled, hard-boiled eggs down the length of the pan. Cover eggs with the remaining spinach and top with meat. Place the reserved pastry on top, crimping the edges to seal. Cut a 1-inch-round hole in the center of the pie. Using scraps of leftover pastry, cut out leaves and place them around the hole. Beat the egg yolks and milk together and brush the entire surface with the mixture.

To unmold the pie: run the blade of a sharp knife around the inside of the pan and dip the bottom in hot water. Place a plate on top of the mold, hold on tight, and pray. That done, quickly turn the whole arrangement over. Rap the plate sharply against a flat surface and the pie should slide out easily. Turn it over and it is ready to slice.

Torta rustica is splendid for summer lunches or for light summer suppers, or it makes a hearty first course.

And finally, our recipe for Sangria. We carry the pitcher everywhere, from front porch to the beach. Sangria seems to go with almost anything—or anyone.

Sangria

1 bottle red wine
¼ cup brandy
1 small bottle club soda
Sugar to taste—¼ cup suggested
Slices of lemon, orange, apple

Stir red wine, brandy, club soda, and sugar together. Pour into a pitcher of ice. Stir. Add fruit slices. Stir again.